Painting and Drawing Water

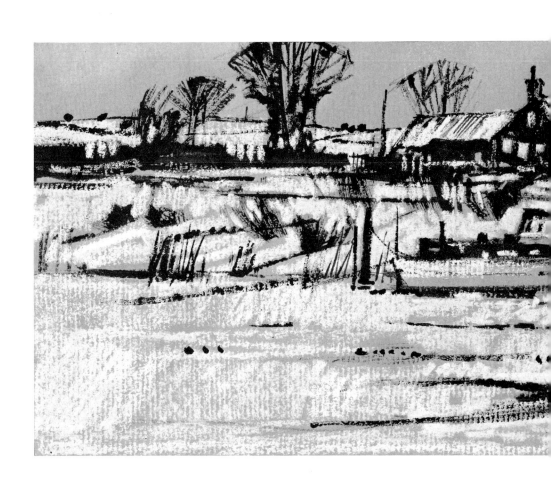

Painting and Drawing Water

Norman Battershill

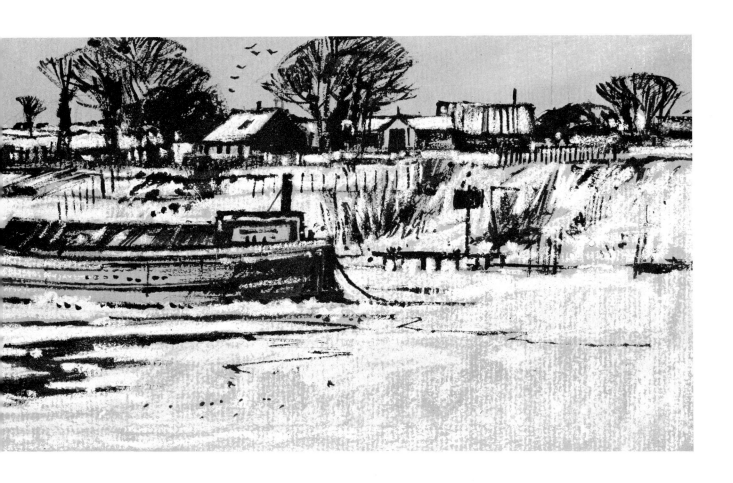

VNR VAN NOSTRAND REINHOLD COMPANY

Published by Van Nostrand Reinhold Company Inc.
135 West 50th Street
New York, New York 10020

Macmillan of Canada
Division of Gage Publishing Limited
164 Commander Boulevard
Agincourt, Ontario M1S 3C7, Canada

Library of Congress Catalog Card Number 83-27354
ISBN 0-442-21185-6

Library of Congress Cataloging in Publication Data

Battershill, Norman.
 Painting and drawing water.

 Bibliography: p.
 Includes index.
 1. Water in art. 2. Art—Technique. I. Title.
N8261.W27B37 1984 751.4 83-27354
ISBN 0-442-21185-6

Filmset by Latimer Trend & Company Ltd, Plymouth, England
Printed in Hong Kong by Dai Nippon Printing Co. Ltd

Acknowledgements

My thanks to the patrons who have kindly given
permission for the reproduction of paintings and
drawings from their private collections, and to Walter
Gardiner, Photographer, for his work in supplying
many of the colour transparencies.

My thanks to Helen for her patience in typing the
book.

Lizard

Contents

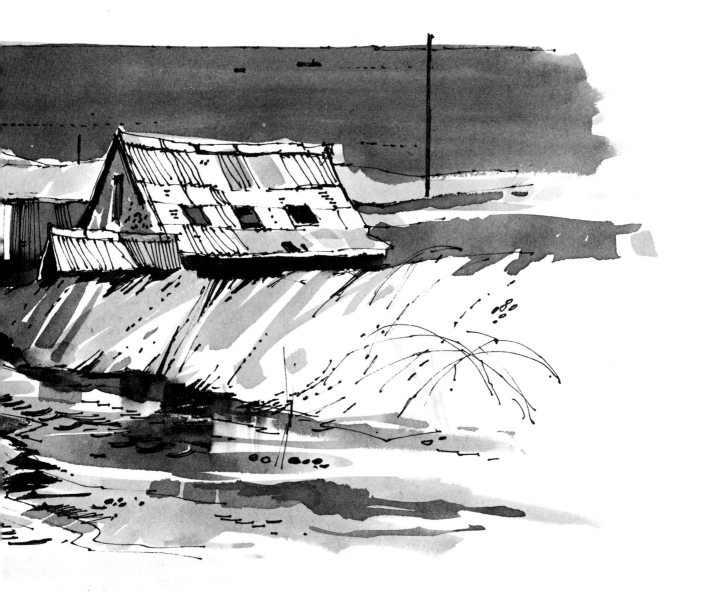

Introduction

'I have started again to paint the impossible: water, with waving grass in the background. It is wonderful to look at, but it drives one mad to try and paint it. However, those are the sort of things I go for.'

Claude Monet (1840–1926)

Any aspect of water in a painting has a special appeal. The varied forms and moods of water in countless settings make it a marvellous source of subject material for the perceptive artist.

The ability to paint water should be within the scope of all landscape painters, but it is often poorly depicted and its importance overlooked. Water is, in fact, one of the commonest substances on earth, and covers 70% of the earth's surface. It can be found in both liquid and solid forms. Clouds consist largely of water and are also rather neglected in landscape painting.

Water is one of the most challenging and difficult subjects for a painter. But there are few occupations as pleasant as setting up your easel by a flowing brook or painting the power of the sea on a deserted beach. The pattern of frozen water in a cattle trough, rain puddles in the mist and light in a glass of water all have a touch of magic too. My own study of water has been one of the most pleasurable and calming experiences any artist could wish for.

How this book works

The book is structured to help you develop your ability to look closely at the various forms in which water is found. It is intended as a series of studies and looks at how water can be rendered convincingly in landscape paintings. The book consists of my finished sketches, drawings and paintings with my comments and observations, as I believe that this is one of the best ways to arouse your interest and stimulate your ideas, but I have also included a fair number of demonstrations to show you my working methods.

The first four chapters discuss and illustrate the principal aspects of moving water, still water, shallows and reflections. One chapter is devoted to seascapes, and then we look at water as part of weather —as rain, mist, fog, dew and ice. Creating a sense of space and atmosphere is of special interest here, and I discuss it with selected paintings.

Each chapter has equal emphasis on drawing and painting. Subjects are chosen to illustrate particular points, and I discuss why the subject interested me, the medium used and how it was done. Drawing is a fundamental part of painting and develops our perception and understanding of form, texture and tone. You will find tone illustrations in pencil, charcoal, conté, pen and wash, and a combination of mediums. The paintings are also in different mediums — acrylics, oils, pastel, gouache and watercolour —with advice on the suitability of each for depicting water. Wherever feasible, the original drawings and paintings have been reduced in size as little as possible so you can see the technique I have used more clearly. The dimensions of the original are stated in each caption and also the type of surface and medium, to give you as much information as possible about how I work. Each demonstration is done to the same size of $7 \times 4\frac{1}{4}$ in. and reproduced at a common reduction throughout the book.

You can pick up the book and study a section at random, or read through each chapter in sequence. Either way you will find information and plenty of encouragement which is sure to stimulate your interest in the many fascinating forms of water. I hope you will gain pleasure and benefit from this book, the first to be written specifically on drawing and painting water.

Materials and equipment

There are already a number of books on drawing and painting materials, and I assume that the majority of readers are familiar with most of this information. But you will want to know something about the colours I use and my personal observations on materials and equipment. As well as being a guide to how I work, this may tempt you to try another medium which may be more expressive for you.

Charcoal

For drawing water or capturing atmosphere my choice is willow charcoal stick, a beautiful and expressive medium capable of a sensitive line or a rapid range of broad tonal areas. But charcoal does flatter weak drawing, and I would recommend that you use pen or pencil to strengthen drawing ability.

An excellent combination for drawing water is a charcoal stick, and white soft chalk pastel on blue or grey tinted pastel paper. I also use scrap-book sugar paper. It is cheap and ideally suited to both direct studies or finished work, providing the surface is not spoilt by rubbing out or overloading with too much pastel. Some watercolour papers can be used to great advantage. Cartridge paper (drawing paper) has a slight surface texture ideal for charcoal. Many of my drawings illustrated are on 70 lb cartridge paper. Fixative is essential to prevent charcoal from smudging.
A note of advice when using charcoal sticks. According to the nature of the wood, some sticks make black marks and others brown marks. If you want your drawing to be a consistent colour make sure to select either black or brown charcoal sticks. I personally don't think it is satisfactory to mix the two types.

Pencil

Most of my pencil drawings are done with a 6B graphite pencil or EE carbon pencil. My preference is for the latter, which gives a black line without being shiny when pressed very hard. Choice of pencil and the grade is personal for every artist, however and you can judge the expressive quality of different pencils by studying the drawings illustrated.

The surface texture of paper influences the character of a pencil mark. Rough paper produces a rugged coarse mark, whereas paper with a fine surface produces a smooth mark. It is as well to know the characteristics of different pencils and papers because both will influence your drawing technique.

Don't make your pencil drawings too big to start with. Work within the limits of your capabilities until experience is gained.

Pastel

Soft chalk pastel is unrivalled for its immediacy, wide range of instant colour and variety of expression. Because it is a dry medium it can be handled speedily outdoors for studies or finished paintings, which is a great advantage. For the best colour results and range of tone, I would recommend you have a comprehensive selection of pastels. You will find a selection of muted colours is more suitable for landscape than bright colours, which are better suited to still life.

A pastel painting quickly becomes dull and muddy if too many layers are superimposed. To overcome this problem, apply fixative and work over it when dry. This technique can be used to achieve an effect of translucency when painting moving water: my pastel paintings in Chapter 1 are examples of it.

For preliminary studies sugar paper has an acceptable surface and is economical. A lot of my sketches are on this type of paper. A variety of coloured pastel papers is available and I recommend you use the neutral shades of grey, brown or blue, because a bright colour is too predominant. Slightly textured watercolour paper is suitable for pastel painting, but a wash of ground colour will be necessary to tone down the whiteness of the paper.

Fixative is a must to prevent pastel smudging — but applying it too heavily results in the pastel becoming darker. To remove loose particles of pastel it is preferable to tap the paper instead of blowing it off which creates fine dust. Pastel pieces can be cleaned by shaking them in a container of ground rice.

Watercolour

Painting water in watercolour must surely be one of the most daunting of tasks. In skilled hands the medium has a beautiful transparency and freshness ideally suited to the subject of water. The beginner can go a long way to achieving success by being decisive and not overlaying a lot of paint, which only results in opaque muddiness.

Choosing a selection of watercolours is personal to the artist, but you may find my choice useful to you as a guide:

Paynes grey	cadmium lemon
Prussian blue	cadmium yellow
ultramarine	yellow ochre
cobalt blue	burnt sienna
light red	burnt umber
alizarin crimson	viridian
cadmium red	

Some of these I may use more than others and I often work with a limited palette. Whether you use white paint is a matter of choice. It should not be used indiscriminately with watercolour because it will tend to make the painting look chalky and colours will lose their brilliance. My preference is for tube colours and I set out a range on my folding metal palette before going out to paint. When working with watercolours in the studio I use a large plastic palette consisting of twelve mixing areas and eight paint wells, with an assortment of saucers.

Good quality sable brushes are very expensive but buying just one good sable is a worthwhile investment and it does the work of several smaller brushes. I have a No. 8 and No. 3 which I bought many years ago and they still meet my needs admirably. For larger areas of colour I use a wide varnish brush, and for fine line a long haired nylon or sable 'rigger'.

Some synthetic brushes are excellent value and offer a reasonable alternative to the higher quality and price of the traditional sable.

My normal choice of watercolour paper for painting is 140 lb Bockingford,* Whatman paper or watercolour board. But for most of my drawing and watercolour sketches a 70 lb cartridge paper (drawing paper) suits me admirably. Pencil and pen move easily over it, and because of the whiteness of the paper watercolour or ink washes have a high transparency. I also paint and draw on brown paper, cardboard, tracing paper and tinted pastel paper.

For watercolour painting and pastel painting outdoors I carry a lightweight board and fix the paper by masking tape. Sometimes I dispense with the board and work direct on to a spiral bound sketchbook. For large work my stalwart French box easel is indispensable. Having a modicum of comfort when painting outdoors is essential and a suitable lightweight stool is often necessary for sketching or painting if you prefer to sit.

Oils

For suggesting the power and dignity of the sea artists past and present have chosen oil paint as their principal medium. My own experience of painting a 3 ft × 2 ft canvas on a wintry beach was enlightening, enjoyable and one which I am not likely to forget. It also confirmed that for such a subject oils are the ideal choice. Many of my smaller scale oil studies are also painted direct outdoors.

I normally work on the smooth side of hardboard and prime with acrylic gesso. Occasionally I apply a stain of acrylic burnt umber, but mostly prefer to work on a white ground.

My largest marine painting to date is 4 ft × 3 ft, but some years ago I was commissioned to paint directly on to a plaster wall a 40 ft long × 14 ft high seascape of square riggers; the biggest vessel was 6 ft high. From that commission I received another to paint a 16 ft × 8 ft seascape mural which by comparison seemed a mere postcard. Both murals were painted in oils. By contrast, the smallest of my marine paintings is 11 × 7 in. Contrast of scale is stimulating and it is well worth experimenting with a change of size.

Whatever size I work to, however, my endeavour is always to create a sense of atmosphere, space, and an effect of light.

My choice of colours for painting water in oils is the same as for landscape painting, with the addition of a few extra for purer colour when needed:

* The nearest US equivalent to this is Strathmore 130/1.

ultramarine	light red
cobalt blue	burnt sienna
cadmium yellow pale	cadmium red
cadmium yellow	alizarin crimson
yellow ochre	titanium white

I also keep in my box:

cadmium green	cadmium orange
prussian blue	burnt umber
cobalt blue deep	viridian

To keep colours clean when mixing I use separate brushes for the sky and the lightest parts of water. My paintings are usually in the middle tone range, so I keep colour as fresh as possible to avoid dullness.

Although I have tried most of the mediums I prefer to paint in oils without them. For laying in I thin the paint with turps; this soon dries and the picture is then finished without any dilutent or medium.

My choice of oil brushes are long flats with a square end, and a sable 'rigger' for fine lines. These brushes have a resilience which I much prefer to the shorter variety. But the preference is a personal one.

For convenience I use paper tear-off palettes in the studio and outdoors.

Acrylics

A great advantage of acrylic paint for rendering water is that it is quick drying, which enables a series of transparent washes to be overlaid without disturbing the underpainting. This technique is known as 'glazing', and some remarkable effects can be gained with it; for example, a yellow glaze over blue produces a beautiful transparent green impossible to achieve by any other means. The effects of transparency can be further enhanced by the addition of gloss or matt medium to the acrylic.

Glazing can be used in both large and small areas, to portray shadows, reflections, to indicate the depth of water, and it is also very well suited to painting cascades or moving water. Try experimenting on scraps of acrylic primed paper, varying the strength of colours used for glazing.

A gel medium can be used with acrylic for impasto, and for glazing and texturing. It increases the gloss of acrylic colours. Yet another advantage of this versatile paint is that it can be diluted with water and used in a similar manner to watercolour. A number of paintings in this book are acrylics so you can assess its qualities. I normally paint on acrylic primed board or paper using nylon brushes and oil colour brushes.

My palette of colours is similar to that of oils with some exceptions:

quinacridone red	red iron oxide
cadmium red light	ultramarine
cobalt blue	cerulean blue
azo yellow light	yellow ochre
cadmium yellow medium	burnt umber
burnt sienna	indo orange red
titanium white	

Sometimes I may use only four or five colours from this range which I find quite adequate, particularly for painting outdoors when the weight of equipment and materials is to be considered.

It is essential to carry enough water in a lightweight container for painting and washing out brushes immediately after use. And a paper tear-off palette or plastic palette should be used. Acrylics adhere firmly to porous surfaces such as a wooden palette.

Tone

Tone, to an artist, means thinking of colours in terms of the intensity of lightness and darkness rather than as reds, blues, greens, etc.

Defining tone values as distinct from colour values is a constant problem for students, but it is a skill that must be learned. Painting from black and white photographs is a good way to develop skill in defining tone.

Don't try to define too many of the separate tones you see outdoors. The range is infinite. Half-close your eyes and look for the principal contrasts; as your painting progresses you can increase the number of tones. If you want a strong contrast of light and dark in your picture, the fewer gradations of tone there are the better. Building up a contrast of light and dark tones will give your landscape paintings a sense of recession, and tone values are also important in creating the dominant mood of the painting, as we shall see.

Colour

The colour of water seems at first difficult to understand because it is so varied, but there are a number of things which determine it: the colour of the sky, the intensity of light, the depth of the water, and the particles of matter suspended in it, the (apparent) colour of the bed, and the surface texture of the water. You don't need to know in detail about these things —just be aware of them and keep them in mind when you are painting water.

Determine the overall colour of the water first, and then look for the addition of other colours. Even if the colour of the water is dull it is advisable to start off with a clean fresh colour. It is easier to tone down a dull painting than trying to brighten it.

The best way to find out what you can produce from basic colours is to experiment freely on scraps of paper, and make notes of the colours you mix. Avoid the use of viridian green until you gain experience in colour mixing. It is a virulent colour which stains, as you will see by your brush.

Light

Successful portrayal of the quality of light in a painting is one of the most difficult but desirable achievements for an artist. Light creates mood and atmosphere, and puts life into a picture, but this does not necessarily mean that the lighting need be overstated, or dramatic.

The appearance of the landscape is generally determined by the quality of light present. Soft diffused light, filtering through an overcast sky can make a painting look flat and dull, because it makes shadows indefinite, with minimal contrast between light and dark tones. Hard direct sunlight has the contrary effect.

On a clear bright day a stretch of water reflects light back into the sky, so that the sky seems to shimmer with reflected light. This phenomenon is particularly noticeable on the coast. Studying the effect of changing light conditions in the sky should always be a preoccupation of the landscape artist; study also the effect of natural light on glossy and matt surfaces, such as glass and polished metal, or gloss paintwork and shiny plastic, wood and dry stone, shiny leaves and dull leaves. By making

comparisons such as these you will more readily understand the variations which are possible.

When I am drawing or painting outdoors I am aware of fleeting light and shadows moving across the landscape. I look closely at the way light can completely alter the mood of a scene; indeed, the same subject will hold the possibility of several paintings, if different conditions of light are portrayed. Experienced artists will have gained enough from their outdoor observations to be able to create any effect of light in studio paintings. You should work towards that end, too.

Brushwork

The way paint is applied is particular to the artist, and developing an individual style is an important part of an artist's development. A calm stretch of water would, obviously, not be painted in the same way as a bursting wave, but we should be able to identify the 'handwriting' of the same artist in both. Brushmarks express form, texture, and direction: to what extent this is emphasised depends, again, on the artist. But, nonetheless, you will find that following the movement and direction of water with your brushmarks will portray it with more energy than smoothed-out paint would. Paint as simply as possible, with the minimum of brushmarks —an overloaded painting looks fussy and contrived. Contrast busy areas with quiet areas.

1 Moving water

The lazy trickle of a stream or the swift surge of tide are contrasting examples of motion. But with any subject, the first consideration is to determine how the water moves. If you get this right your painting will have a sense of action. Moving water assumes an endless variety of shapes; even in a comparatively simple form, such as a slow running tap, the movement is very confusing. But with all water in motion, however simple or complex it may appear, the important thing is to determine the form and direction of movement and the speed.

This is the basis of all preliminary observation. For example, the slow moving water from a tap is roughly cylindrical in shape and there may be a twisting movement. The lack of force behind the fall means there will be very little splash. When the tap is fully opened the increased force dramatically alters the flow of water: from a slow twisting dribble it changes its form into a powerful gushing jet.

Similar comparative observations can be applied to any aspect of moving water. A fountain shows very interesting contrasts of shape, texture and movement. Splash, jet and spray are all different in character and motion, and make very paintable subjects separately. A breeze across the surface of the sea produces short choppy waves quite different in character to tidal waves. You can also see the effects of changing surface texture when the wind blows across still water, creating patterns as it changes direction.

Many forms of moving water—a breaking wave, the swirl of a river current or the arc of a waterfall—can best be expressed by a few descriptive lines, much as you would express the basic action of a running figure. Learning to do this is a simple but important preliminary.

The next progressive step is learning how to eliminate detail from the mass but still retain all the essential elements of the subject. Take, for example, a series of waves stretching to the horizon; to include them all results in a fussy painting which lacks conviction. To capture the spirit of moving water some detail must be lost or your painting will look overworked. My own method of approach when drawing or painting the open sea is to put in a few of the nearest waves which suggest the mood of the scene. Others are reduced in quantity and merely suggested as they diminish towards the horizon.

You can, however, also use detail as a subject in itself. All forms of moving water have shape and dimension, even those which you wouldn't expect to have these qualities. A cloud of spray from a bursting wave is not flat, as it is often depicted but a three dimensional shape similar to clouds in the sky. It is the contrast of light and shade which gives shape and dimension to a cloud of spray.

Cascading water is one of the most difficult subjects to paint. The initial movement is upwards and outwards and very rapid at the point where the cascade plunges down and emerges as foam. The main area of interest, which you might select for a detailed study, is usually at the base. Foam, bubbles and ripples give a lively texture, and sometimes move so fast it seems impossible to capture the action.

Bubbles are formed by the fall of water, which simultaneously creates ripples, moving outwards from the point where the water first fell. The ripples take the bubbles outwards with them, but a slight breeze sends the bubbles scurrying backwards and forwards like dodgem cars.

You will find that by selecting just a part of a subject the composition is not only more interesting but more compact. It is also likely that you will capture the sense of action and character of moving water more successfully. A camera is a very useful aid to the study of moving water. It reveals the intricacies of texture, form, movement, colour and light and shade. It can strengthen our observation and understanding but should not take the place of personal expression.

There are, of course, many other considerations which affect the portrayal of water: perspective, composition, atmosphere, the colour of water and the effect of light. But rather than discuss these aspects more generally, I prefer to look at them as they relate to individual drawings and paintings, though some introductory comments and suggestions have just been given in the Introduction.

Preliminary sketches

Quick sketches are an invaluable method of capturing just the essentials of a subject but including enough information for a possible painting. Don't make your sketch too large or be afraid of making several studies on one page. Many of the great artists used small sketchbooks and often filled a page with tiny drawings.

My sketch is drawn with litho crayon, a responsive and expressive

Medium Litho crayon on drawing paper
Size $7\frac{3}{4} \times 5\frac{1}{2}$ in.
Title **Sussex stream**

medium with a rich dark intensity. As it is greasy, rubbing out is not satisfactory so it encourages directness of touch. I do not map out a composition before drawing but work direct.

The paper I used is cheap but has a surface suitable for all drawing mediums. For line and wash drawings I prefer a better quality cartridge paper.

One of the common mistakes of students drawing outdoors is to include all that is visible and entirely miss the main point of interest. There was a lot more in the subject

for my rough sketch but I avoided overcrowding by ignoring unnecessary detail. The off-white paper is left untouched in big areas and helps to give a feeling of space and a suggestion of light. Blank spaces also give emphasis to the dark tones.

For the next study I fixed up a garden hose so the water fell into a large bowl placed on the lawn. The movement at first seemed rather complicated but proved simple when the motion of water was closely observed. The difficulty came in drawing it.

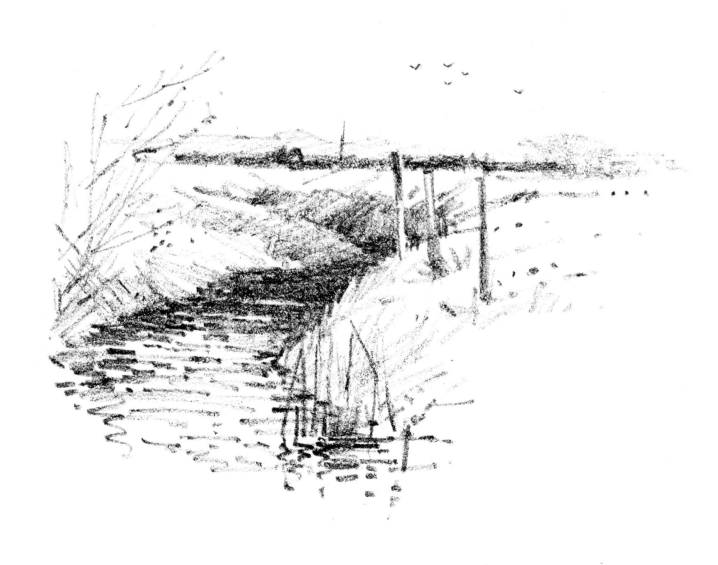

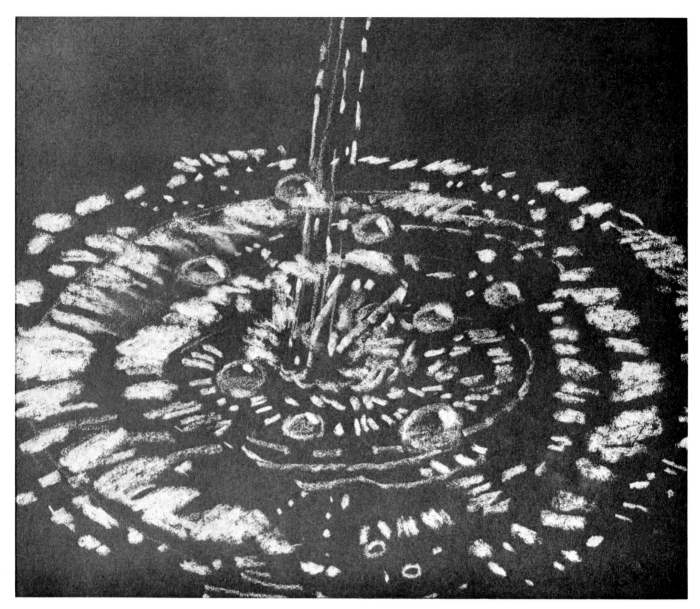

By choosing soft chalk pastel I could express movement broadly and rapidly, and this helped me to get a feeling of rhythmic action. Perhaps I should have blended the outer marks to achieve the effect of recession, but on such a small area it is unnecessary. The drawing is direct and spontaneous, with attention to pattern and movement.

By keeping it very simple I could concentrate on the effect of falling water only. It is a method you may adopt for your studies. First of all I lightly indicated the ellipses of ripples and a line to show the falling curves from the hose pipe. Then I started to draw shapes of the ripples and bubbles with positive marks of the pastel. A lot of detail and tonal values have been left out. One way of eliminating detail is to half-close your eyes. The paper I have used for the sketch is grey sugar paper, obtainable in cheap scrap-books. It is very suitable for charcoal, pastel, pen and pencil, and so economical that there are no qualms about throwing away failed work.

Medium White soft chalk pastel on grey sugar paper
Size 8 × 6½ in.
Title **Falling water**

I have used this type of paper for sketching for many years and have not noticed any marked fading or discolouration. With a piece of white soft chalk pastel, a stick of willow charcoal and a pad of grey paper the whole range of light and dark tone values are at your fingertips. Because both mediums smudge you will need to fix your drawings with charcoal fixative.

Contrasting movement

The curve and texture of a wave rebounding off a rock face is a popular subject with many seascape artists. But for my sketch here I have isolated a very small part of the action. For your early studies you will find this method of approach helps to develop an understanding of moving water without it being too complicated.

The essential quality of movement in this study is provided by the left vertical and the curve in opposition to it, and these are the two directional lines I put down first.

I make a mental note at this stage to remember the curve must not be a tight geometric shape but have a naturalness about it. I shall loosen it up as the drawing develops. The next step is to establish the dark and light tones in the simplest manner without considering any detail, so I sweep in the left hand vertical and continue the dark tone right across the paper to form the background.

The curve of water is then firmly established by wiping out the shape from the background of charcoal with a paper tissue. Some areas of tone are left untouched. Creating contrast of tone is essential to give shape and dimension.

I work into the basic tones with a putty rubber, lifting out lighter tones to express light and shade. The marks are positive —like brush strokes — emphasising movement and adding vigour. Some have defined edges, others are blurred by softening with paper tissue. The upward sweep at the bottom is important because that is where the curve begins, so I give it emphasis with a defined edge. Finally I lift out with the putty rubber an effect of flying spray and use it to give more directional movement, particularly at the base of the sketch.

The charcoal is then fixed with an aerosol fixative. Charcoal is essentially a spontaneous medium and my personal choice for a subject like this. I also find the technique similar to painting, without using a brush.

For isolating a specific area of a subject, particularly a complicated view of moving water, the viewfinder is indispensable. Practically all artists know about this aid to composing a subject but it is worth mentioning again. From a piece of stout card measuring 7 × 5 in. cut a rectangle of 2 × 1 in. in the middle. If you use grey card instead of white what you see through the rectangle will be more clearly defined because of the darker surround.

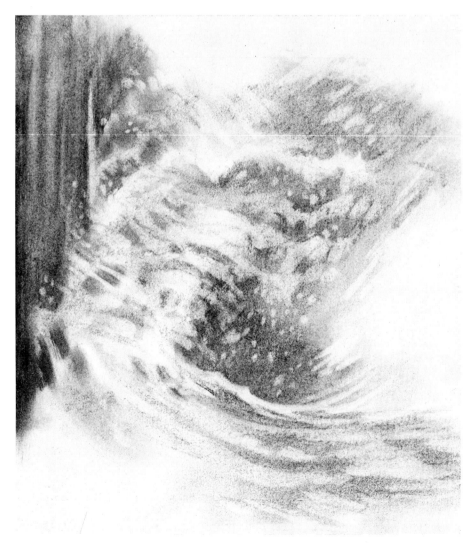

Medium Charcoal on cartridge (drawing) paper
Size $6\frac{1}{2} \times 7$ in.
Title **Rebound**

The surface of this Dorset river has an interesting texture of ripples and eddies caused by the swift tide. There were many more than I have shown but to include them all would have made my drawing much too fussy.

Selecting the most significant lines of motion in water is essential, but secondary lines also contribute to the feeling of action. The smudged lines to the right of the sketch are not all prominent but you can see how they add to the suggestion of movement.

The reflection is only visible in the smoother part of the water and emphasises the ripple motion in the foreground. The bridge buttresses and the dark shadow between emphasise the flow of the swift river, and the weathered stone repeats its texture. A great deal of thought can go into the simplest of studies and is not the result of merely recording what you see. My sketch here is an example. Composition has been considered very carefully to make a balanced study.

The sketch is a good example of the versatility and expressive qualities of charcoal. The patch of water in the foreground is the white paper. Other areas of light are lifted out with putty rubber. I have used a paper tissue to drag down the charcoal in the foreground and also in the upper area on the right. This produces a softly blended middle tone and contrasts with the rich darker tone values of the bridge.

The effect of light on water has interested artists for centuries. It has an elusive quality, not easy to capture. But if you can achieve it your paintings will take on a new meaning. Studies like this one are a sure beginning towards that end.

Medium　Charcoal on cartridge (drawing) paper
Size　8 × 7 in.
Title　**Swift tide**

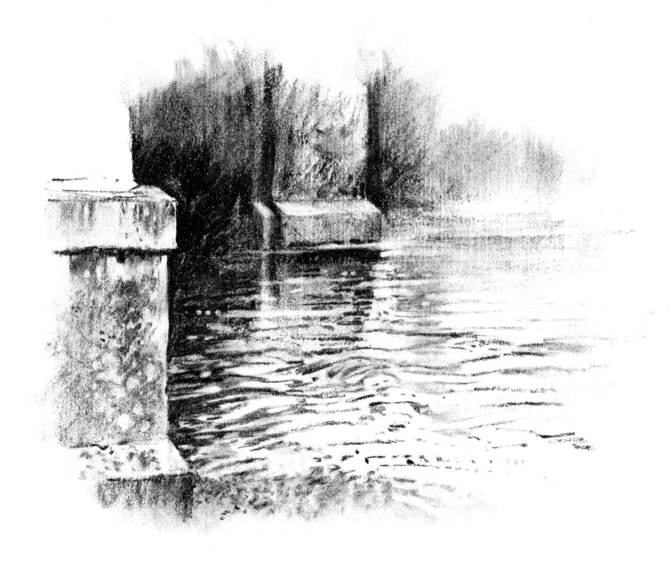

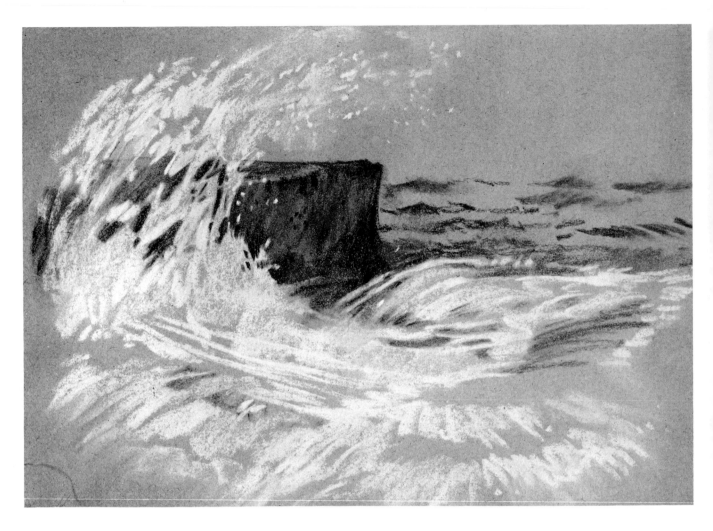

Here is another example of drawing with white pastel and charcoal on tinted paper, which I discussed in the introduction. The study is on the blue sugar paper which is found in some scrapbooks and the cheaper sketch pads. The colour is very suitable for the subject because it suggests the colour of water.

I like using this paper. It has just the right surface texture for pastel and charcoal without being too pronounced as some pastel papers are. The surface is soft and not suitable for rubbing out, an asset in developing spontaneous drawing. If a mistake is made when drawing it is better to discard it and start again instead of rubbing out.

My sketch is a study of the incoming tide at the island of Portland in Dorset. It is a rugged area of stone quarries and open space joined to the mainland by the remarkable stretch of Chesil Beach. The rocky coastline is powerful and wild, not unlike Cornwall. I spend a lot of time on Portland drawing and painting the sea, rocks, lighthouse and grey cottages. The scenery is bleak, the skies and horizon vast but it holds a special attraction for me.

My main interest is the rebounding wave and surge of incoming tide. Before starting to draw I devoted a long time to observation so that I became familiar with the problems. This is an essential prelude and helps me to become absorbed in the atmosphere of the subject.

My sketch is a much simplified version of what I see and basically

Medium Charcoal and white soft chalk
 pastel on blue sugar paper
Size $12\frac{1}{4} \times 9\frac{1}{4}$ in.
Title **Incoming tide**

concerns the action of opposing curves. It is an example of how the complex subject of moving water can be separated into positive descriptive shapes. This is the key to all aspects of moving water and must be our primary consideration.

When charcoal and soft chalk pastel are mixed the result is a gray smudge. To overcome this problem the charcoal must be sprayed with the appropriate fixative, and then the pastel can be drawn over it without the possibility of smudging. This is the technique used for my sketch, and you will see that I use it extensively throughout the book.

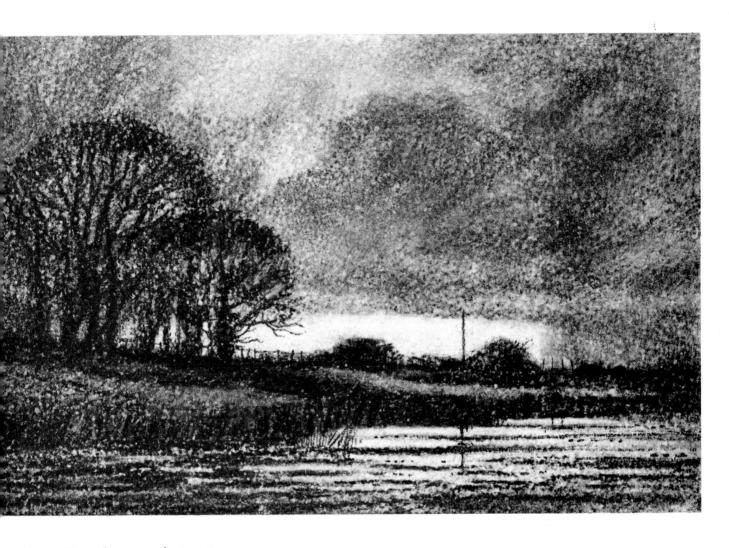

Medium Charcoal on watercolour paper
Size 8 × 5 in.
Title **Early morning**

A flowing stretch of water can create a problem of composition. Unless there is sufficient counter-balance the water will appear to be moving right out of the picture — like a directional arrow. Here I use the vertical of the trees to counteract the forceful horizontal movement of the river, and the silhouetted shapes have a similarity to the clouds. The larger areas of land and sky balance the smaller area of moving water.

A further method of retaining this movement without unbalancing the composition is to lose definition towards the outer edges. This is noticeable in my drawing.

Darkening and softening the left and right areas of the river contains its movement and directs our interest to the central area.

The technique can also be applied to sky and landscapes. By making outer edges slightly out of focus you create a feeling of atmosphere and aerial perspective.

A canal boat on a waterway is my subject here. I have used two different mediums, black poster paint and white soft chalk pastel. The grey pastel paper is ideal for the middle tone.

After lightly roughing in the main shapes with charcoal I then paint all the darkest areas with poster paint and a dry brush, dragging it across the textured surface of the paper. With a piece of white soft chalk pastel the sky, and the light on the bridge and water are drawn in

carefully. Full use is made of the textured surface by not pressing the pastel too hard. You can see the effect quite easily. The painting is now completed by some drawing with a fine brush to the canal boat, bridge, trees and river bank. Detail is kept to the minimum to ensure the concept of the subject remains bold and direct.

The area of most importance is the reflection, whose edge has to accomplish two things—to suggest forward movement of the boat and

the effect of water. Without this the painting would lose its significance. The contrast of light and dark on the right hand edge of the reflection expresses movement. I made sure that every application of pastel or brush was positive and direct, and the result is strong and spontaneous

Medium Black poster colour and white soft chalk pastel on grey pastel paper
Size 8 × 7 in.
Title **Canal boat**

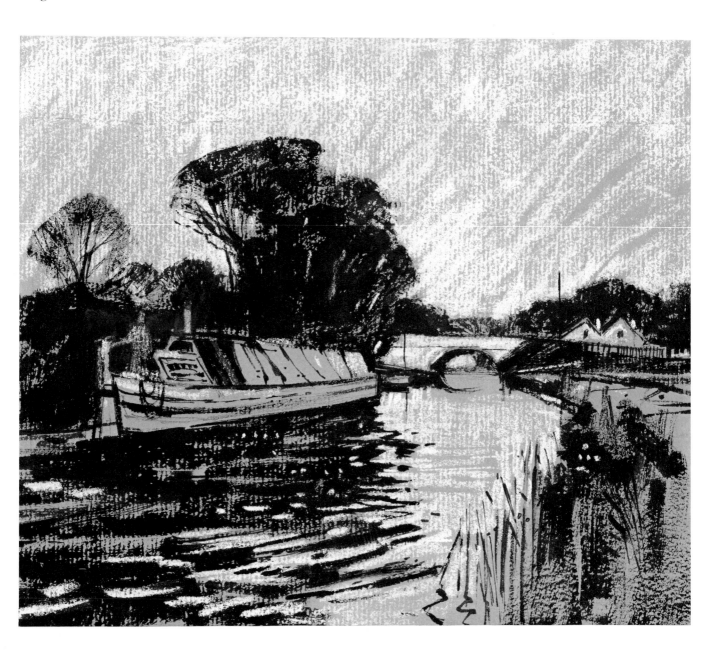

DEMONSTRATION: Charcoal on cartridge paper (drawing paper)

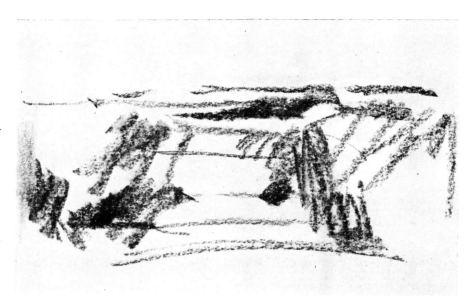

Step one
Broad shapes are swept in to position the rocks and waterfall and to establish the general movement of curves and angles. I prefer this vigorous approach when beginning a sketch.

Step two
After drawing in some more with the charcoal stick I lightly rub it over with paper tissue. If charcoal is rubbed in too hard, it leaves a stain which cannot be removed, so I leave areas of paper which I want to be white in the final stage.

On the right I smudge in a tone to suggest a clump of trees. But I am not sure whether they will work out or not. Next I begin to bring out the shape of rocks by lifting out light parts with a putty rubber and adding shadows. The effect of tumbling water is moved slightly more to the right, to avoid the centre of interest being in the middle of the picture.

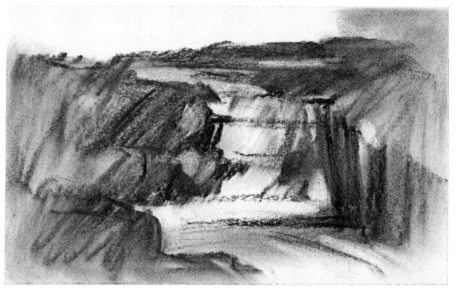

Final stage
Rock shapes are now more clearly defined by creating contrast of light and shade. The levels of cascading water need a careful arrangement of tones. You will notice that the lightest area is at the bottom. The upper parts are lightly smudged and then lifted out with a putty rubber to give the effect of movement.

The clump of trees attracted too much attention so I decided to rub them into a sky tone, which I think is an improvement.

To give a sense of scale I add some distant poles with charcoal pencil.

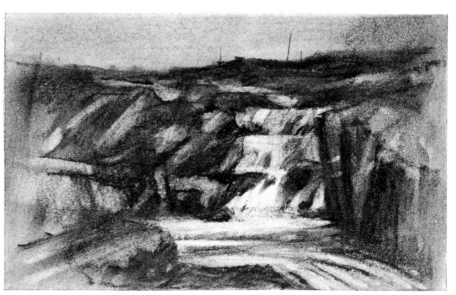

Surface texture

This is one of six drawings commissioned by *International Newsweek* to illustrate a desk-diary circulated throughout the world.

The effect of moving water can be achieved by pen and ink drawing alone but I wanted a contrast of techniques and a greater feeling of 'wetness', so I decided to use watercolour, because of its transparent qualities. The drawing was done first with waterproof black ink and a steel nib. Pressure on the nib is varied for a contrast of line thickness and density.

When the ink was thoroughly dry I laid a wash of tone over the sky, the shadow side of the buildings, and the mooring poles.

The most difficult part of the painting, the water, I left until last, by which time I had built up my confidence sufficiently to tackle the problems involved. I spent a while considering how I wanted to illustrate the effect of water.

The shadows of ripples and reflections are the most important means of conveying a sense of movement and the effect of reflected light. I achieved the effect you see by direct painting, without any preliminary drawing in of shapes or the use of white paint. Luckily it went right first time and I was pleased with the spontaneous and fresh result.

The photograph I was given to work from is excellent reference material, but in my interpretation of the subject I simplified the mass of tone values down to just a few. The drawing had to be my own expression, not a copy of a photograph. Photo-realist painters work in opposition to that principle,

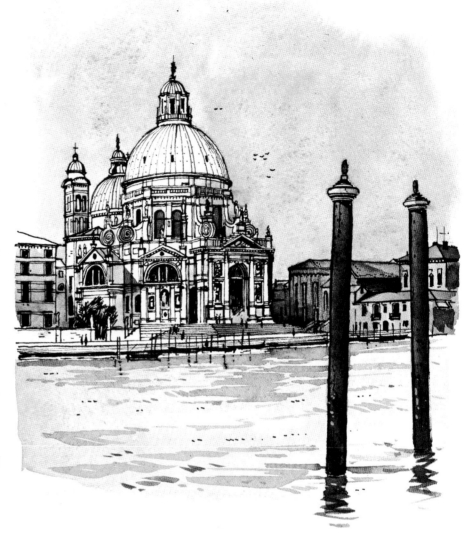

Norman Battershill

but most landscape painters seek a more personal expression.

Working from your own photograph is more satisfying than using one taken by someone else because you composed the subject.

Painting in colour from black and white photos is an excellent method of learning about the essentials of tone values. It also helps you to develop colour memory by recalling colours of the subject. There is, however, no substitute for drawing and painting direct from nature.

Medium Pen and ink with watercolour wash on smooth illustration board
Size 8 × 7 in.
Title **Venice**

You can combine it with working from photographs but for your development as a painter I would suggest you first gain a lot of experience painting and drawing outdoors.

A swift flowing tidal river reflecting sunlight is a fascinating subject and one which I enjoy painting. I worked from a photograph I had taken while wandering around Littlehampton riverside, a favourite haunt for drawing boats and the pier. There is a strong direction of tide and a rippling movement of swift current which I wanted to capture.

The composition of the photograph was reconsidered in the studio before I started any painting, and I decided to include more water because that was going to be the main interest. There are always alternatives to a composition and it is worthwhile considering them before you begin. For this painting I positioned the landing stage off

centre. It could easily have dominated everything else.

The contrast of light and dark in painting or drawing must be balanced, so here the wall of the left-hand wharf is also dark —so too is the bridge column. After lightly indicating the composition with a pencil I applied masking fluid to where I wanted to suggest the areas of speckled light on the surface of the river. Masking fluid is used by a number of watercolourists, and is an excellent way of suggesting highlights and fine lines. It is applied with a fine brush to areas where you wish to suggest highlights, and rubbed off later with a putty rubber or tissue, leaving the white paper showing through. When painting in watercolour I often

begin with dark colours and I followed this practice here by establishing the background of trees first. Then followed the middle tones, the wet mud, river and house. I have already mentioned the value of contrasting the different textures of water and this subject is a good example. The deep colour of reflections in the smoother parts are a foil to the texture of the surface movement. Deep water usually flows faster in the centre of a river because of underlying currents —its shallows are calmer and movement slower resulting in a smoother surface.

Medium Watercolour on watercolour
paper
Size 12 × 10 in.
Title **Littlehampton—Sussex**

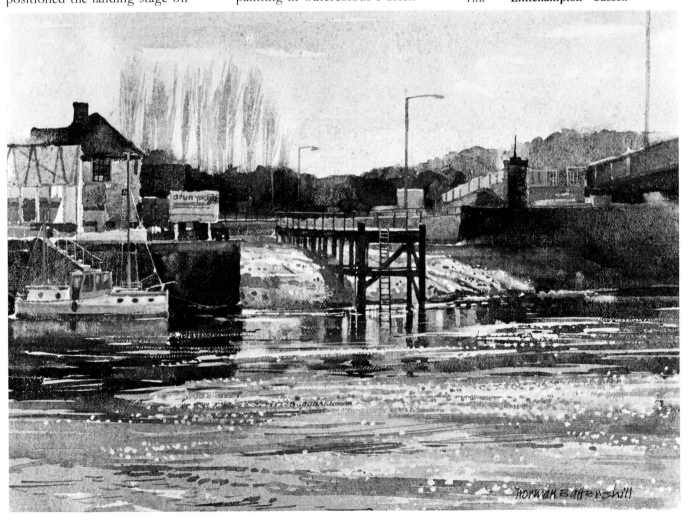

Foam

A bursting wave, with water cascading on water or breaking on rocks is one of nature's most impressive sights.

My abstract drawing is based on a pattern of mass and surface foam. It is an imaginary sketch in which I have tried to convey the tumult and movement when falling water forms clouds of misty spray.

Foam on the surface of the water is compact and follows the direction of the current until it is fragmented or joins more foam to create new patterns. The contrast of these firm lacy patterns against the soft edges of misty spray is a delight to observe.

It is worthwhile paying attention to edge values as I have here when painting moving water. For example, if I had sharply defined all the edges the effect would have been boring, but by contrasting defined edges with blurred edges it becomes interesting and atmospheric. Try smudging a broad single line of soft pastel in the middle with paper tissue—a very simple exercise to demonstrate this effect. However, don't over-emphasise this technique — pastel lends itself to blending and smudging but too much of this will mean that your work lacks substance.

Medium Soft chalk pastel on blue sugar
 paper
Size 8 × 6 in.
Title **Abstract**

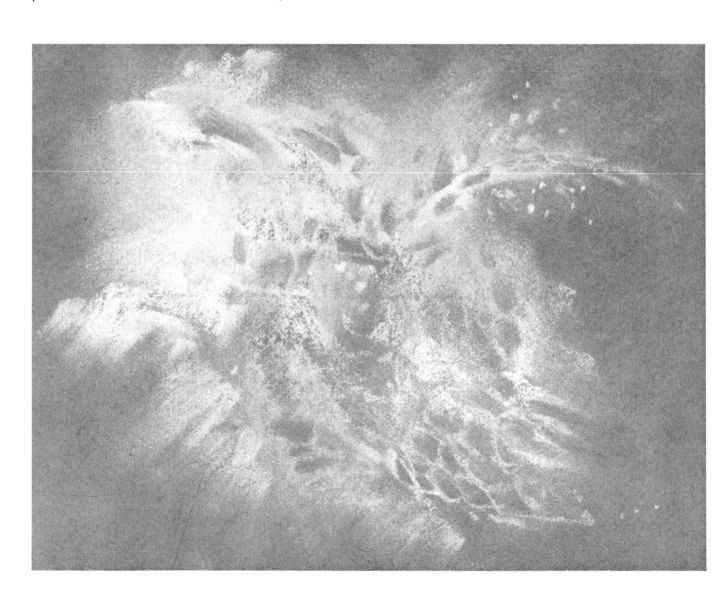

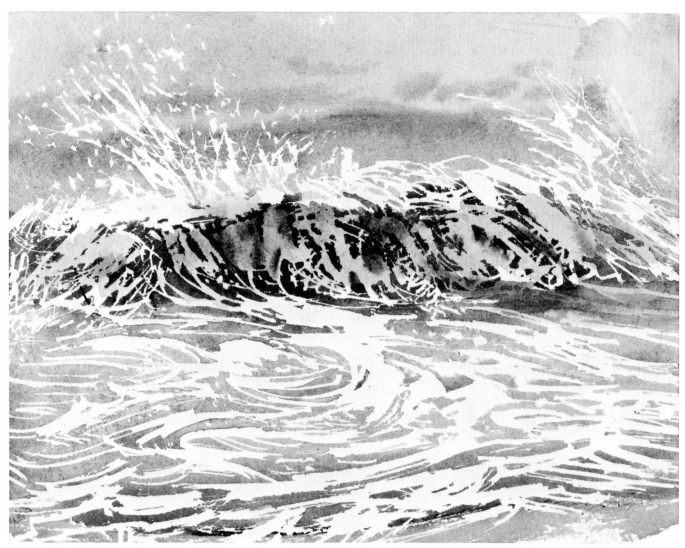

The delicate pattern of surface foam swirling and rising into the underside of a breaking wave is a fascinating subject and is the theme for my imaginary painting.

The white lines and patterns are created by drawing with masking fluid.

Mistakes are not easily rectified when using masking fluid and with all my drawing I work as directly as possible, so with a fine brush I gradually built up the lacy patterns. I varied the width of lines to create interest and contrast. Surface foam is compact and its beautiful abstract shapes move in an almost leisurely manner to create ever changing patterns.

After the masking fluid was absolutely dry I laid a thin wash of pale Paynes grey over the paper. When it was dry I put in a darker wash to the underside of the curving water and blended the lower edge to create a soft effect. Making sure the watercolour had thoroughly dried I gently rubbed off the masking fluid to reveal a pattern of crisp white lines.

You may like to try a similar experiment yourself—if you do, make sure to wash your brush out in the appropriate solvent as directed by the manufacturer.

With all your studies of water don't be afraid to experiment with different techniques and mediums.

Medium Watercolour on 140 lb Bockingford paper
Size $7\frac{1}{2} \times 8\frac{3}{4}$ in.
Title **Lacy pattern**

They might not all work but you may well find a new method of expression. I paint in a traditional manner but am quite happy to experiment too.

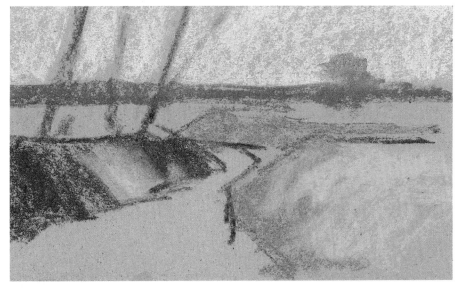

Step one

My pastel painting is quite small—
$7\frac{1}{4} \times 4\frac{1}{4}$ in.—so I select a paper that
does not have a pronounced surface
texture—sugar paper is ideal, and
the grey tone admirable as a base
colour. I draw in the main
composition with charcoal.
Although it may look very loose
and free the preliminary lines are
carefully considered. The beginning
of a painting is its structure.

Step two

Indicating light and shadow is the
next stage. Direction of light has to
be determined before an effect of
sunlight is introduced.

Grey-blue distant trees are overlaid
with a mauve to give atmosphere
and more colour. I prefer the direct
method of pastel painting and avoid
overlaying colours as much as
possible.

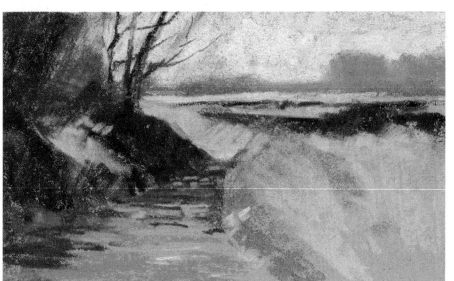

Final stage

To keep pastel marks fresh the
painting is given a couple of light
sprays with fixative. I can now work
without having to worry about
smudging, and if I want to alter a
colour it will not lift when another
colour is superimposed, which is
particularly helpful when painting
the branches against the sky.
Movement in the stream is the last
consideration; here I can repeat
some of the landscape colours to
achieve harmony.

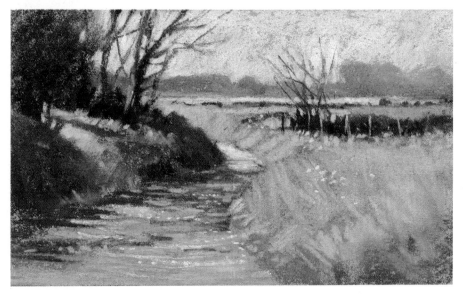

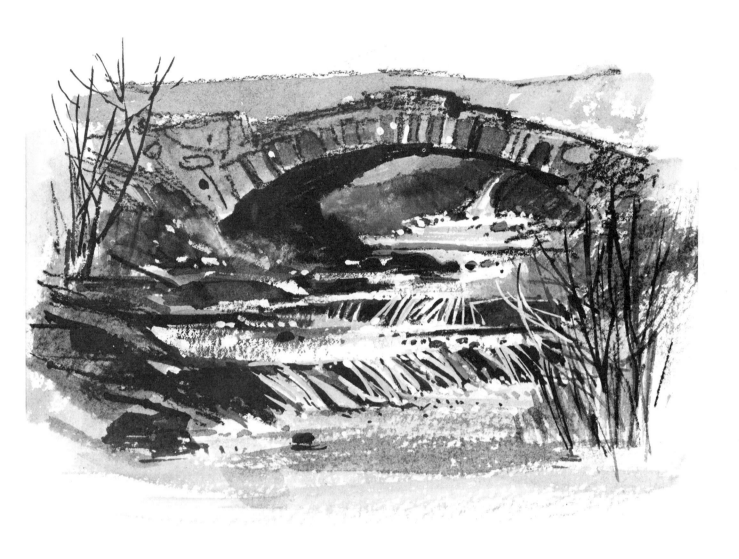

I lightly sketched in the composition with a soft grade carbon pencil and then laid in washes of Paynes grey. With an almost dry brush the paint is dragged across the surface of the paper in the foreground to give texture and sparkle.

After building up the darkest areas under the stone bridge and parts of the foreground I left the painting to dry. When it was ready I used a fine sable brush and process white to draw in the rivulets and distant water cascading down the hill.

There are four main techniques for achieving a sparkling effect on the water surface: dragging a dry brush across the paper, using white paint, using a blade to pick highlights out, and masking fluid. I use three of these methods in this painting.

In the foreground just above the first cascade I loaded the brush with white paint and dragged it. Here and there a sharp blade is used to pick highlights out of the paper surface. I mix white with Paynes grey watercolour to make the paint opaque for painting in the rivulets, which I do with a fine brush. I paint the winter shrubs in undiluted Paynes grey.

The combination of dark grey watercolour and process white is

Medium Watercolour on 140 lb Bockingford paper
Size 6 × 4½ in.
Title **Pack Bridge**

particularly adaptable for outdoor studies.

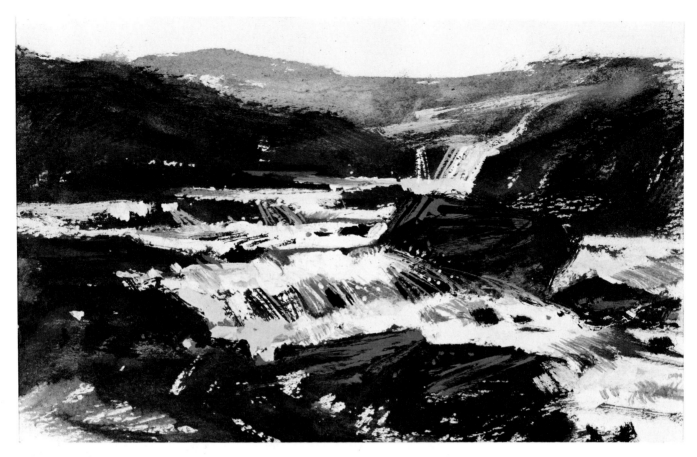

Medium Watercolour on Bockingford paper
Size 7 × 4½ in.
Title **White water**

Cascades

Water cascading down the hills and roaring over a rocky river bed continues to foam until it reaches calmer stretches, where the foam dissolves. It is an awe-inspiring sight and we are very much aware of the tremendous constant surging energy.

Foam pours into crevices like icing running down a cake. Away from the main source of movement rivulets run off rocks and trickle into emptying pools. You can take the smallest area of such a subject and find innumerable sources of painting material, or paint the stretch of water as I have done in my watercolour.

Composition is important in making this small sketch balanced. A sense of recession is necessary to give scale and space. Here I have used the principle of diminishing perspective and made the stretches of water narrower and smaller towards the background. The river is not in a straight line but curves round adding more rhythm to the movement.

If you are in doubt about your composition it is worthwhile making a few very small preliminary layouts. Drastically altering a composition half-way through a painting inevitably means starting again, by which time your interest and enthusiasm may have considerably diminished. Solving some of the problems before beginning to paint adds a great deal to the chance of success.

Construction work on a Dorset harbour gave me the opportunity of this study of gushing water. I painted it in oils using only black and white—giving myself an exercise in tone values.

There is little artistic merit in the subject but the cascade of water is a good example of movement and form. At the beginning of this chapter I discussed the action of tap water when fully turned on, and this industrial scene has similar characteristics. A small waterfall, too, looks similar to this gush of water.

The painting also shows a contrast of edges. The left hand side of the jet is sharply defined against its cast shadow but the right side has softened edges.

Brushmarks contribute to the directional movement and texture in all painting, and here you can see the effect they have in describing the fall of water. Bold broken lines on the water surface indicate ripples and depict the movement which takes place as the cascade hits the surface. Brushmarks should always follow the flow of the water—use plenty of paint to suggest texture. Expressive brushmarks are clearly shown at the base of the cascade. You can also see the drybrush effect used on the spray, the foam of churned up water and the lacelike holes and waterdrops. All these brushmarks lend character and action to the subject and can be applied in the same manner for seascapes, fountains, waterfalls or any other form of falling water. If you refer back to the illustration on page 22 you will see a similarity of expression in the abstract drawing of foam.

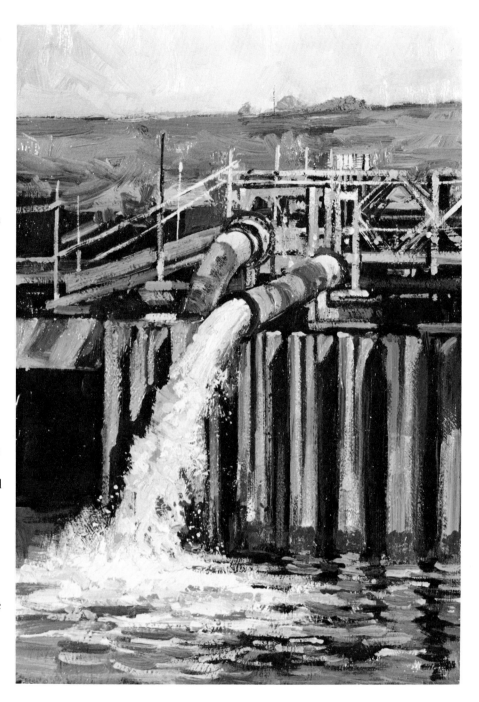

Painting in black and white is an excellent progression from drawing in monochrome. It is not at all tedious, and all artists who take their work seriously confirm that it is a valuable way of learning about colour.

Medium Oil colour on board
Size 10 × 8 in.
Title **Coffer Dam**

Acrylics are an ideal choice for painting cascading water. Because they dry quickly thin stains of colour can be glazed in quick succession. Moreover, transparent effects can be heightened by adding acrylic medium to the paint.

When a subject like this painting has an overall dark tone, a stain of blue–green over a white priming gives a toned and transparent ground to work on. Painting direct on to a white ground is difficult because it takes time to establish an overall colour.

Brushwork technique is very important here in describing texture and the direction of movement. You can see the different brushstrokes in the ripples, foam and glassy sheen of the cascade. The translucent sheen of cascading water is achieved by building up the underpainting with diluted paint and then overpainting some areas with thicker paint.

With acrylics, as with oils, I begin with dark colours: the lightest parts are added last, and only in small selected areas. Too many spots of white are distracting and look like a handful of confetti at a wedding.

For the preliminary staining of the board I diluted phthalo green mixed with ultramarine, without any white. Whilst the stain was still wet I began laying in the general shape of the cascade effect. Throughout the painting I endeavoured to keep the colours as fresh as possible by minimising the use of white. For the dark green of the wall I mixed phthalo green and quinacridone red, which produces a beautiful rich warm green. Cobalt blue and a touch of azo yellow light and red iron oxide and white are the colours I mixed for the lighter parts of the water.

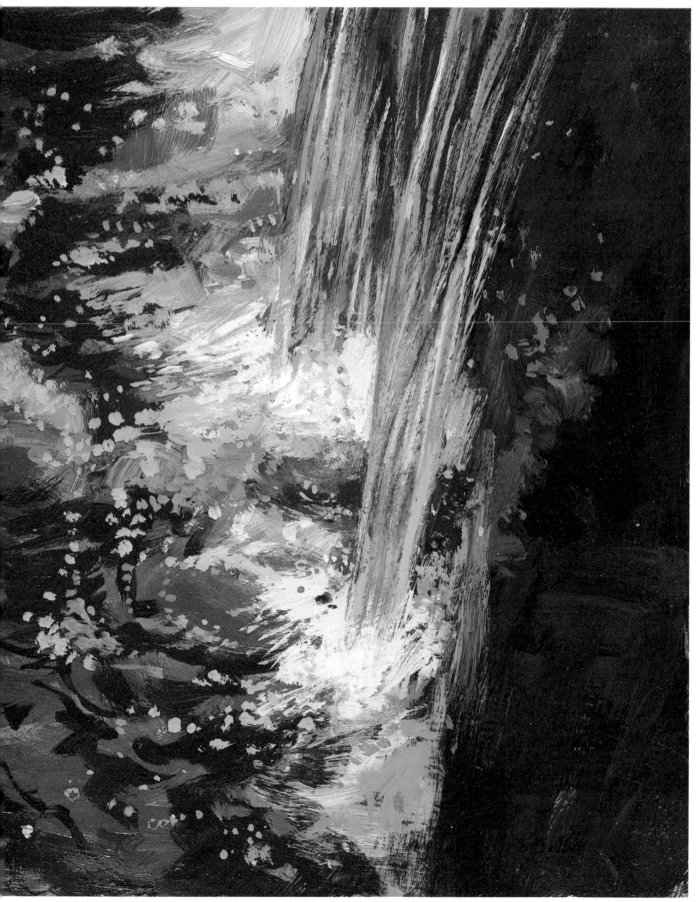

Medium Acrylic on board
Size 10 × 7 in.
Title **Cascade**

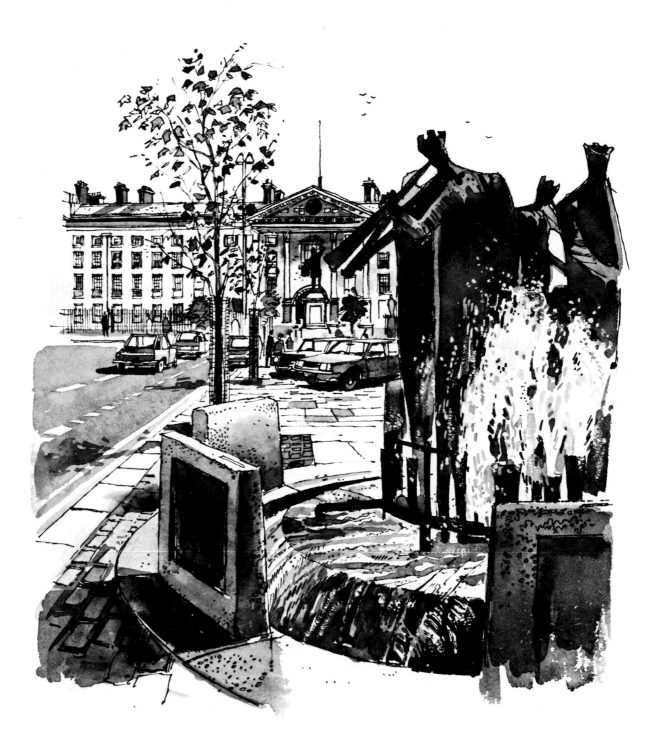

I have included another of my drawings commissioned by *International Newsweek* to show you an example of moving water combined with sculpture. The upward propulsion of water from the jets creates an interesting texture of broken edges and a tumbling movement downwards. The ragged shape of water from the jets contrasts with the smooth cascades running off the circular base.

The illustration is on smooth illustration board. I used a steel nib for the drawing and black watercolour for the washes of tone. The flecks of spray are created by touches of process white and scratching out with a knife.

For the main body of water from the jets I worked direct with pure watercolour.

Medium Pen and ink and wash
Size 7 × 6½ in.
Title **Dame Street—Dublin**

2 Calm and still water

Calm water and reflections are really two aspects of the same subject, but in this book I've chosen to look at them separately to allow for more detailed discussion. Certain points will inevitably be repeated, but I hope that this will usefully emphasise them.

A still body of water has a tranquillity of immense attraction to the landscape painter. When perfectly smooth it reflects the sky and objects like a mirror. Disturbed by a breeze or current, the surface becomes textured and reflections diffused and elongated. For our discussion it will be helpful if we establish the differences between calm and still water. A common fault is the notion that calm or still water, because it is flat, should be depicted entirely with horizontal streaks. But this is wrong, and indicates lack of observation. Calm water is not, in fact, absolutely still. Its surface may be affected by the tide, by currents or breezes. Surface disturbance varies from eddies of current to short waves. When a shaft of sunlight strikes the textured surface each facet facing the sun sparkles and there is an effect of shimmering, dancing light.

The colour of the sky and localised objects reflect on to the water but the shadow and light of ripples break up the purity of reflected colour. The overall colour is that of the sky, but darker.

A calm sea is never still but its surface can appear smooth. Sunlit clouds may sometimes be reflected in the sea.

Still water, on the other hand, reflects everything clearly and accurately, like a mirror. The problem with painting perfectly still water is that you have to decide how important the reflections are because they can easily dominate the picture. You should make sure that reflections harmonise with the rest of the painting. I shall be discussing this more extensively in the following chapter.

My landscape paintings often include water, either as the main subject or as part of it. Whatever its mood or form I have long had an interest in portraying its many aspects.

An enclosed area of water is found in many environments and provides endless scope for painting material. It can be a puddle in a city street or country lane —a lake or village pond —a swimming pool — water in a cattle trough —the bath, boating pool, etc.

If you think of the atmosphere created by early morning mist and then add an aspect of tranquil water a potential subject begins to materialise. Working out the idea as a preliminary charcoal sketch will help to establish the tone and atmosphere, and from there it is a short step to painting. Learning to be aware of the possibilities for painting material develops over a period of time. So, the next time you are in a rainy street or lane look for puddles. Take photographs if you like.

The great English painter William Turner was criticised for spending hours just throwing pebbles into the water. But Turner was studying the effect of ripples. Observation is an essential part of an artist's life and never a waste of time.

Painting and drawing outdoors presents problems, but the results are sufficient compensation for discomfort or difficulties.

Diffused light

There is a rich source of subject material in quiet waterways. The effect of light and reflection attracted me to this backwater near Wareham in Dorset.

The morning was absolutely still and the river calm with a slight current. I have simplified the scene a lot. There were many more boats but I did not want a crowded and busy scene—an atmosphere of serenity interested me most of all. The sheet of water determines the mood. If the whole of the surface was rippled the illusion of tranquillity would have been destroyed. The flat sky devoid of any cloud also adds to this effect.

The surface of water is seldom completely smooth, however, so I have introduced small areas where a light breeze disturbs the surface. The blended tone in the foreground also suggests slight movement.

Recession lends interest to the drawing and helps to create a sense of air and space.

Water carried down to the bottom of a picture can look as if it is falling out—to counteract this a darker tone can be carried across the lower part, as in my drawing. This method is much better than a contrived pelmet of foliage stuck right on the bottom edge, which is a common mistake.

Medium Charcoal on drawing paper
Size $8\frac{3}{4} \times 5\frac{1}{2}$ in.
Title **Dorset river**

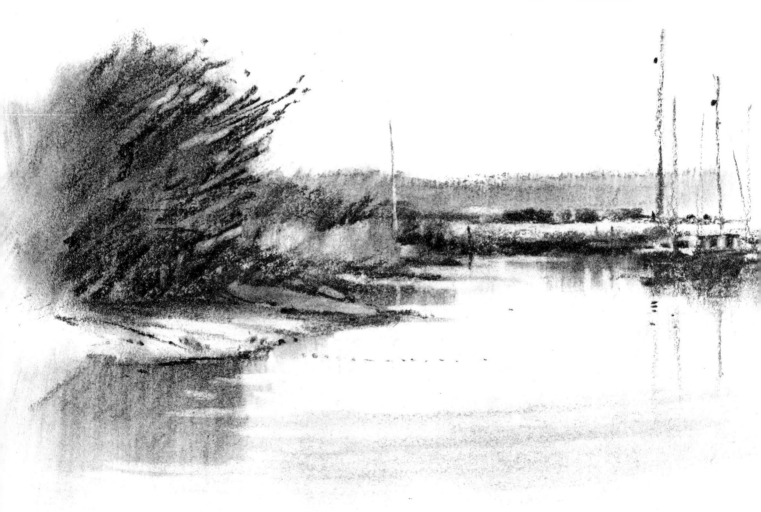

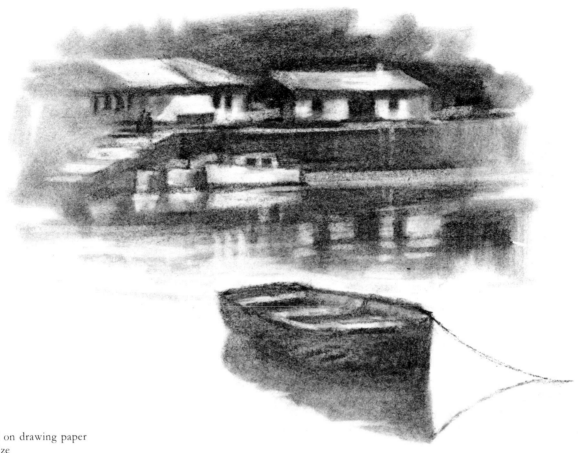

Medium Charcoal on drawing paper
Size Actual size
Title **Harbour**

The richness of charcoal and its capacity to give a wide tonal range is exemplified in this drawing.

To render the darkest tones I sprayed the first application of charcoal with a fixative. I was then able to apply a second layer which resulted in a much denser tone.

The water is almost still but the slight movement of its surface disturbs the reflection of the boat. Background reflections are broken and diffused by the ripples of tide; which are suggested by calm lines. Short curvy lines, by contrast, would suggest an agitated movement of waves caused by a strong surface wind.

The direction of light from the sky is an important consideration before starting any drawing. My sketch was done in the studio, and I decided the light was to be fairly bright but diffused by an overcast sky. The quality and direction of light has a marked influence on the water, boats and harbour, making the shapes less distinct and sharp-edged. I am careful to carry this feeling of diffused light throughout my drawing to create a total and harmonious effect. It's important to consider mood, atmosphere, tone and the effect of light if you want to achieve harmony in your work.

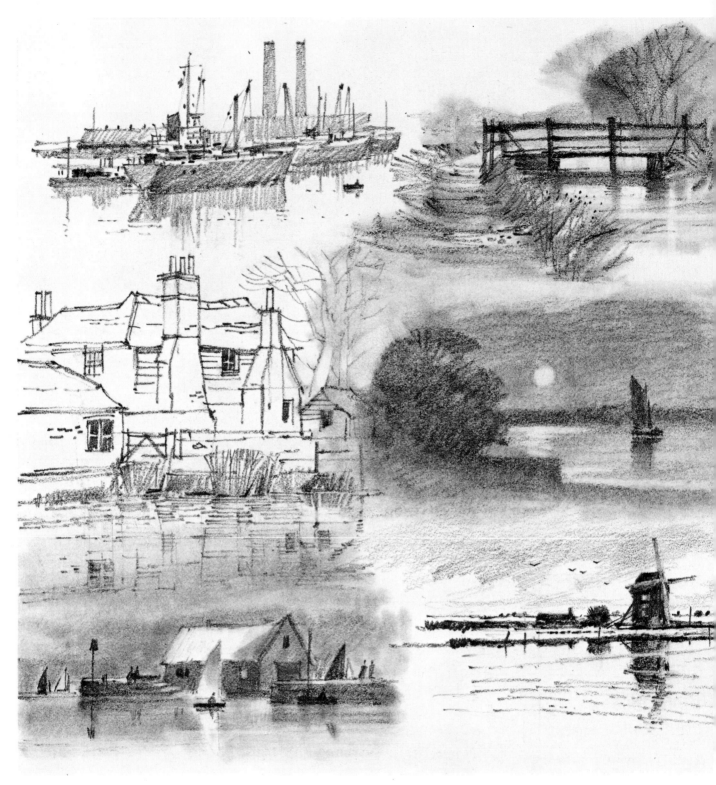

These drawings are reproduced actual size to show the various textures produced by a soft grade pencil, and how smudging can render tone. Each drawing illustrates a tranquil stretch of calm water, and the atmosphere this can create. I have included the sketch of a Sussex cottage as an example of combined line and tone.

Before I begin a drawing I have a fairly clear idea of the effect I want, as the technique of pencil smudging does not readily lend itself to alterations.

Medium 6B graphite pencil on drawing paper
Size Actual size
Title **Calm and still water**

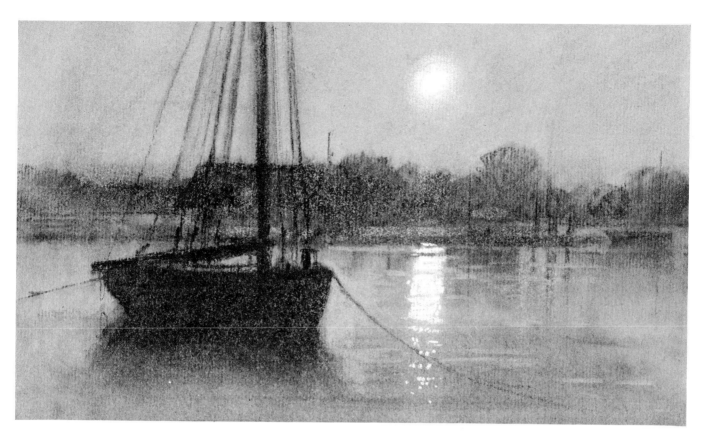

Interest in this drawing lies in the simple silhouettes of the boat and distant bank and the moon and its reflection. The composition has exactly the same elements as the painting in colour on page 41 — a series of horizontals intersected by verticals. These are strong elements of composition and repeat themselves in almost every landscape painting.

The reflection of the moon is broken up in the foreground by ripples of the tide. I purposely did this to avoid the reflection falling out of the bottom of the picture, which we discussed earlier. Again, a darker tone in the foreground of the water helps avoid this problem. These are elementary considerations, often overlooked.

Unity can often be attained by repetition. In my drawing, for example, the verticals of the mast and reflections are repeated in the background. Another means of achieving unity is by including an orderly succession of similar shapes, which is particularly effective with water. In my drawing a series of ripples across the surface of the water harmonise with the furthest horizontals. Horizontal lines suggest repose and by repeating these a sense of calm is achieved in my drawing.

I must stress that I do not consciously apply any of these principles to my work. I depend upon my judgement. If it doesn't work then I do it again.

Medium Charcoal and soft chalk pastel
Size $10\frac{1}{2} \times 6$ in.
Title **Evening**

This lovely Scottish castle in its surrounds of lochs and mountains is a source of inspiration to many artists, and I was no exception. I spent many enjoyable hours drawing from different angles, and absorbing the wonderful feeling of aerial space and distance. It was early autumn and I remember grey rainclouds partially obscuring the summit of distant mountains—the last of the summer flowers turning golden-brown among the rocks and a feeling that time was standing still. I have tried to recapture the atmosphere of that moment in my drawing.

To convey the tranquillity of the scene I decided to ignore the textured stones, slit windows and castellation and show the castle as a silhouette. The effect of rising mist softens the silhouette and adds to the atmosphere. Reflections in still clear water are as well defined as the object itself, so the castle is also reflected as a silhouette but I have only suggested detail. You may also notice that the left hand edge of the reflection is not clearly defined. This would attract interest to it, whereas my main theme is the castle and everything else is subordinated.

Contrast of texture creates interest and here I have used the flat silhouette of the castle and the speckled sky as foils for each other. The roofs are clearly defined and bring attention to the sky. The speckled texture is also repeated by the flower shapes in the foreground. These shapes and other areas of light tones are lifted out with a putty rubber kneaded to a point.

The recession of sky, land and water creates a dimension between these three planes and adds to the feeling of aerial space and atmosphere. It would take quite a while to row from Eilean Donan Castle to the furthest shore. You are made aware of distance by the contrast of light and dark tones.

The flicks of light drawn across the surface of the water make it lay flat and stop the vertical reflections from falling out of the bottom of the drawing.

A common fault is to include too many horizontal lines on the water surface. These look contrived and draw attention to the lines, rather than to the overall effect, and they also destroy the illusion of calmness. My drawing has one major line across the reflection; the rest are of secondary importance. The most forceful shapes, which contrast with the verticals, are the arches of the bridge. It is tempting to emphasise the effect of light through the arches but that would overdo it: the rhythmic repetition of the series of curves are, again, of secondary importance, and provide a strong contrast with the horizontals of landscape. Forceful shapes must harmonise with the natural order of landscape.

Medium Charcoal on drawing paper
Size Actual size
Title **Eilean Donan Castle, Scotland**

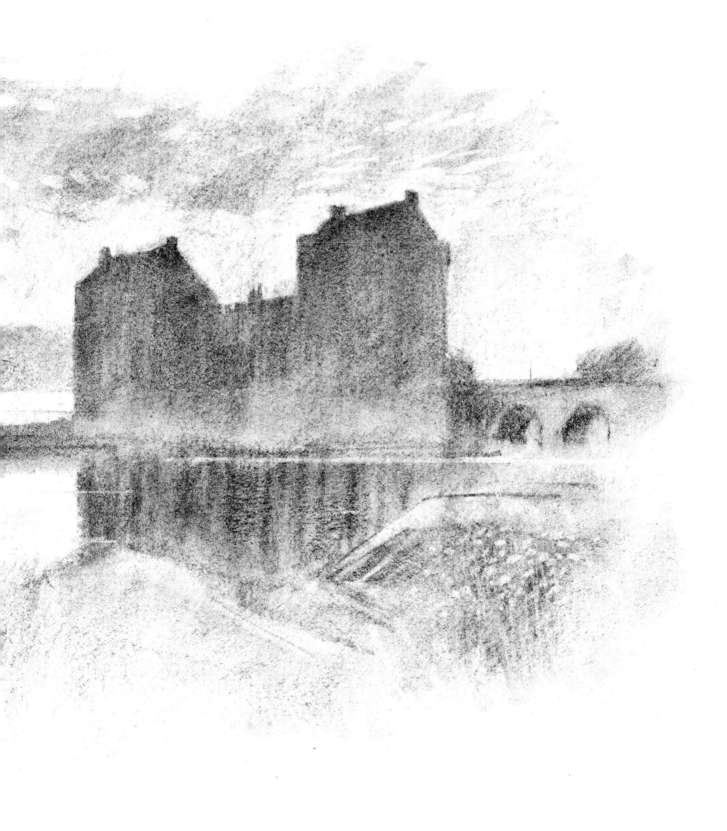

Industrial backwaters of cities and towns are often rich in character and a source of material for painting subjects. In these more enlightened days a number of canal areas are being restored, and others developed with perceptive appreciation of what a unique environment they constitute. These modernised areas must not be disregarded for quite often the warehouse facades are unspoilt, and although the waterway is tidy its character remains unchanged.

With a sketchpad and pencil I have enjoyed many explorations down the back alleys and riverside streets of the river Thames. My drawing illustrates an approach you may like to try when sketching similar industrial waterways. The problem with buildings found there is that they often have a mass of small windows, doors, outside iron staircases, gantries, corrugated iron fences, railings and a family of chimneys — all clearly reflected in the water.

There are two approaches to drawing a building: you can show both the facade and the outline or concentrate on the silhouette. For my drawing illustrated I have chosen to concentrate mainly on the silhouette as I did for Eilean Donan Castle but with a slight difference. There is a suggestion of windows, walls, steps, path and smoke, which I included to give a feeling of industrial activity in the scene.

The drawing is loosely based on an actual place but the mood and atmosphere is entirely imaginary. You may like to take a similar subject and create an atmospheric mood from your imagination. It will also be an excellent exercise in working out subtle tone values and the effect of light on water and other surfaces.

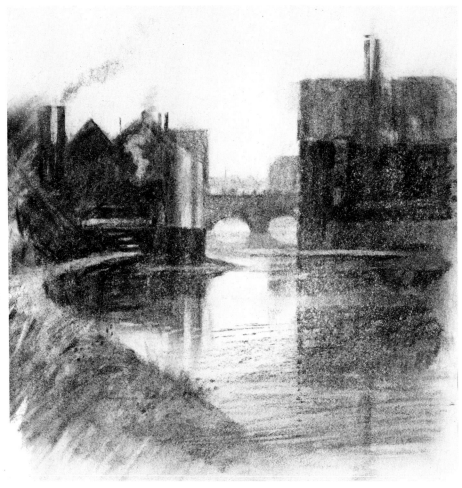

Medium Charcoal on drawing paper
Size 7 × 7 in.
Title **Industrial reflections**

DEMONSTRATION: Charcoal on cartridge
paper (drawing paper)

Step one

As I rough in the general shape of
the landscape I realise that I'm not
entirely decided on the effect I want.
However charcoal is such a versatile
and expressive medium I know that
with a few rapid tones I can solve
the problem quickly.

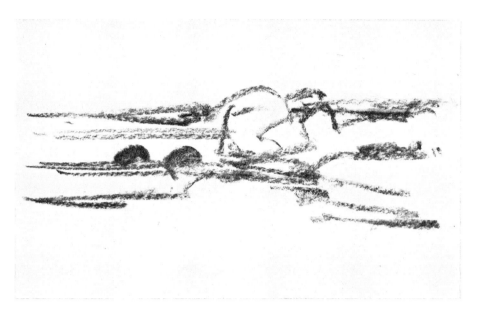

Step two

A summer day is my theme. The
sun is high, casting a shadow across
the stone bridge and the trees are a
deep tone. I decide on the direction
of light. I block in more areas of
tone and smudge it with a paper
tissue to soften and lighten the
effect. Sunlight across the bridge and
meadow is going to be the focal
point. I leave the paper untouched
so I can get brightness into the final
stages of the drawing. With a paper
tissue dabbed in charcoal dust I rub
it lightly over most of the sky area,
keeping the tone pale. The bridge
needs to contrast with the
background. A line of shrubs will
help to emphasise sunlight on the
bridge.

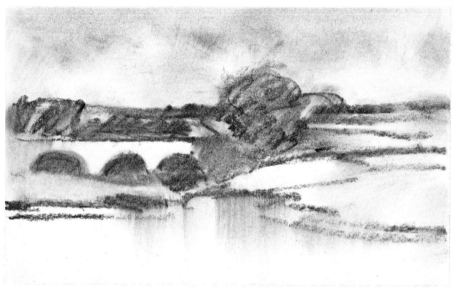

Final stage

The whole drawing needs
strengthening to give a feeling of a
bright sunny day, so I draw into it
with some rich dark tones. Now my
sketch is taking shape. Instead of
allowing the reflections to go off the
bottom of the paper, I rub in
charcoal and use a putty rubber to
lift out the effect of a breeze
disturbing the surface. This
emphasises the horizontal plane, and
suggests calm. Clouds are lifted out
with a putty rubber.

To get a sharp edge to the shadow
on the bridge I laid a piece of paper
over the shadow side, and then
rubbed out the sunny part.

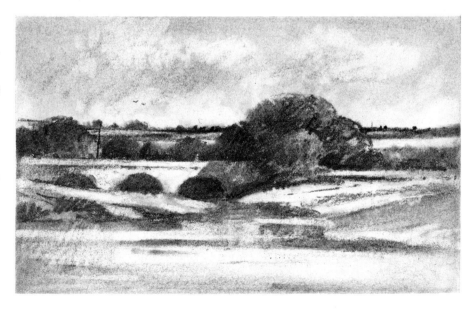

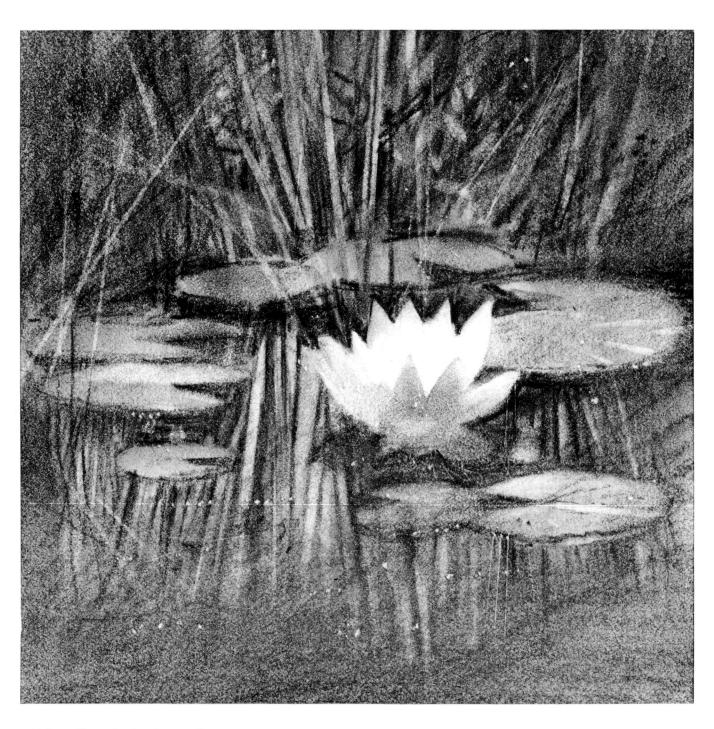

Medium Charcoal and carbon pencil on drawing paper
Size Actual size
Title **Water lily**

My subject is simple but the composition had to be carefully considered to arrive at a balance of shapes which would harmonise with the forceful pattern of the open lily. The segment of each lily pad repeats the petal shapes and they also face inwards to counterbalance the strong directional lines of the reeds and reflections. There are no horizontal lines across the surface of the water but instead the lily pads create a feeling of flatness. Around the edge of the pad, water tension creates tiny flecks of reflected light. I have picked these out with a sharp blade. I began the drawing by lightly rubbing charcoal all over the surface but leaving the centre of the lily clear. Then the darks were established. The narrow light lines I achieved by cutting slots out of a piece of paper and then rubbing between them. For the touches of black I used a soft grade carbon pencil.

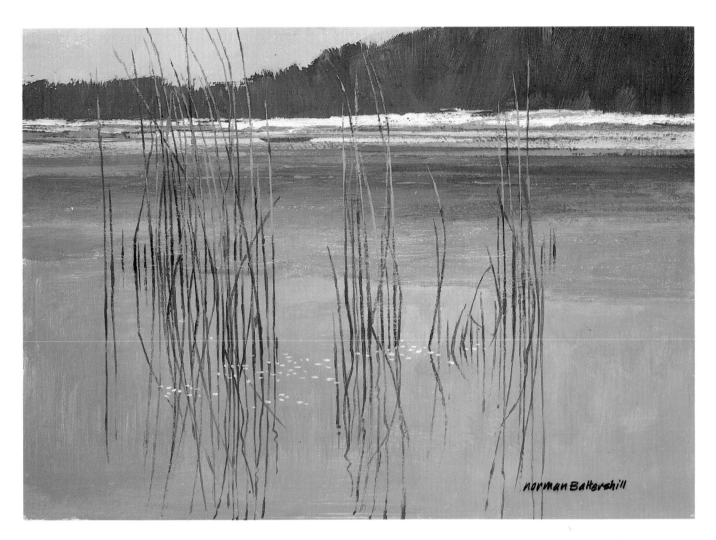

Here is an interesting example of water in both its solid and liquid form. The frozen pond is beginning to thaw. Nearest to the bank the ice has melted and reflections are sharply defined in the perfectly still water. Behind the reeds a layer of ice extends to the distant snow-textured bank. This multiplicity of contrasts appealed to me.

My painting was done in the studio using a photograph and several drawings. I used my imagination for the colour scheme, composition, distant trees and snow covered bank. In the photograph the foreground is a confusing mass of reeds and reflections—there is no sky because the distant trees are much higher than shown in my painting. I made drastic deletions to arrive at the

simplicity of my painting, but it does capture my original conception. Although it is a cold winter subject there is a lot of red in the colours, particularly the sky and trees. I included a punt in the middle distance to give a sense of scale and increase the feeling of distance.

If you analyse the composition it is a series of horizontal lines bisected by equally forceful vertical lines. The composition is well balanced, but as I have said before, this is not a result of a preconceived geometric approach.

The colours I used for this acrylic painting are:

cadmium red light ultramarine
cobalt blue yellow ochre
red iron oxide titanium white

Medium Acrylic on board
Size 11 × 7 in.
Title **Thaw**

The overall colour of this painting is mauve. Without the introduction of its complementary colour, yellow, it would lack harmony. The foreground reeds are just sufficient to effect the balance needed.

You will notice there are touches of yellow in the sky and the snow-covered bank. Dispersing a colour like this brings together all parts of the picture into colour harmony. Another method is to stain the board or canvas first. To have the underlying colour showing through here and there in the final painting relates all parts of the picture.

Accent of light

The sky was overcast when I started this outdoor sketch and rain was coming up from the horizon accompanied by a fresh breeze. I thought it prudent to stop painting. Loading my gear into the car I happened to turn around and saw the stretch of water shining like silver in a fleeting ray of sun. Next day in the studio I put that effect of light into my painting. It is a humble outdoor study but I learned something from it.

An overcast sky dulls the colours of a landscape and minimises the contrast of light and dark but a dull painting can be enlivened in the studio. A patch of light in the sky or on a stretch of water may be all that is needed to give a subject importance and life. Diffused light has a softness which I find particularly pleasing. Generally cool in colour it softens all edges and shadows lose intensity. Transient light effects are not always dramatic and the landscape painter must be aware of subtle changes. The same degree of light intensity all over the landscape may not prove as interesting as a painting which shows a variation of light. And this also applies to the painting of water, whatever its form.

The oil colours I used for this painting are:

french ultramarine	cobalt blue
light red	cadmium red
cadmium yellow pale	burnt sienna
titanium white	

Medium Oils on board
Size 12 × 10 in.
Title **Dorset landscape**

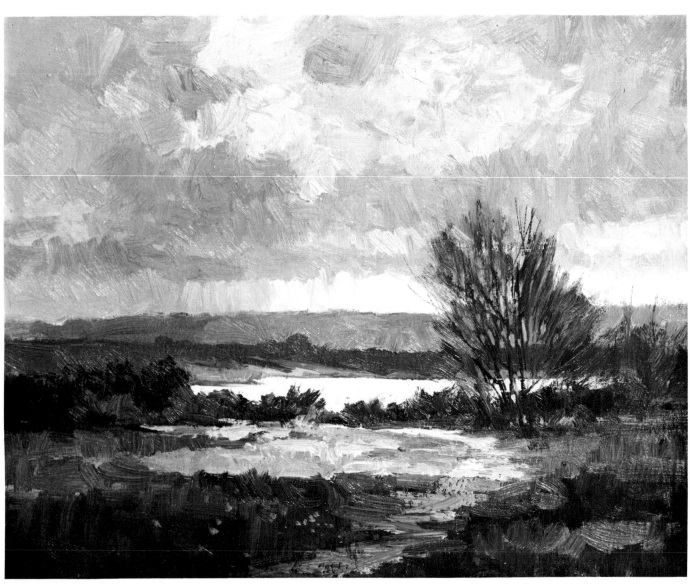

A very hasty watercolour to capture the stillness before the weather changed. I painted this scene with blue-black writing ink and a sable watercolour brush. This ink is very clean when diluted and does not granulate when washes are laid. Applied straight from the bottle it is a rich blue-black, but with more red in it than black—so the darks are not flat and dull but have life. I have tried several drawing inks but now prefer to use ordinary writing ink for my sketches. I am not certain about colour fastness but so far there has been no sign of fading.

There is no preliminary drawing. I often work this way when painting outdoors. If it doesn't work I discard it and start again on the back or on a fresh piece of paper. Quick sketches teach you to look for only the essentials of a subject; your observation is also developed by knowing what to leave out. In my painting there was a lot more detail than I have shown. Boats were also moored on the left of the river bank, more in the middle and a lot of activity in the background. There were various alternatives to the subject but I chose this one to illustrate the effect of still water.

Medium Writing ink on Bockingford paper
Size $8 \times 9\frac{1}{2}$ in.
Title **Still reflections**

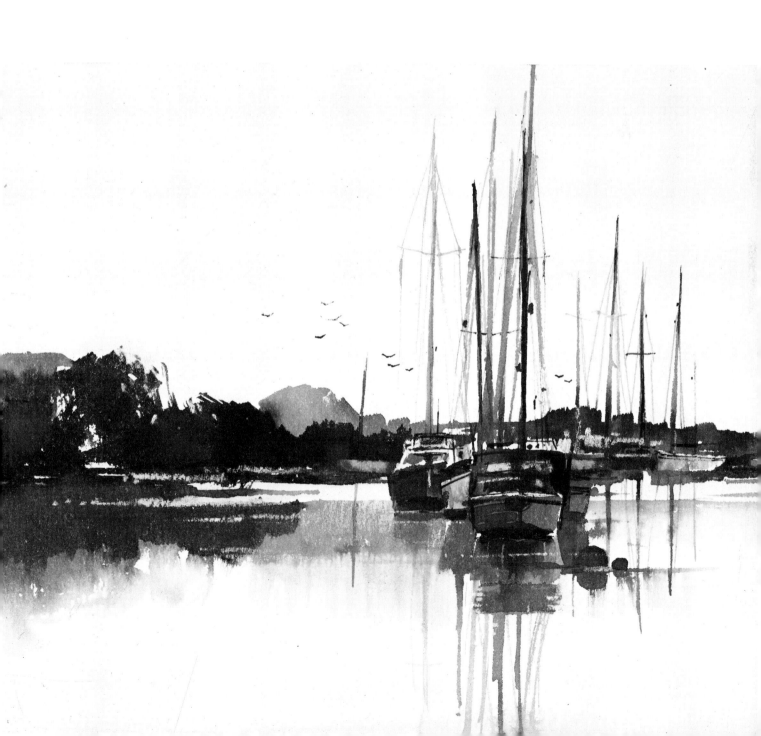

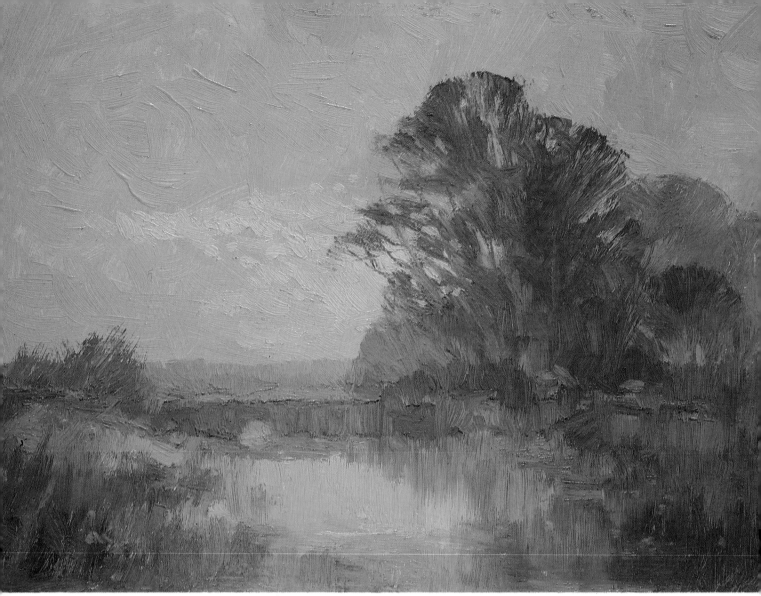

Light on water

Medium Oils on board
Size 11 × 7 in.
Title **Morning mist**

In these three subjects you can see the very different effects of light on water.

Early morning after rain or heavy dew is a magical time of day. The air is soft, surfaces gleam and a thin, almost transparent mist lies across the water diffusing reflections. My painting was done in the studio. I used a very limited palette —the colours are:

ultramarine cadmium red
lemon yellow yellow ochre
titanium white

The first step is to lightly stain the primed panel with lemon yellow. When it is dry I then start to establish the final colour of the sky and also the dark elm trees and bridge. Brushwork is direct and as spontaneous as possible to get a feeling of freshness and sparkle.

I imagine that I am actually there and can feel the atmosphere of light and mistiness.

For the silhouetted trees I mix cadmium red and ultramarine with a touch of yellow ochre so that the resulting mauve colour is not too forceful. The touch of yellow is also the colour of sunlight and adds to the atmosphere of light on the fields, trees and water.

Throughout the painting I try to keep the selection of colours to a minimum. My painting is basically a harmony of mauve and yellow.

After the darks are established I create recession and aerial perspective by adding distant trees and fields. The final touch is the effect of light in the sky. For this I mix lemon yellow and titanium white. I have not used any painting medium, as I find the consistency of undiluted paint is sufficient for expressive brushwork.

A studio painting from an outdoor sketch.

The pattern of the cattle fence and the light on the water immediately attracted me to this subject. The day was overcast and the sun hazy with a softening of the shadows. A few hours later the sky cleared and completely changed the atmosphere on the landscape. My palette of acrylic colours consisted of:

burnt sienna ultramarine
cobalt blue cadmium red
yellow ochre titanium white

I painted direct on to the white primed board without any preliminary staining. Recession is necessary in this landscape painting, otherwise interest does not move to the horizon. To suggest recession I made the middle distance fairly dark in tone and the furthest hedge slightly lighter. For the distant hills

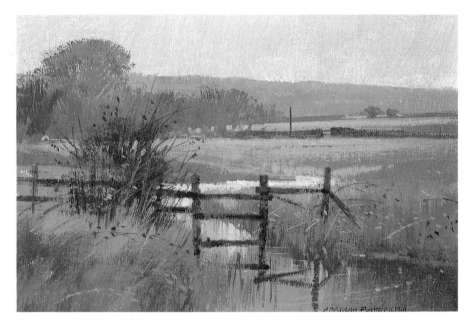

I mixed cadmium red, ultramarine, a touch of yellow ochre and titanium white. Using the dry brush technique I dragged colour over the textured surface for the fence reflections, trees and fields.

Medium Acrylic on canvas board
Size 20 × 16 in.
Title **Dorset landscape**

The theme of flooded fields often occurs in my paintings. A stretch of shallow water, sunlit fields and reflections of a bush and fence offers many variations in atmosphere and composition.

My pastel painting is imaginary, based on references from my sketch books. For a simple composition such as this my preliminary drawing is very loosely indicated with charcoal—just a few lines to place the main shapes. The landscape is divided into well defined horizontals. Without the verticals of the fence and shrub these forceful lines would predominate. Diagonals in the foreground also contribute to the balanced composition. The water is still but the surface is broken up into interesting areas of tone and colour with a few flicks of light introduced here and there to add sparkle.

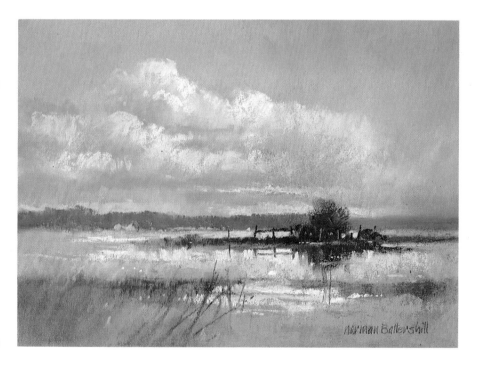

To suggest a feeling of calm, pastel marks are restrained and edges softened.

Medium Pastel on grey Ingres pastel paper
Size 20 × 16 in.
Title **Flooded field**

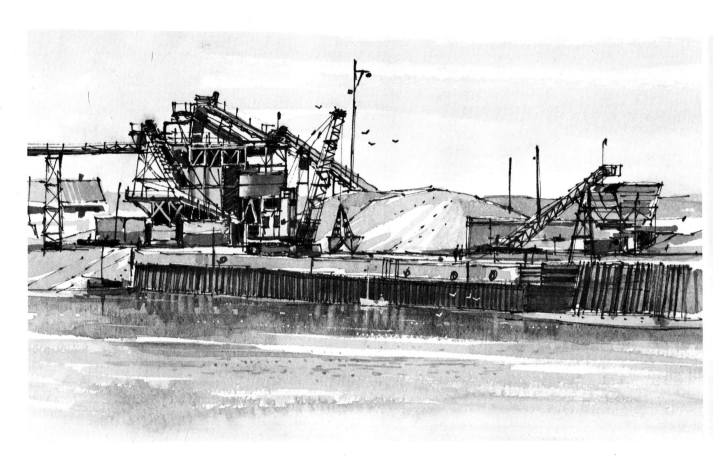

Medium Pen and ink and watercolour on
Bockingford watercolour paper
Size 8¾ × 5 in.
Title **Littlehampton dockside**

Riverside industrial subjects

Here are two very different studies of wharfside subjects.

This Littlehampton ballast works has endless possible viewpoints, and a multitude of textures. My interest here is the complexity of gantry, hopper, conveyor and crane in contrast with the sheen of water running alongside. I enjoy this kind of drawing because a collection of lines and angles makes for a fascinating study.

I used a permanent ink fine tip pen for drawing, which I did direct without any preliminary pencil work, starting with the conveyor structure on the left.

The watercolours selected are:

ultramarine yellow ochre
burnt sienna Paynes grey

Most of the colour is confined to the wharf. The river is Paynes grey with a touch of yellow ochre added. A breeze breaks the smooth surface into ripples creating texture and flicks of light. I added the man in the boat and a few seagulls last of all; they add movement to the lower part. Water can be of secondary importance in a painting as in the illustration here, but it requires the same amount of consideration as the rest of the painting. The water must 'fit' the landscape and harmonise with its surroundings, or the painting is divided into two unrelated parts.

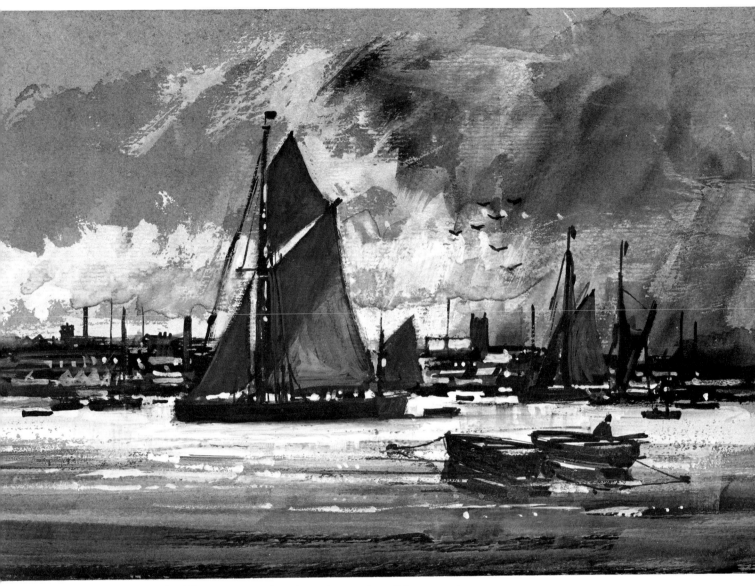

The grace and dignity of a Thames barge slowly making its way down-river is a beautiful but very rare sight these days. Occasionally I have seen a barge at sea, its vast area of tanned sail dwarfing nearby yachts. A great source of pleasure to me is a 21 in. model of a barge I had made some years ago, complete in every detail. I continually use it for reference.

This is a studio painting of a barge and busy river scene on a bright but cloudy day. Light on the river and wet roof-tops gives a sense of prevailing weather conditions. Small touches of detail in the background lend scale and recession. I have used black poster colour and white on grey Ingres pastel paper.

The sky and river were painted first and then the distant town. I did not put in detail to the background until last of all. The barge was lightly drawn in with a soft pencil and then I painted its silhouette. A couple of dinghies and a figure were added in the final stages. Apart from the barge, which was the main theme, I was also interested in showing the dramatic effect of light and shade, which may remain for a fleeting moment only and then is gone.

Medium Poster colour on grey pastel paper
Size $6\frac{1}{2} \times 4\frac{3}{4}$ in.
Title **Thames barge 'Kathleen'**

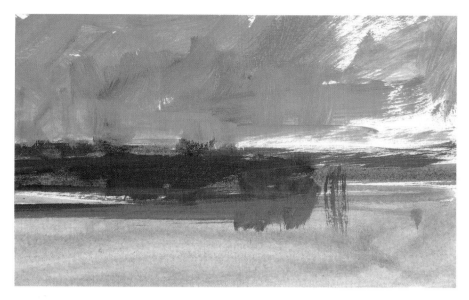

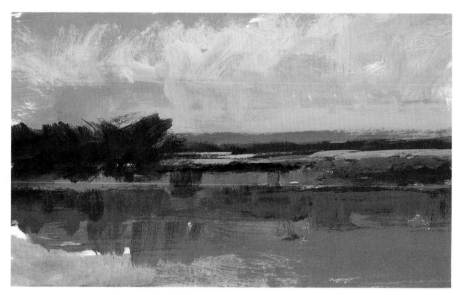

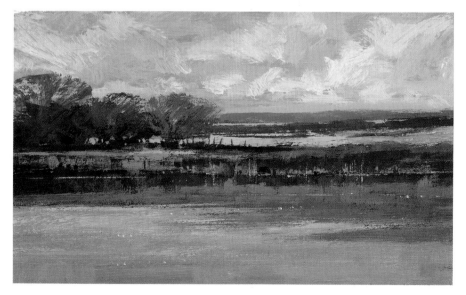

Step one

Instead of drawing the composition with a brush as I normally do, I lay in the large areas of colour straight away. It is a simple composition so preliminary drawing is unnecessary.

Step two

The picture begins to emerge already and I keep the painting technique very simple. Detail will be added last of all. The main thing at this stage is to get the contrast of tones right, and dark and light tones are used to suggest sunshine and shadow, across the fields and distant hill. The reflection of the sky is darker than the sky itself, so I indicate this. It is only a rough indication, however, and I can easily alter it because acrylic dries so quickly. Having established an overall effect I can start pulling it together.

Final stage

The effect I want to try and get is still water with part of its surface disturbed by a breeze. I achieve this by dry brushing a grey colour, to suggest a disturbed surface, over the dark colour underneath, with a few spots of light. On the river bank reflections are cut round with a paler sky colour following the contours of the reeds. Trees are given shape in the final stage to get a dry-brush effect over the sky.

Touches of light and a few fence poles complete the picture. The acrylic colours I have used are:

ultramarine blue red iron oxide
cobalt blue titanium white
quinacridone red
cadmium yellow pale

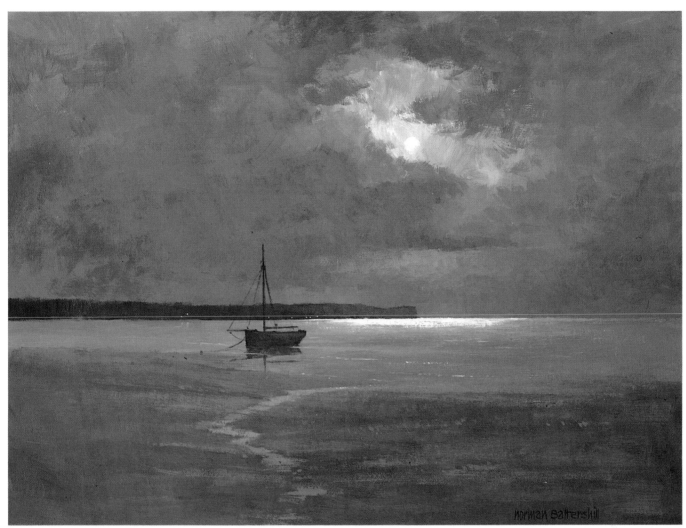

Tonal relationships

Tone values are critical in a painting of this nature. Everything must be in its proper plane to achieve the desired effect. If the foreground were as dark as the boat, interest would be diverted to the bottom of the picture and the feeling of space and light at sea over-dramatised.

Every colour has a value of either light or dark and colour temperature. The overall colour temperature of this painting (allowing for the difference between artist's paint and printer's ink) is warm. Red is a warm colour, ultramarine is also a warm colour because the blue has red in it. Ultramarine and cadmium red are

the principal colours which have been mixed for the clouds. The number of colours I used for this oil painting are limited: cadmium red, ultramarine blue, yellow ochre, burnt sienna, titanium white.

The darkest tones are the boat and distant headland—placing them close together emphasises them and also creates a sense of recession. The strip of moonlight on the sea joins the headland, and links the two areas. You will notice that the unison of foreground and middle distance is achieved by the trickle of water running into it, and the tone is similar to that of the sea.

Composition in this painting is very simple and compact—but what determines whether the picture

Medium Oils on board
Size 30 × 20 in.
Title **Calm night**

succeeds or not is the relationship of one tone to another. A dominating mood or atmosphere depends on getting tone values to harmonise. Although the calm sea occupies a small area compared with the foreground and sky its surface has a variation of subtle tones. The student may be tempted to paint the moon white as it is the brightest part of the scene but, in fact, this would detract interest from the rest of the painting. You can see my solution to the problem. I have purposefully not emphasised the moon by adding touches of yellow ochre and grey to the white.

49

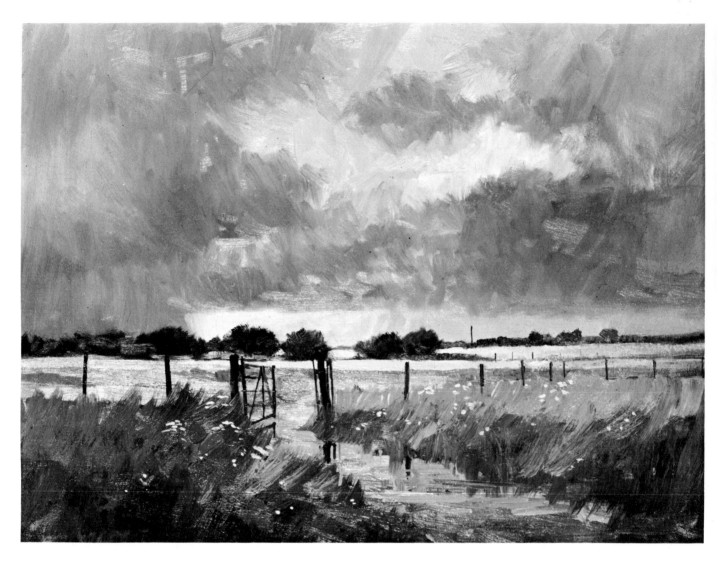

Diffused lighting can make a painting look flat and dull because shadows are indefinite with minimal contrast between light and dark tones. My painting of a rainy day scene is an example of soft down-light from an overcast sky. The wet fields and flooded path reflect light but there are no definite shadows. To contrast with the light horizontal planes all verticals are darker.

Hedges, gate and posts provide these essential dark tones and lift the painting from possible flatness. Reflections in the flooded track are minimal but do suggest that the ground is wet. The lightest part of the sky is between the falling rain in the distance, above the open gate and reflections. You will notice that the gate is open on the side which leads into the picture, not out of it. Close grouping of features creates a compact composition. The colours I mixed for this acrylic painting are:

ultramarine yellow ochre
cadmium red red iron oxide
titanium white burnt sienna
cadmium yellow medium

Medium Acrylic on board
Size 20 × 16 in.
Title **After the rain**

50

3 Reflections

When water is absolutely smooth it reflects everything perfectly, like a mirror. As it becomes disturbed by ripples or swells, the reflected image is distorted and elongated to form abstract moving patterns. Reflections of an image disappear when the surface of the water is choppy, but the light and colour from the sky are always reflected. The exception would be the steep face of a wave, where the angle is such that any reflection is minimal. So, essentially, understanding reflections means understanding the varied textures produced by the movement of the water's surface.

Directing light on to crumpled silver foil both from above and at diverse angles demonstrates the principles of surface reflection. By varying the intensity of light you will also see that bright light defines contours, and diffused light flattens them. Explaining the perspective of reflections can involve complex geometric diagrams but an understanding of a few basic principles is all that is needed to render reflections convincingly. Looking down obliquely on to a matchbox placed on a mirror the matchbox appears foreshortened so that we see little of the sides reflected on to the mirror. When seen from just above the level of the mirror, the whole of the side of the box is visible, and its reflection repeats that image. Ripples will break up the surface of still water into troughs, and we can therefore only see fragments of a reflection on the side of the trough facing us. The colour of water is influenced by the colour

reflected on its surface, with the exception of shallow water, where the bed will contribute to the overall colour. A sandy stream will make the water appear rather a pale colour, whereas a muddy bed will make the water dark, and the reflections will not have any definite colour.

Moving reflections reveal an endless source of patterns and can make exciting separate studies. It is simpler to take a photograph of a moving reflection and extract the design element from it in the studio, rather than drawing in detail outdoors. I have done this for the more intricate designs illustrated in this chapter.

Try to keep your work fresh and spontaneous by painting or drawing direct, and avoid using white paint. Your outdoor studies of reflections can be in any medium you choose, but a broad medium is preferable to the fine point of a pen, for easy handling and speed.

Reflections can often create very forceful shapes and can dominate a painting to the detriment of the subject as a whole. They must become a natural and harmonious part of the landscape, and accomplishing this becomes simpler if you remember that water reflects the sky — if you paint the water as a darker colour of the sky the two will be unified, and adding some of this colour to the landscape and reflections will help increase the harmony of land, water and sky. The following drawings and paintings will serve as a basis for you to make your own observations.

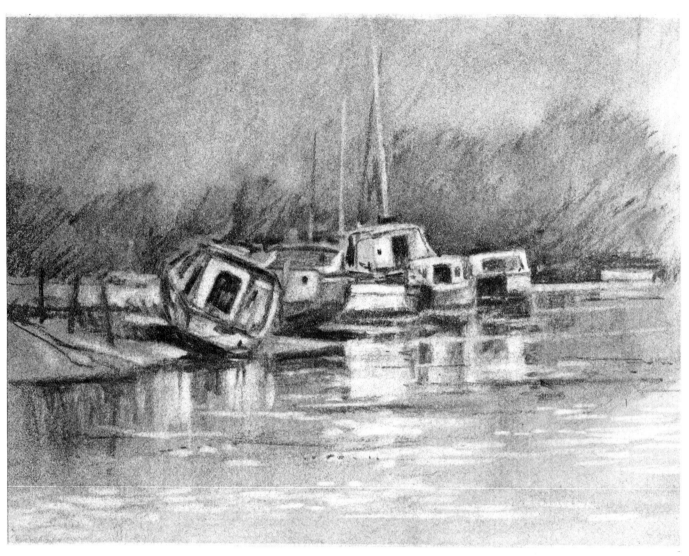

Working on a toned background

The river was on the ebb when I came across this subject at Wareham in Dorset. Boats at various angles jumbled together in a confusion of interesting shapes made a very compact composition. I did some pencil sketches on the spot, making a note of the direction of light and water movement. Sometime later I came across my sketches and decided to make this charcoal drawing from one of them.

Instead of drawing direct on to the white paper I established an overall tone by lightly rubbing charcoal over the surface and blending with paper tissue. A toned background unifies a drawing in the same way as a toned ground does for a painting. Then I drew in the darkest tones of the background and boats, making sure the steepest angles sloped inwards, as angles pointing to the outer edge can alter the focal interest of a picture. With a putty rubber I lift out accents of light from the boats and reflections. The river is tidal so movement is suggested by broken reflections and ripples of light across the surface. Recession is achieved by the strong contrast of light and dark to the bend of the river on the right.

Medium Charcoal on cartridge paper (drawing paper)
Size 8 × 6 in.
Title **Boats at Wareham**

Drawing on a tinted ground with charcoal pencil and white pastel produces a wide range of subtle tones. My drawing of this stretch of water shows the contrast between a flat surface and a textured surface. The reflection of sky on water is generally darker than the sky itself, so I left the colour of the paper for the water and lightened the sky with a thin layer of white pastel. The contrast of tone is very subtle but sufficient to make the necessary difference of values between the sky and reflection. The subject is very simple, with a strong contrast of light and dark on the water broken up by long ripples.

Placing the boats is critical to the balance of the composition, because they point outwards. I have counteracted this by the large area of reflection and trees on the left, so that the focus of attention does not leave the picture. At the edge of a reflection there is often an area of light, as I have shown near the boats: this also occurs with shadows on the landscape. Don't make the light too intense, because if so the subtle contrast will be lost. The silhouettes of trees and their reflections are very dark, but not dense and flat. Pastel paper gives a lustre to shadows and light if the textured surface is retained, by not pressing too hard with the pastel.

Medium Charcoal pencil and white soft chalk pastel on blue pastel paper
Size Actual size
Title **Calm water**

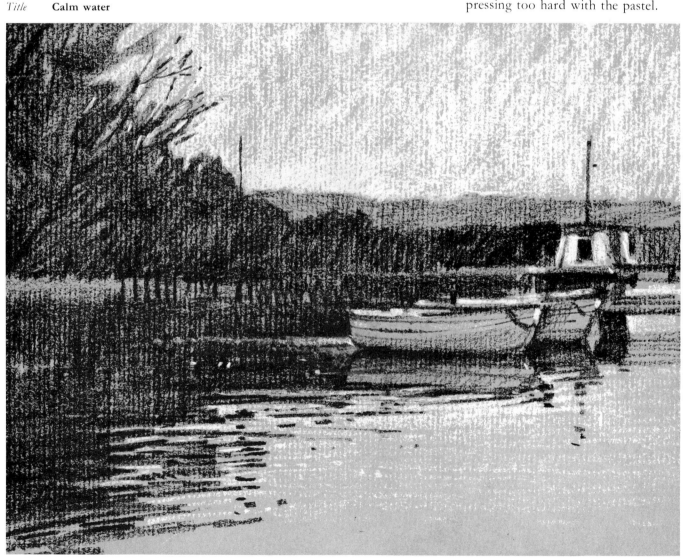

Patterns in reflections

Medium Carbon pencil on drawing paper
 (cartridge paper)
Size Actual size
Title **Fragmented reflection**

Close-up studies of moving reflections show beautiful complex patterns. If a slow swell arises in water that otherwise appears smooth and glassy, reflections can become twisted and elongated into shapes which bear little resemblance to the objects reflected. Ripples also make images break up into zig-zag edges and assorted shapes. My drawing is an example of an abstract treatment of a fragmented reflection.

A photograph is a very useful aid for studying moving water and reflections, revealing intricacies the eye cannot see. I have used one of my photographs as a reference for this illustration; this one is in colour, but black and white photos are preferable because tones are more easily discernible.

Drawing part of a reflection will probably have as much interest as the whole of it. My illustration here is of a breakwater post reflected into the sea, but I am not really concerned with what the object is. It is the pattern that matters most. The drawing is direct, without preliminary layout, nor is there any blending by rubbing. To avoid smudging I began at the top and worked downwards, following the movement of the reflection as closely as possible. This method of drawing is painstakingly slow but I feel the result is well worthwhile.

Again, this powerful pattern
developed from a photograph I took
of an iron pole and slurry at the
edge of a country pond. A series of
geometric curves in the liquid mud
has been formed by the action of the
water as it swirled around the pole.
Bits of broken reeds add to the
collection of varied textures. There
is a lot more detail of reflections and
reeds in the photo but I have
concentrated on just a part of it.
The drawing is reproduced actual
size to illustrate clearly the
intricacies of pattern and texture.
I used a soft grade carbon pencil
which produces rich matt dark
tones. The light part at the extreme
bottom left has been obtained by
rubbing down the dark tone with a
putty rubber. Instead of taking a
reflection too literally, regard it as
an exercise in discovery and search
for its patterns. You don't have to
be a designer to do this, nor is it
necessary to produce a drawing with
'finish'.

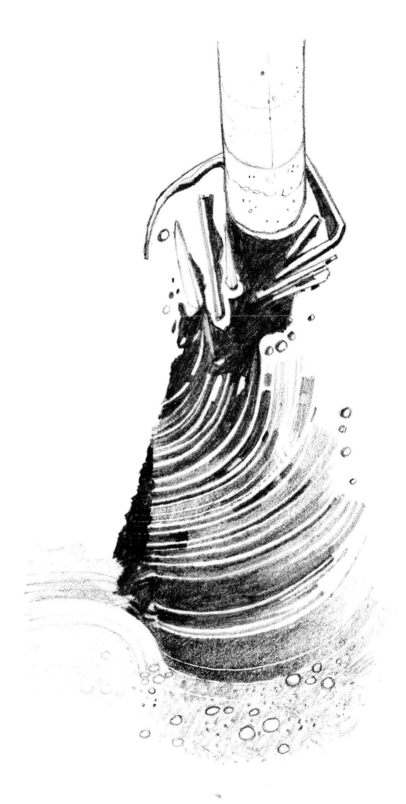

Medium Carbon pencil on cartridge paper
Size Actual size
Title **Slurry**

Step one

Conté pencil is a sensitive medium but does not have the blending qualities of charcoal. I have chosen it for this demonstration drawing for you to see the effect of reflections drawn direct without any blending.

Step two

Boats are complex shapes and must look as if they are in the water, and not just on the top of the surface. After the boats are correctly drawn my first consideration is to establish the direction of light, because it affects the reflections. The sun is shining from the right on to the hulls and makes an interesting contrast with the shadowed side of the harbour wall.

I roughly indicate the areas of shadow and dark reflections, trying not to make any mistakes. Conté cannot be rubbed out easily, and it shows.

Final stage

Reflections are very lightly indicated first of all so that the shapes and positions can be judged. The untouched areas of white paper are critical in a drawing like this. If every inch is covered up with shading the result can look rather dull. Here the water is smooth with some shallow ripples which distort and extend reflections. There are many more small reflections in the actual scene, but simplification is necessary because my drawing will be far too fussy.

Finally I add the other side of the harbour and a few boats.

Medium Charcoal pencil and soft white
 pastel on blue sugar paper
Size 6 × 4¼ in.
Title **Duck and reflections**

This drawing illustrates light
reflected on a textured surface.

The duck is pushing against a
flowing current, bringing about the
pattern of ripples in front and at the
sides. Lines drawn in front of the
duck are thick and undulating, to
indicate the movement of the
current. Each line is used to describe
the action, shape, texture, and the
effect of light on the surface of the
water. The blunt bow of a dinghy
moving against a swift current
would have an effect on water
similar to that of the duck.

In clear water, shadows cast by
objects on the surface can also be
seen on the bed. When there is
matter in the water such as mud or
algae, the surface may appear

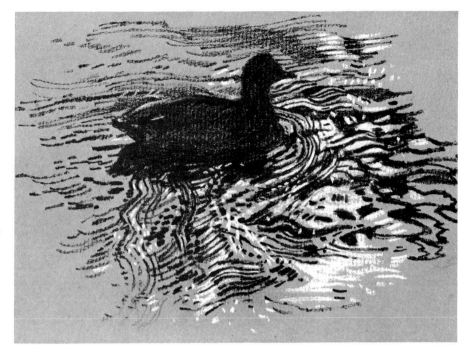

opaque, and the shadow will fall
only on the surface.

Medium White pastel on black paper
Size Actual size
Title **Silhouettes**

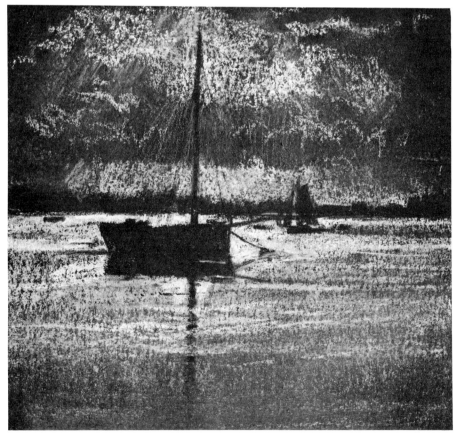

Moonlight on water is one of the
most beautiful and romantic subjects
to paint. It does, however, demand a
close control of tone values. A
common error is the use of too
much white and indiscriminate
scattering of glitter. Accents should
be left until the final stage. Linking
up tone values creates unity and
harmony, and I have concentrated
on this in my drawing.

The silhouettes of the boats and the
dark horizon intersect and form a
close group of similar tones. There
are no distracting areas of dark
outside this area. I lightly rubbed
white pastel all over the water area
to get a middle tone. Accent of light
is concentrated not on the moon but
on the water in the far distance,
which has the effect of creating
recession. The light tone of the
shadowy clouds also contributes to
the feeling of distance by not being
too dark: I have avoided giving a
strong impression of moonlight
behind the clouds in order to direct
attention to the brighter area of
water.

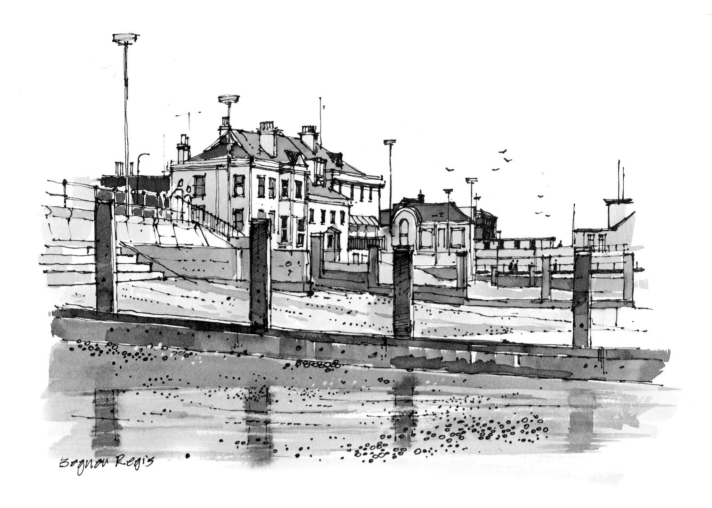

Bognor Regis

The sheen of wet sand left by an ebb tide has a most unusual appearance. Soft edged reflections are muted in colour, and the wet surface is textured by gleaming pebbles.

The subject for my line and wash drawing interested me for several reasons. I enjoy drawing structures and the background of hotels and part of the pier gave me the opportunity to incorporate them into a water subject. The vertical shapes of reflections, breakwater columns and buildings are all unified into a rhythmic pattern, and the shiny surface of wet sand provides an interesting contrast of surface texture.

All the drawing is done direct with a pen without any preliminary pencil work. For the washes of tone I diluted blue-black writing ink. No white has been used at all. Final touches are the pebbles and seagulls. The problem with a subject like this is not to make the nearest verticals too pronounced. To overcome this I made the top parts of the poles blend into the background a bit. I left this until last so I could more easily judge the correct tone values. As cartridge paper (drawing paper) is so absorbent, it's not possible to make corrections by wiping out. All work must be right first time, an excellent incentive for developing immediacy of drawing and painting.

Medium Pen and ink on drawing paper
Size $9\frac{1}{2} \times 7$ in.
Title **Low tide—Bognor Regis**

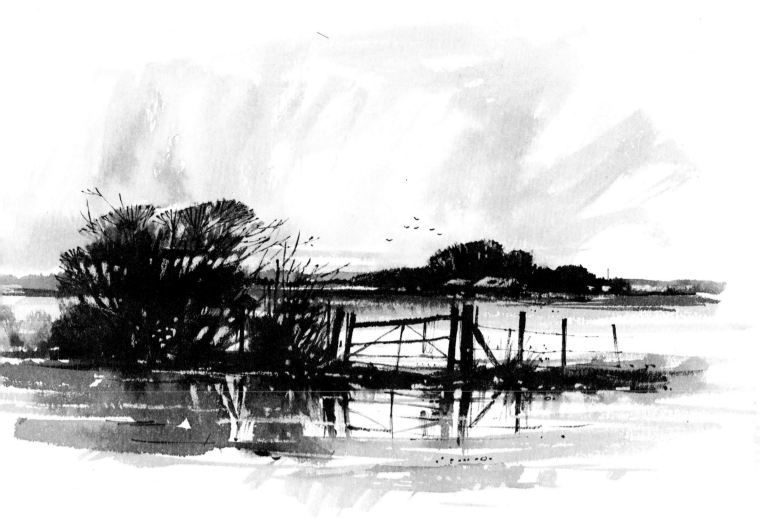

During very heavy rain the low-lying fields north of the Sussex Downs become enormous lakes, changing the character of the countryside overnight.

My watercolour sketch is at the time when everything becomes calm and quiet again after the storm has passed. I have tried to suggest this by contrasting a rugged sky with still stretches of water and unbroken reflections. The writing ink I use is black and dilutes to very pleasant tones of grey. It handles extremely well for spontaneous sketches or finished work. I use it a lot.

A partially open farm gate always attracts me. Each one has its own character, texture and colour, and the shape of a barred gate reflected in water forms a fascinating pattern of varied angles.

I begin my sketch by lightly drawing the composition with a pencil. The next step is to lay in the middle tones of clouds and fields, leaving a lot of white paper. The brush is lightly dragged across the surface to suggest a sparkle on the water. When this is dry I fill the brush with plenty of diluted ink and indicate hedges and trees. The final touches of gate and posts are drawn in with a small brush. For twigs, birds, and fence wire I use a fine tip nylon pen. In all my drawings and paintings I am concerned with achieving an effect of light, distance

Medium Writing ink on watercolour paper
Size 10 × 7 in.
Title **Winter floods—Sussex**

and atmosphere. In this painting I have shown light by leaving a large area of white behind the gate and including a much smaller streak on the distant fields—strategically placed just above the opening of the gate. When water is included I try to get the quality of reflected light, movement and wetness. To develop your observation go out next time it rains and afterwards paint an impression from memory without any references. That is how this painting is done.

Boatyards always fascinate me and have enough interesting subjects for several pictures. The stretch of river at Littlehampton is no exception. A busy yachting and fishing port, it is always crowded with craft of all types. I enjoy going there to draw or just watch the activity. The river is tidal and the harbour entrance is just a few hundred yards from this spot so the water flows swiftly with strong undercurrents. I have endeavoured to show this movement in my watercolour.

The subject appealed to me because of the interesting textures of the boatyard and the reflections being broken by a swift flowing tide. It also set a problem of how to unify them all. One way of achieving unity is by repeating shapes, and I decided to concentrate on this. The sheds, boats and reflections are very forcefully repeated verticals and could quite easily dominate the composition, were it not for the large horizontal signboard. Horizontal movement is repeated on the surface of the water and boat hulls and acts as a counterbalance to the verticals. The time to assess whether a composition is satisfactory or not is when you are at the drawing stage, and as the watercolour progressed I was glad I had solved some of the problems at the beginning. But I had yet to tackle the water. The river was moving swiftly with clearly reflected images, and the ripples were quite strongly textured. Most of these I wiped out with a brush full of clean water which I then blotted with blotting paper.

A common mistake among students is to place too much emphasis on ripples and lines on the surface of smooth water. The result is unconvincing. Lessening the emphasis is much more subtle and harmonious. There were many more reflections than I have shown but to include them all would make the scene far too fussy. Learn to be selective. Painting water is no exception.

The tarpaulin hanging from the shed sign adds an interesting touch: notice how the curves of the folds are repeated in the mooring lines —a further example of harmonious repetition of similar shapes. As I have previously worked as a designer I was tempted to make a neat job of the lettering on the fascia-board, but decided not to. It would have been out of keeping with the character of the boat shed and have been much too dominant. I added another window inside the shed to the right: the small area of light here counteracts the larger area of darkness and gives interest to an otherwise blank space.

The watercolours selected were:

burnt sienna light red
raw sienna ultramarine blue
cobalt blue

Medium Watercolour on watercolour board
Size $9\frac{3}{4} \times 6\frac{3}{4}$ in.
Title **Boat yard, Littlehampton, Sussex**

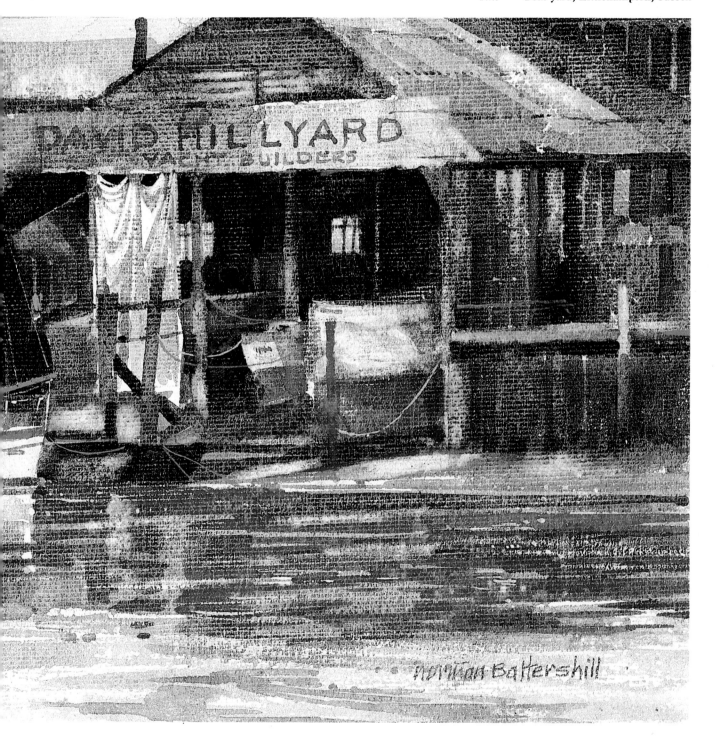

This fascinating contrast of wet mud, moving water and wharfside immediately attracted my attention for a study. I did several charcoal sketches on the spot but the effect of light seemed elusive, so I took a photograph for reference in the studio.

The detailed reflections are complex and required a methodical approach to get the tone values right. Careful attention to perspective and composition was also necessary, but I had solved most of the problems by preliminary site sketches. Establishing the middle tone first provides a tonal key against which all others can be judged. There are, however, no rules; I often begin a watercolour with the darkest parts, to establish quickly the contrast of light and dark. When the general tones are worked out the effect of light starts to become apparent. At this stage further progress must be considered.

A painting is often spoilt by adding too much detail in the final touches. The contrast of ripples and stones and the effect of light is the main theme of this subject, and I took care to retain my original purpose.

A few more stones and some pen drawing on the wharf completes the painting.

Medium Writing ink on watercolour paper
Size Actual size
Title **Underneath the arches**

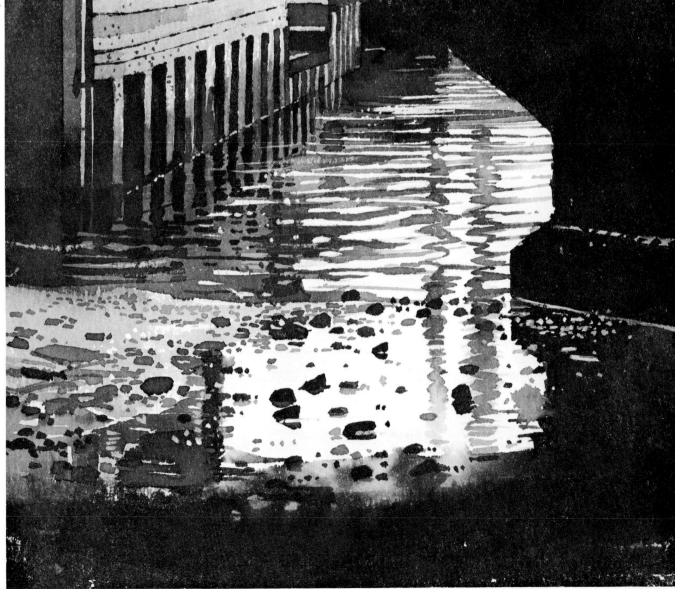

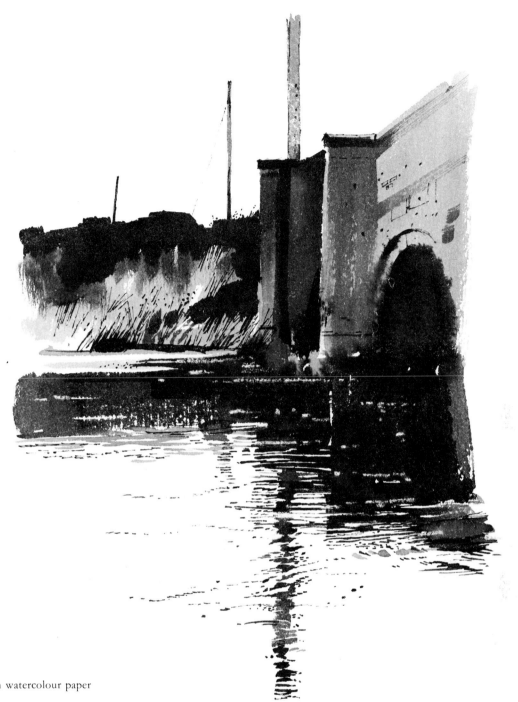

Medium Writing ink on watercolour paper
Size Actual size
Title **Bridge, Dorset**

I thoroughly enjoyed doing this monochrome study. It was a good exercise in composition, tone and surface texture. Paintings do not always have to be in colour to be interesting.

Earlier in this chapter I mentioned that the tone of sky reflected in water is usually darker than the sky itself. But in this painting I have left white paper for the sky and water and it works—creating a feeling of reflected light. We have already noted that reflections can dominate a painting, because of their bold patterns and broken lines. To counteract these there must be strong areas of deep tone and positive shape, unless, of course, you intend to make reflections the main theme. You can see how the rich tones of the bridge, poles and riverbank balance the forceful pattern of reflections. Swirls and ripples are drawn with a brush and pen in a variety of shapes and textures, each mark considered before it is put down. I have deleted all the tones on the water except for the darks to get maximum impact.

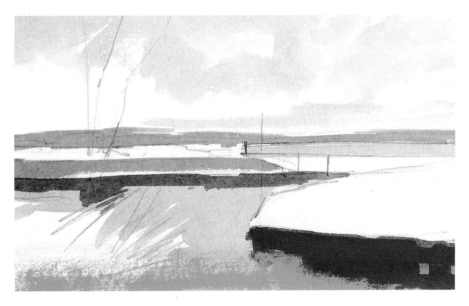

DEMONSTRATION: Watercolour and gouache on watercolour paper.

Step one

The combination of watercolour for transparent effects and gouache for opaque effects can be used to advantage. Designer's gouache is of finer quality than poster colour, and mostly used in commercial studios. Mixing white with watercolour has a similar effect, but is rather extravagant.

The composition is drawn in with a 2B pencil, leaving out all detail until last.

A wash of pale ultramarine is laid over the sky leaving patches of white paper for clouds. I begin to combine the watercolour and gouache at this stage.

Step two

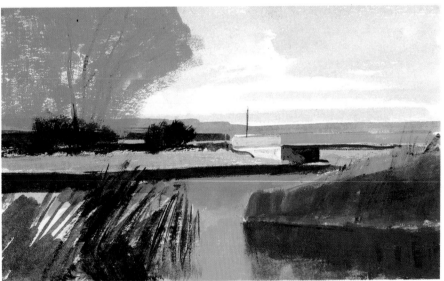

The dark tones now have to be established so that I can judge the overall effect against the sunny parts. The position of the sun must be determined to get all the shadows going in the same direction, and also the light on the bridge. Some of the colours will need strengthening but I leave that until the final stage.

Final stage

As the picture is nearing completion I can add some detail of fences and foreground reeds etc. It is very easy to carry on too long with a painting so I emphasise only the detail that matters.

The opacity of gouache is very useful for strengthening the effect of light and shade, and here I use it to good effect with final touches to the bridge, water and river banks. To retain luminosity in the sky the original watercolour wash has been left untouched. With a few touches of highlights the painting is completed.

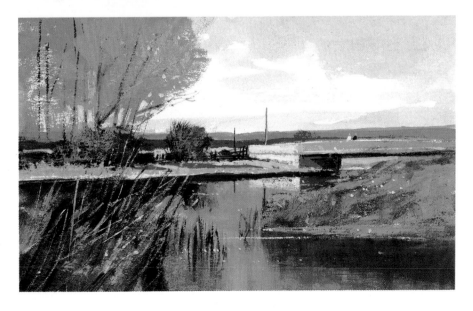

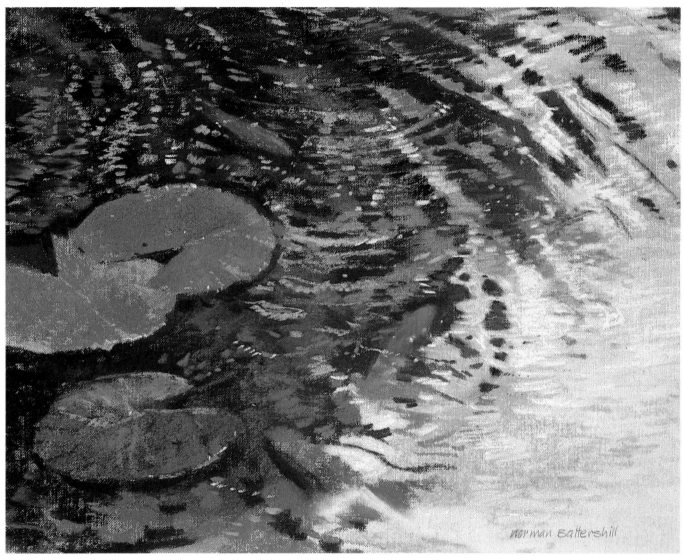

Medium	Pastel on canvas board
Size	24 × 18 in.
Title	**Goldfish**

I did this pastel in the garden of a Jacobean manor in the Cotswolds. This is a difficult subject because of the problem in showing the reflected light from the sky and depth in the water. The splash from the fountain created ripples which form a delightful pattern of broken light and shadow. The subtle curves of the ripples are repeated in the ellipse of lily pads. As I sat very still the goldfish came to the surface and I was able to add the beautiful orange colour.

The canvas board is textured and to get the necessary build-up of colours without the pastel lifting I sprayed the various stages with aerosol fixative. The lily pads are the main pattern of the picture, and I have to be careful in placing them to balance the composition.

After I had sketched them in I established the dark colours in a mass, so I could more easily judge the design and weight right at the beginning. Getting this part correctly balanced was the most critical part.

As you can see I have used small touches of colour to suggest vibrancy of movement.

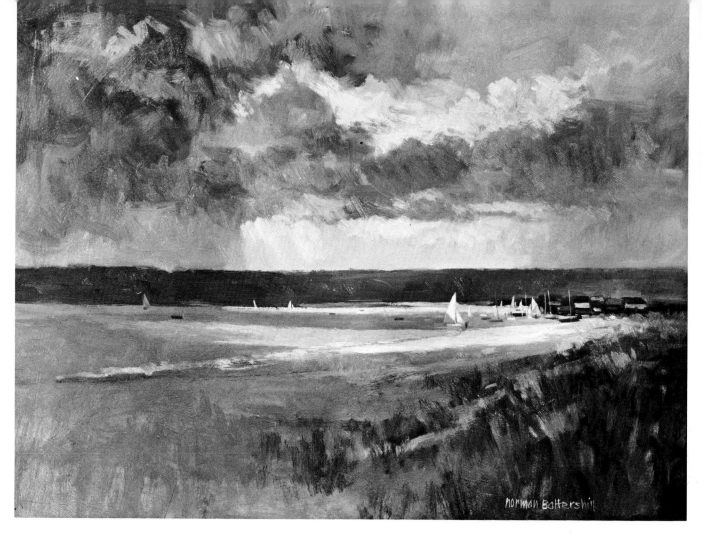

The sea reflects light from the sky with varying intensity, depending on its surface texture and prevailing cloud conditions. This painting illustrates the effect of cast shadows, cloud reflections and reflected light.

The colour and tone of an overcast sky is reflected on the sea. One very dramatic effect arises when the sea is almost black from storm clouds overhead and a strip of sunlight gleams like silver in the middle of it. I live only a few minutes from the sea, and have seen this marvellous sight on many occasions.

The placing of an accent of light, or a shadow is not haphazard. It must be natural and fit in with the balance of the composition.

There are two 'highlights' in this painting—the far strip of reflected sunlight on the sea and the nearest sail. Sunshine also falls on the close foreground but is less intense. Hard edge contrasts between shadow and light do not suggest aerial atmosphere. Softened edges do.

In the top left hand corner of this illustration the camera has picked out the glint of varnish on texture and made it appear lighter in tone than it should be. It is not an error on my part.

Brushwork is as important to a painter as his handwriting; the mark of a brush is similarly expressive and individualistic. Here I have used vigorous brushstrokes to suggest movement in the sky, and the texture of the dune grasses.

My colours for this painting were:

ultramarine blue	cobalt blue
cadmium red	cadmium yellow
burnt sienna	yellow ochre
titanium white	

Medium Oil on canvas
Size 30 × 24 in.
Title **Sailing club**

For the dark area of the sky I mixed ultramarine, cadmium red, burnt sienna and titanium white. By adding cadmium yellow and yellow ochre I then had a general colour of the sea.

Cadmium red and burnt sienna are strong colours and only a touch is needed to change the other colours. The sand is a mixture of yellow ochre, burnt sienna, cobalt blue, cadmium red, titanium white.

Here's my favourite writing ink again. It really is a delight to use.

I saw this ketch off Poole Harbour and made several drawings of it. This painting is from one of them. The white sail of the distant yacht is an important part of the composition. Although the ketch is sailing out of the picture your interest is brought back in again by the tiny patch of white against a dark background. Both writing ink and watercolour are quickly absorbed on cartridge paper (drawing paper) and therefore the amount of blending you can do is minimal but it is possible if you work quickly, as you can see by the sky in my painting.

Any material or medium that encourages directness and spontaneity is worth trying—the lesser quality papers often have a very sympathetic drawing surface. Some children's sketchbooks are worth seeking out.

Medium Writing ink on cartridge paper (drawing paper)
Size 7 × 5½ in.
Title **Calm before storm**

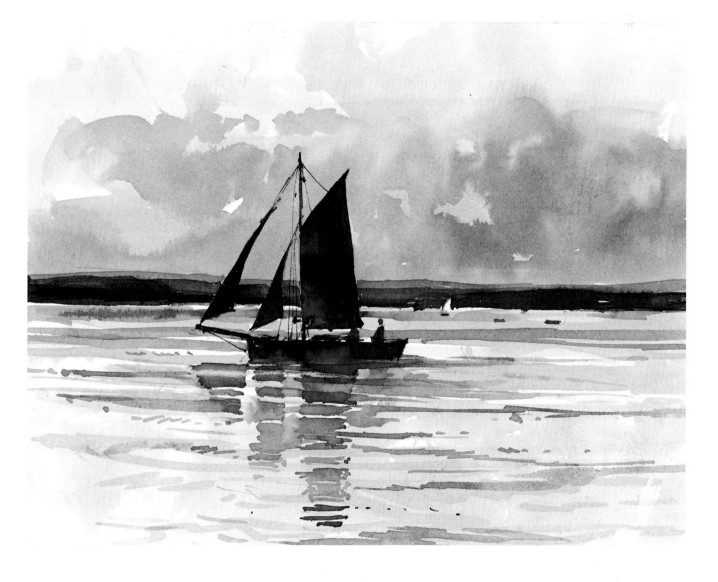

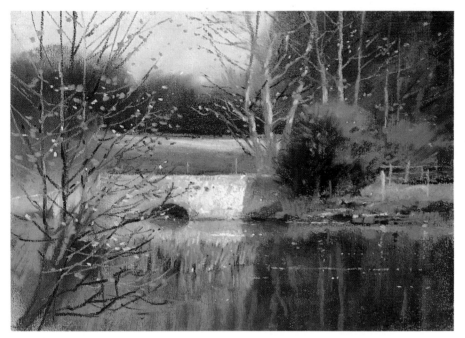

Medium Pastel on grey pastel paper
Size 20 × 16 in.
Title **Spring morning, Sussex**

Accent of light

The warm light on the weathered bridge and the still pond is the principal attraction in a tranquil setting of trees and fields. Reflections from the bridge illustrate the interesting fact that the reflection of a light object is darker than the object itself, reflection of a dark object is lighter than the object itself. This is particularly noticeable with boats on calm water.

For my pastel paintings, I normally lightly indicate the main shapes with a charcoal stick—if I make a mistake it can be dusted off. The first consideration before colour is to get the tones right. Sometimes I block in the dark tones with charcoal then fix it and work over the top with pastel. With a subject like this it is tempting to overstate the intensity of sunlight on the bridge. If the tone is too light, though, it will look unconvincing and out of place. The shadow must not be too dark, or it will not relate to the sunny part. Spending a lot of time looking at your subject and defining tone values is more beneficial than rushing into colour without thinking.

When you paint outdoors make sure you take account of a possible change in the weather and light. If I am in doubt I roughly indicate the accents of light during the early stages of the painting and keep to that. Constant alteration can only lead to confusion and lack of conviction. Charcoal and white pastel can be used to show shadow and sunlight before you start to paint. You then have a sound basis to work on.

Whether you paint the sky first or last in a landscape is a matter of choice. But if the scene has water in it, it is preferable to lay in the sky first so that you can more easily judge the tone of the water—the most critical part of your picture.

Completing the sky before the rest of the painting is developed does not allow any room for adjustment. I generally put in the sky quite loosely with a rough indication of the landscape and then progress with the painting as a whole. This way sky and landscape are unified in tone and colour. I leave painting water until last, as tone and colour must be exact and properly related to the sky. Because the surface of water is shiny and reflective it is easy to misjudge how dark it really is; but if

Medium Pastel on pastel paper
Size 16 × 12 in.
Title **Early morning**

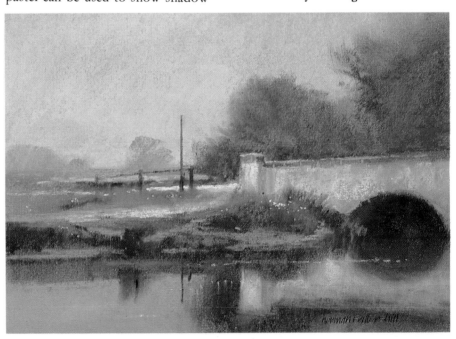

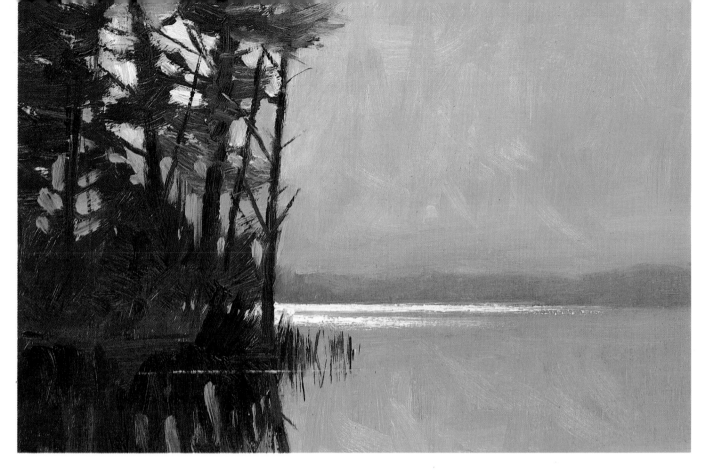

continued

the water is painted too dark it will look like a hole. By making the water slightly darker than the sky the tone value will generally appear to be correct. Remember too that the reflection of the sky is duller than the sky itself. If the reflection is too bright it will lessen the illusion of water by becoming assertive.

There is often confusion as to how far below the water line an object is reflected. As a very rough guide, you can take it that the reflection is as far below the water line as the object is above it — that is, the object and its reflection are more or less equidistant. Exaggerating the length and proportions of reflections can, however, benefit a painting. What matters most is whether it looks right.

Medium Oil on canvas
Size 24 × 15 in.
Title **Moonlight**

My picture is from a pencil sketch I made in the Lake District while on my way to give a painting demonstration. I didn't think much of the sketch at the time: it seemed too simple. But by creating a specific mood the sketch has evolved into a painting of substance.

Tone values and shape in the foreground are unaffected by the misty atmosphere of the distance, and the contrast of light and dark tones helps to create recession. The moon behind the trees is not visible as a positive shape, but the glow tells you it is there. The flash of light is more important in this instance than the moon so that is where I've placed the emphasis.

I used only a few colours for this oil painting:

cadmium red burnt sienna
ultramarine yellow ochre
titanium white cobalt blue

I first of all established the darkest trees with a mixture of ultramarine, cadmium red and a slight touch of titanium white.

I avoid using too much white in the early stages of a painting because it can become chalky.

For the sky I mixed cobalt blue, ultramarine, cadmium red and a touch of yellow ochre, with white. At about the half-way stage I added the streak of light to the water so that I could judge how dark the colours should be to create a contrast.

This is a method I apply to similar subjects. It minimises adjustment of tone in the last stages of the painting.

I have added this drawing to the end of the chapter because I think it says all there is to say about the wonderful abstract patterns of reflections. The design here is not an exaggeration, but an accurate recording of the observed image. As we have seen, movement of smooth water can distort and extend a reflection out of all resemblance to the object reflected. I have eliminated every other detail to extract that part which interests me most. It is difficult to imagine what the object is in this drawing. You may like to know the answer to the puzzle.

At the top is the reflection from the bow of a boat. The long undulating line is the mast and the much thinner line is the reflection of rigging from mast to bow. To appreciate the pattern and balance turn the page upside down and also horizontally.

Medium Carbon pencil
Size $7\frac{1}{2} \times 4\frac{1}{2}$ in.
Title **Abstract reflection**

4 Shallow water

Shallow water does not in itself offer an extensive range of subjects, but there are possibilities for painting rather different themes from those of the usual landscapes. For instance, pools of water left between rocks by the ebbing tide can provide any number of different formations and a variety of marine life. It is my ambition one day to paint a large canvas of a tidal pool.

Streams are very various in character. Every few yards the texture can change from smoothness to ripples, from shadow to light. Flowers and grasses bedeck the banks, sometimes trailing in the stream. And there are many other subjects to be found if you think imaginatively. A close-up detail of stones in shallow water with light reflected on to the bottom is a difficult but fascinating theme, which has great charm. Mud flats are not the most painterly of subjects, but with a sheen of shallow water reflecting sunlight the mundane is transformed. Add a boat and you have the possibility of an interesting painting. Wet sand from the ebb-tide and children paddling is a familiar scene. River shallows are another source of subject matter.

One of my favourite subjects is a country lane or track after the rain. Puddles and textures are plentiful. Colours are deeper and richer when it has rained—like a varnished picture. Some of the most enjoyable times I have spent outdoors have been during the winter months walking muddy lanes and fields. And a humble back garden patch of water has painting potential. Bird baths and reclining nudes in domestic baths have all qualified as painting material. There are many more subjects which a person with developed powers of observation can perceive. The common denominator with all of them is light—natural or artificial, and how it strikes shallow patches of water.

One of the problems in painting clear shallow water is to show both the bottom, and the reflected light on the surface. One method of doing this is to paint the bottom first, and then apply a thin stain of diluted colour over the top, allowing the first colour to show through. Another method is to apply a semi-opaque layer of paint over the transparent underpainting, allowing some of the underpainting to show through.

As pastel is a dry medium, glazing is not possible; my pastel painting on p. 89 explains how transparency was achieved.

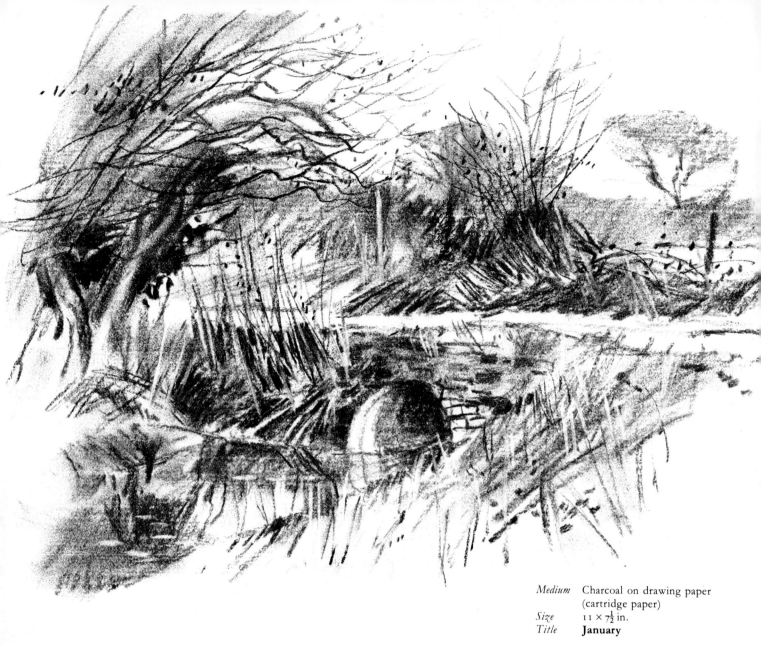

Medium Charcoal on drawing paper
 (cartridge paper)
Size 11 × 7½ in.
Title **January**

Just over the bridge the stream emerges into a vast expanse of sky and very paintable countryside. It is one of my favourite areas and I have done a great deal of drawing and painting there for many years. I never get tired of seeing this same corner. Each time the surrounding atmosphere is different. One day I would like to start a series of paintings just following the stream through fields in all seasons.

My charcoal drawing was done on a January morning. The arch of the culvert and the still stream contrasted with the spiky twigs, reeds and branches of winter. The sky was overcast with a flat light that gave little contrast of light and dark, but I did not 'make up' any effect of sunlight and shadow, preferring to be true to what I saw. Lack of atmosphere outdoors can be rectified indoors if it is decided to make a painting from a sketch. Dull weather is no reason for not getting out to do some drawing.

Nature often provides compositional elements which need little alteration, and this drawing of a muddy field is an example. By raising the horizon line I can emphasise the composition and make much more of the rain-filled furrows.

The design has impact because there are only a few main lines of composition. When you are drawing outdoors first establish the main shapes. If too much time is spent drawing in the expressive verve can be lost. I drew this sketch directly. I try to make each pencil mark work for itself by describing shape, texture and tone.

Rugged pencil marks are my way of expressing how I feel about the subject. Your approach may be different. Drawing a subject like this on pale blue paper is an advantage because the colour can suggest reflected light. As the furrows extend into the distance detail is omitted from the surface of the water, emphasising recession. Because the water is muddy we cannot see into it, except from a position in the foreground looking directly down, where I have indicated some stones. A close-up of a furrow filled with water is going to be one of my future subjects for a big canvas.

Medium Carbon pencil on blue sugar paper
Size $9\frac{1}{2} \times 6\frac{1}{2}$ in.
Title **Muddy field**

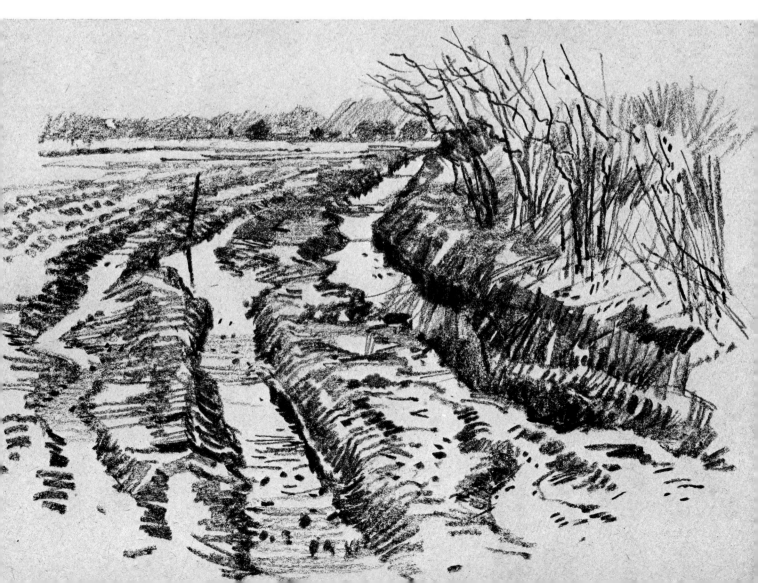

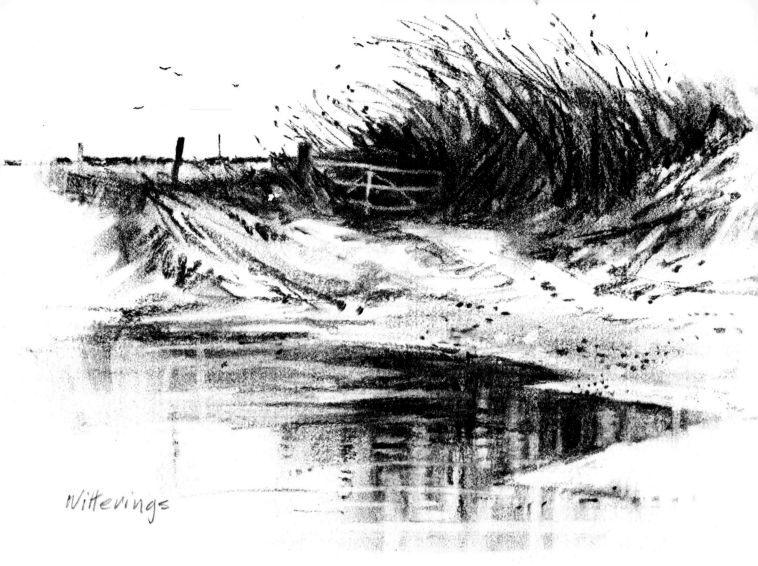

Witterings

Light on shallow water

The Witterings is a stretch of sand
dunes tufted with grasses, and
shallow pools formed by seepage of
the sea at high tide. It is a desolate
area in winter but full of
atmosphere, a calm combined with
the sound of marsh birds.

There is an abundance of painting
material in this area and sometimes
it is difficult not only to select a
subject but to decide which part of
it is most important. I finally settled
on this aspect to illustrate our
subject of shallow water. But
although the pool interests me as a
subject it forms an integral part of
the landscape and is not the main
feature.

The pool occupies nearly half the
total area of the drawing but is

prevented from becoming too
predominant by the gate and shrub.
The dark line of distant hedge and
pole create a feeling of recession.
Creating distance in landscape is
often critical to the balance of a
composition. Cover up the distant
hedge and you will see that the pool
becomes much more important.
Balance of tone is, as ever, essential
to the harmony of this picture. The
dark shrub on the right counter-
balances the dark tone of the pool,
and the gate is a contrast of light
against dark.

By using charcoal for drawing
outdoors you have the chance to
make alterations by dusting it off.
But a firm mark stains the paper,
and cannot be removed with a

Medium Charcoal on cartridge paper
(drawing paper)
Size Actual size
Title **Pool, Witterings**

rubber. For my sketch I use a stick
of thin willow charcoal, and a putty
rubber to lift out highlights and
light tones, such as the gate. The
distant pole is drawn with a charcoal
pencil.

Areas of untouched white paper
create an essential contrast to areas
of tone and create the effect of light.
The distance in my sketch is
accentuated by dark against light.

74

Rain puddles are a favourite subject of mine and I always look out for them along the nearby shore or open countryside. My drawing here is of a stile and cattle fence at Pagham Harbour. The silhouette and curving track make an interesting composition.

Medium Carbon pencil and white chalk pastel on grey pastel paper
Size 8 × 6 in.
Title **Pagham, Sussex**

The day I did this sketch the sky was overcast and the landscape looked flat and dull. The track was muddy but without puddles. When I finished my sketch it looked rather flat and uninteresting because of the lack of contrast, but I decided not to throw it away. Back in the studio I looked at it again. What the drawing lacked was the effect of light so instead of creating light and shade on the landscape I added puddles to the cattle track. The effect was immediate, and I was very glad the sketch had not been discarded. I did

all the pencil drawing first, and then fixed it with charcoal fixative. Soft chalk pastel was then applied over the top, without it becoming a grey smudge. I wanted to add some final pencil touches so I fixed the pastel and drew on top of it. Carbon pencil is not easy to rub out because it can smear, so the drawing had to be direct.

I use this technique a lot for sketching. It has the advantage of a complete range of light and dark tones, from dense black to solid white.

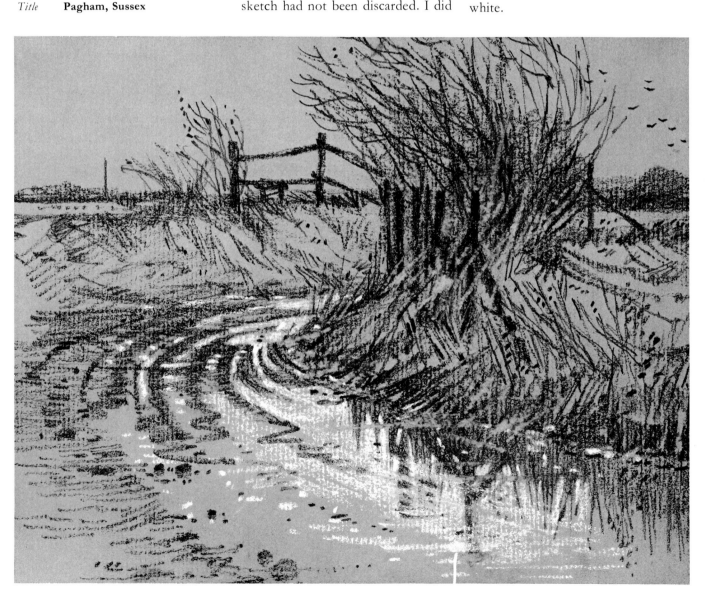

DEMONSTRATION: Charcoal on cartridge
paper (drawing paper)

Step one

The reflection of an evening sky in
wet sand is a fascinating subject for
its tonal values and subtle colours. I
have selected charcoal because it is
ideally suited to atmospheric
impressions. The composition is so
simple I only need a few lines to
indicate the main shapes.

The distant hills are smudged lightly
with paper tissue to indicate tone
values.

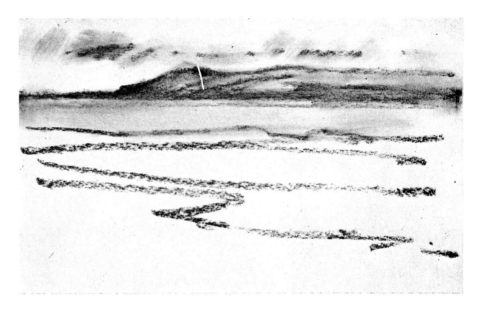

Step two

Darkening the sea emphasises the
light on the shallow water in the
foreground, and also the sky.
Getting the tones balanced is very
important to achieve a sense of
subdued light, as in the evening sky
illustrated here. I leave the patch of
wet sand and the waves until last
because they are critical to the total
effect. Charcoal is applied liberally
and then smudged with paper tissue.

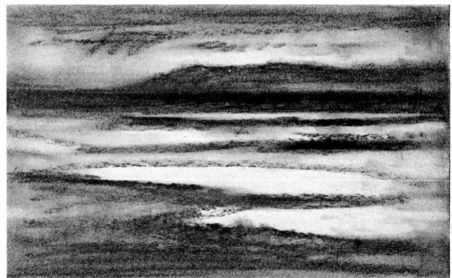

Final stage

A common error in some seascape
paintings of dusk is that the waves
are shown much too white. This is
not possible, as there is no direct
light; at this time the sun has almost
disappeared over the horizon, and
the wave crests are at an angle away
from the source of light. The
brightest part is the reflection in the
wet sand of the pale light in the sky,
and that is confined to a small area.
You will notice how all this part has
been toned right down.

I achieve the effect of wet sand by
lightly smudging the pebbles. The
charcoal drawing has possibilities for
an atmospheric painting.

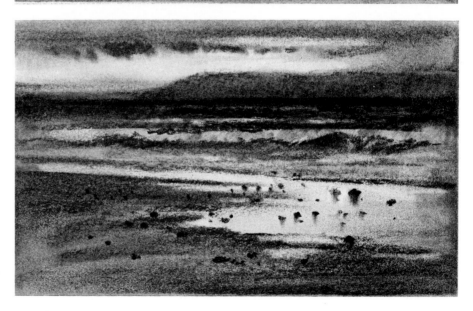

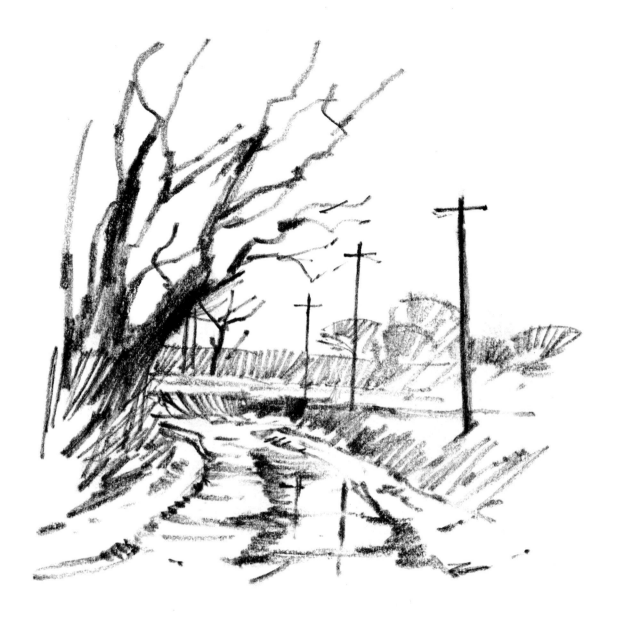

Medium Carbon pencil on cartridge paper
(drawing paper)
Size Actual size
Title **Winter**

When you are drawing outdoors try to think of what you see as masses instead of outlines. Sometimes, I am concerned with the detail of a subject as with the illustration *Muddy field* on p. 73, but my first reaction to a subject is to see it as descriptive shapes.

My outdoor sketch here is an example: I have not consciously tried to make the trees look like trees but consider them as shapes. They are very much simplified but

show the character of trunk and branches.

When I rough out a painting I draw with a brush in a similar manner. The sketch only took a few minutes but has enough information for a painting. My painting demonstrations of up to 3 ft × 2 ft canvases are invariably from small pencil sketches. I myself don't make any colour notes. Consistent drawing and painting outdoors over many years has developed my observation and memory to such a degree I can visualise a black and white drawing in colour. But if you

wish to make colour notes here are three methods:

1 Written abbreviations of colours, i.e. DB = dark blue, LG = light green etc.
2 Appropriate patches of colour crayon or pencil to grass, trees, sky etc.
3 Written descriptions — pewter sky, jade sea, rusty colour etc.

The best way to develop a good colour memory is to constantly observe colour, light and atmosphere, and paint from tonal sketches. It's tough, but it works.

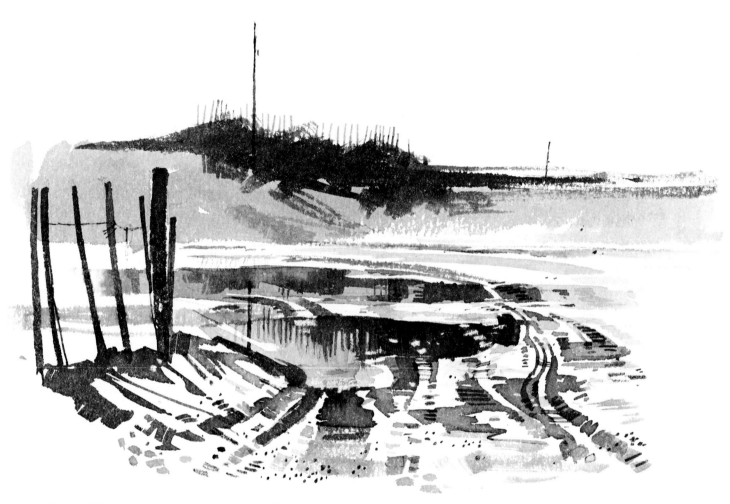

Medium Watercolour on watercolour paper
Size $9\frac{1}{2} \times 6$ in.
Title **Car park**

The pattern of tyre marks and pools of water transforms this car-park entrance into a very interesting study of shallow water and reflections. We can pass a place many times a day without noticing it until certain conditions make it look completely different.

For my painting I used a square nylon brush and sepia watercolour on Bockingford 140 lb watercolour paper.

The entrance to the car park is on a very busy main road and it's impossible to paint from a safe vantage point, so I took a photograph and worked from it in the studio. I have changed the actual view a lot, but kept the pattern of tyres and puddles. A cement lorry was parked on the right and the distant paling fence and pole were not there at all. But by deleting one and adding another the composition becomes much more interesting.

The rutted ground formed a complex pattern which needed simplifying to avoid fussy detail, and I also enlarged the pool of water.

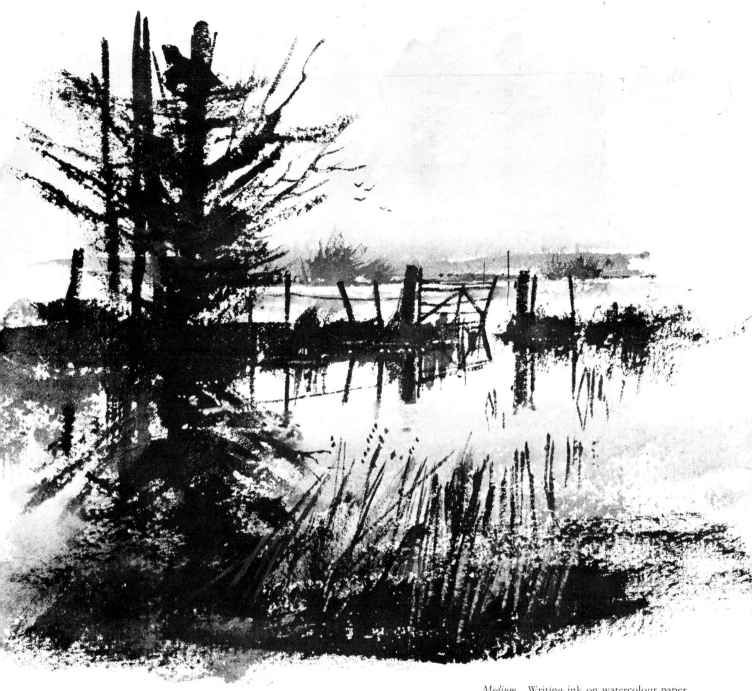

Medium Writing ink on watercolour paper
Size $6\frac{3}{4} \times 6\frac{1}{2}$ in.
Title **After the storm**

For this illustration I have used blue-black writing ink on Bockingford 140 lb watercolour paper. The watercolour is from my imagination, sparked off by the idea of trees and an open gate silhouetted and reflected onto water.

The effect of top-lighting is suggested by the sky being a darker tone than the water; the brilliance of the water is emphasised by the dark sky. This kind of lighting occurs when the source of light is very strong and high overhead. In some areas the paper is left untouched to give the maximum impression of reflected light.

The texture of the paper is ideal for the dry brush technique and I have used it extensively here. It gives sparkle and directness well suited to the subject. The foreground is a bit spiky, but if the ink is wiped out it leaves a purple stain which wouldn't help, so I left the grasses as they are, and remembered not to overdo it next time. A leaning twisted farm gate makes an interesting angle against the near vertical posts. I avoid making my gates and fences too tidy, I want them to look as if they have been there a long time, battered by weather and cattle.

Rocky beaches are a source of many interesting and varied subjects. The first consideration from a practical point of view is to determine the direction of the tide. In no time at all you can be surrounded by deep water and a risky escape route on slippery rocks, so watch the tide. A camera with a zoom lens is useful, as you can take pictures from a safe distance. Side lighting is preferable to top lighting because there will be a more interesting contrast of light and shade, so bear this in mind with photographs. Selecting a viewpoint and angle of interest is made easier by the use of a viewfinder.

For my painting I have chosen a close-up of the moment when the tide swirls over the rocks and fills a pool. By the time it takes to set up an easel I would have been ankle deep in water—so I took a photograph and did the painting in the studio.

Acrylics are ideal for painting shallow water. Because they dry so quickly transparent stains can be applied with minimum delay. The critical area of interest is the cascade of water and the pool it runs into. To emphasise these areas of light I have made the foreground darker than it really was in the photograph. I also re-arranged the composition by simplifying and eliminating a lot of detail, particularly heavy shadows to the rock on the right and clumps of seaweed.

The effect of water is left until the final stages, for the same reason given when discussing how to paint flooded fields; it is much easier to judge effect and tonal values when the painting is nearing completion. It is tempting to rush into painting water but success can depend on how well the groundwork is done. When the rocks are completed I dilute yellow ochre to a watercolour consistency and brush it over the pool. It is barely noticeable but slightly darkens the area of water. Over this is painted foam flecks — taking care to get the tonal value right. The foam in the photograph is much brighter and whiter.

On the slope of cascading water there is a subtle reflection of the sky.

Positioning of limpets and seaweed is critical because they are prominent. Highlights suggest wetness and add a touch of sparkle to complete the painting. The overall colour of this painting is sandy, which I achieved by mixing cadmium yellow medium, red iron oxide, yellow ochre, cobalt blue, ultramarine and titanium white. Yellow ochre is a very useful earth colour but because it is opaque and slightly chalky, too much of it reduces the brilliance of other colours. A lot of the colours in this painting are applied thinly to achieve the effect of transparency.

Medium Acrylic on canvas board
Size 15 × 10 in.
Title **Tidal pool**

Problems with composition

Water and reflections positioned almost on the lower edge of a picture cause composition problems because interest is immediately drawn there. I have employed several methods to ensure a balanced composition. The first was to almost complete the painting before considering the water filled track which I had roughly indicated at the laying in stage. By then all the important tones and effect of light had been established, so I could more easily judge how dark the reflections needed to be.

To prevent the track moving out of the picture I made the outer parts darker and contained interest by the light reflected on the water surface. Reflections from the central trees are light in tone and loosely painted, without any positive detail or outline, whereas in the actual scene all the reflections were clearly defined. An impression often conveys more than a positive image. When I had finished painting the water and merged it into the landscape I felt that some idea of scale was needed, so I included the

post and a patch of rich dark shadow. You will notice that the post also has the effect of taking your interest into the picture across the fields. The band of sunlight is much lighter in tone than anything else and is the anchor of the composition. I added it last of all as the final accent and statement.

Medium Oil on board
Size 30 × 24 in.
Title **Autumn**

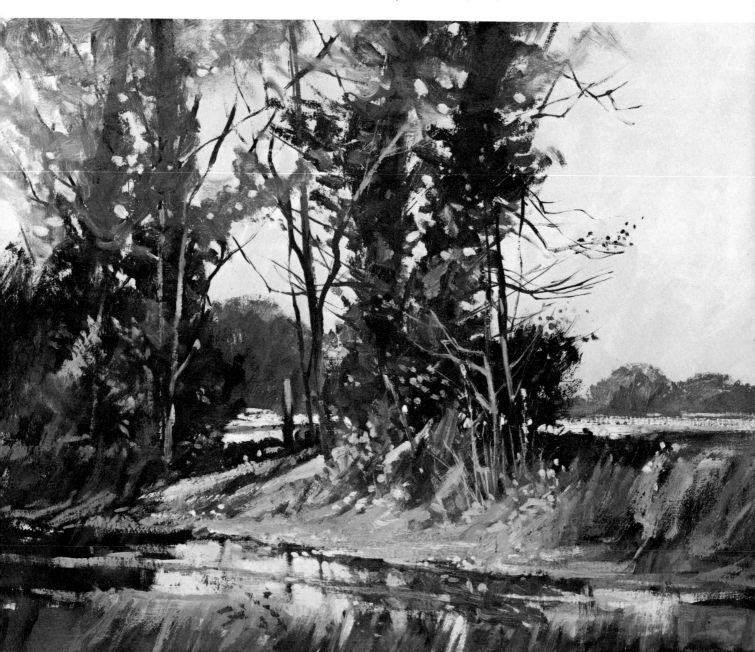

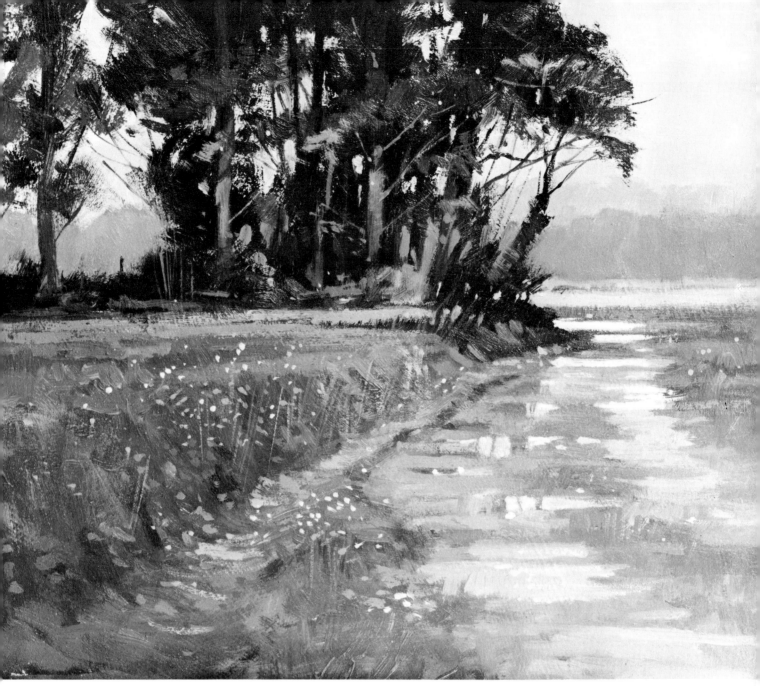

Medium Acrylic on board
Size 30 × 24 in.
Title **Trees and puddles**

The morning I painted this picture
it had been pouring with rain and a
damp mist still shrouded the
landscape. Distant colours were
muted to a warm grey and soft light
from an overcast sky lay across
wet fields. An ideal situation for
painting. It is interesting to compare
this picture with the one opposite
because the effect is so similar
whether the subject is painted in
acrylics or oils.

The track in this illustration leads
into the painting and the composition
is much less complex than that
opposite. Horizontal pools of water
balance the strong angles and
verticals of the trees in a rhythmic
pattern of repeated shapes. In
planning a picture I make sure all
the elements are related. The
puddles, for instance, could look like
shell holes, but by relating the tones
with other parts of the painting they
take a proper place in the order of
things. Cover up the dark trees and
you will see how the rest of the

landscape has an arrangement of
similar close tones. The painting on
the facing page has much more
contrast of tone because the light
from the sky is brighter, and colours
are not affected by a grey veil of
mist.

Compare the background trees in
both pictures. You can see the
difference in the effect of light and
atmosphere. Backgrounds occupy a
very small part of the scenes but are
essential for creating mood. Water
occupies a much larger area in this
painting but does not dominate it.

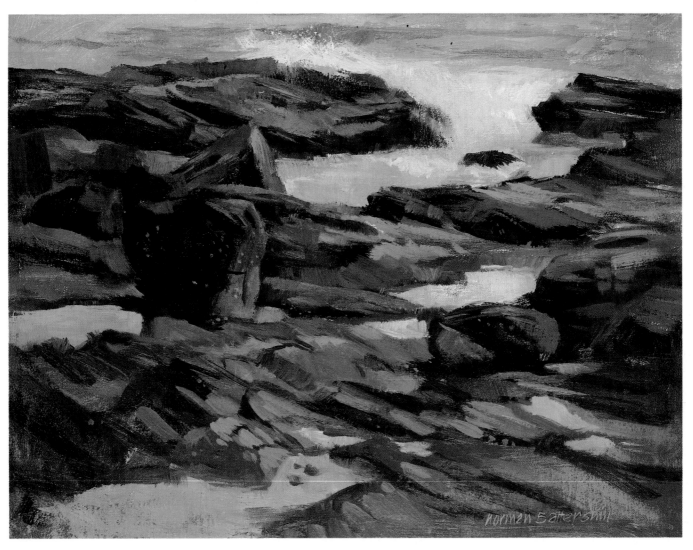

Medium Oil on canvas mounted to board
Size 22 × 17 in.
Title **Rock pools**

When I set up my easel at Lamorna Cove on a bleak February morning I wasn't at all surprised to find the beach totally deserted. But by the time I had got half-way through my painting a crowd of people materialising from nowhere stood watching me and taking snapshots. 'Fame at last' was my hopeful reaction. But the more rational explanation was that only an artist would be fool enough to stand in the same position for hours in such adverse conditions. I stayed in a coastguard cottage and painted on the beach every day for seven days. I learnt a lot from that.

I establish the general tone of the rocks first, diluting the paint with turps. The colours, without white, are: yellow ochre, burnt sienna and ultramarine. Darkest shadows follow next. I determine the contrast of light and dark, and the direction of light. The general colour of the sea is a mixture of yellow ochre and ultramarine with a touch of white, painted thinly. When the general colour scheme of the sea and rocks is established the movement of water must be recorded before the tide recedes out of the picture area. After this is done I make no attempt to alter it otherwise spontaneity will be lost. Light from the sky is reflected in the pools of water, and

consideration must be given to the tone values of each enclosed area.

Form and detail of the rocks are the last stages of the painting. As the picture progressed I added more colours to my palette which finally included:

cadmium red cobalt blue
burnt sienna ultramarine
burnt umber yellow ochre
titanium white

The painting has not been worked on or corrected in the studio at all. I want to leave it exactly as I painted it on the February morning in Cornwall.

DEMONSTRATION: Oil colour on watercolour paper

Step one

To prevent the watercolour paper absorbing too much oil from the paint I primed the paper with acrylic primer. Then I mixed ultramarine and cadmium red without the addition of white to block in the big shapes of the trees, path and horizon. Yellow ochre is mixed with these colours for the dull green. Next came the sky and the dusty purple of the distance. This colour is mixed from cadmium red, ultramarine and a touch of yellow ochre and white.

Step two

The painting is now developed into a colour scheme which sets the mood and atmosphere of an overcast wet day. All colours are muted and greyed by adding a touch of burnt sienna or cadmium red.

Yellow ochre, burnt sienna, ultramarine and white are the colours mixed for the foreground hedges and trees. Shapes of the puddles are indicated to determine a pattern in relation to the overall composition.

Final stage

I work on the puddles and the reflections getting an effect of light which brightens towards the diffused sun in the overcast sky. For the puddles I mix a combination of colours — burnt sienna, cobalt blue, yellow ochre and white. The posts and poles were added last.

The colours for this painting are:

cobalt blue	light red
cadmium red	ultramarine
burnt sienna	yellow ochre
cadmium yellow pale	

Getting the tone value of the puddles is critical so I leave the final touches of highlights until the very last stages of the painting.

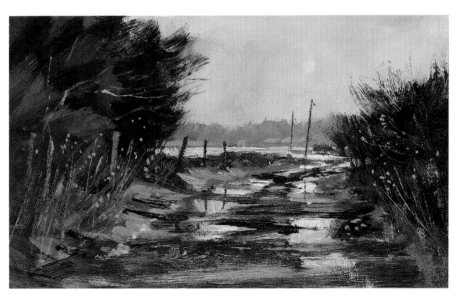

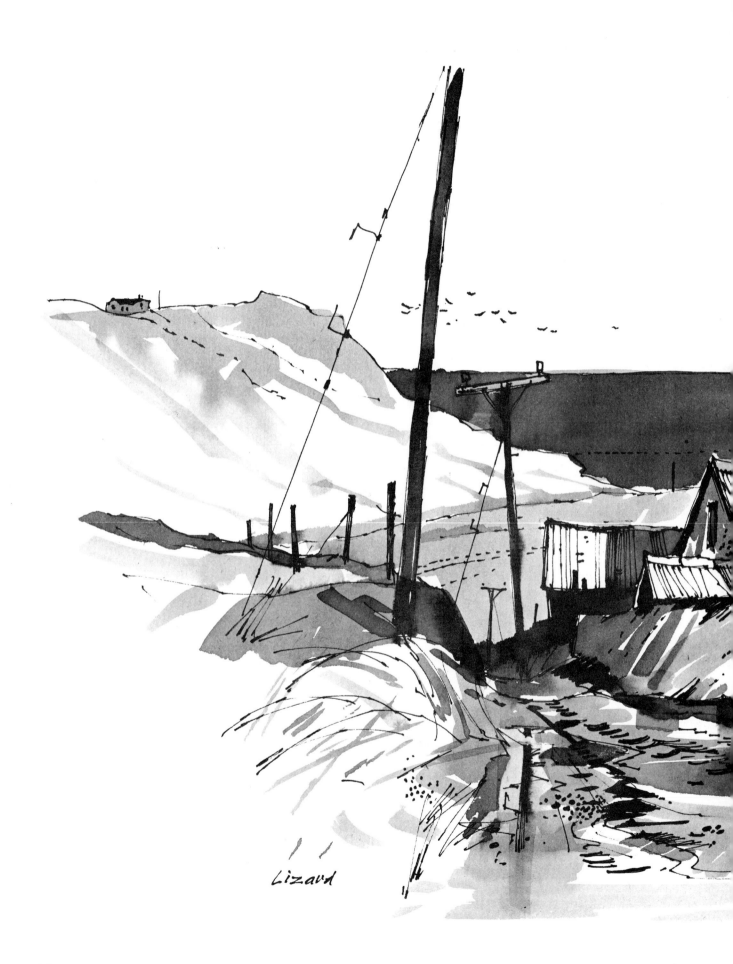

Lizard

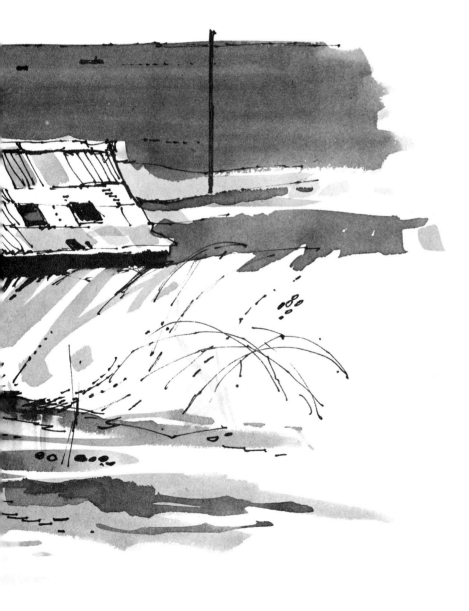

During February I stayed at a delightful little hotel in Cornwall and found enough painting material within half a mile radius to last me a week—there's still a lot left for my next trip.

This drawing is the kind of composition I like—compact grouping of curves and lines—lots of texture and plenty of movement.

It had just rained and water was pouring down the steep track making it glisten like a varnished painting. Colours were rich and dark beneath the film of rain water. The whole subject was very painterly.

It was also excellent material for drawing. The steep banks are a mass of curving brambles and spiky dead grasses, but I decided to minimise them to avoid over-fussiness. With any subject you have to decide what it is that interests you most. Here I am principally interested in the group of farm sheds, the track and poles, so all other detail is simplified into big shapes. The technique of line and wash on thin cartridge paper (drawing paper) must be direct, as its absorbency does not allow for the same handling as stout watercolour paper. You can see from the illustration that I have got the tones right first time. Superimposing too many washes of colour deadens the white of the paper and its transparency is lost. I left painting the track until last. By doing so I was more easily able to judge its tonal value against the rest of the picture. The tone of the lane is dark enough to suggest a wet and rutted surface and offers a contrast to the sunlit parts of the banks and sheds.

Medium Writing ink on drawing paper (cartridge paper)
Size 12 × 9 in.
Title **Wet morning—Cornwall**

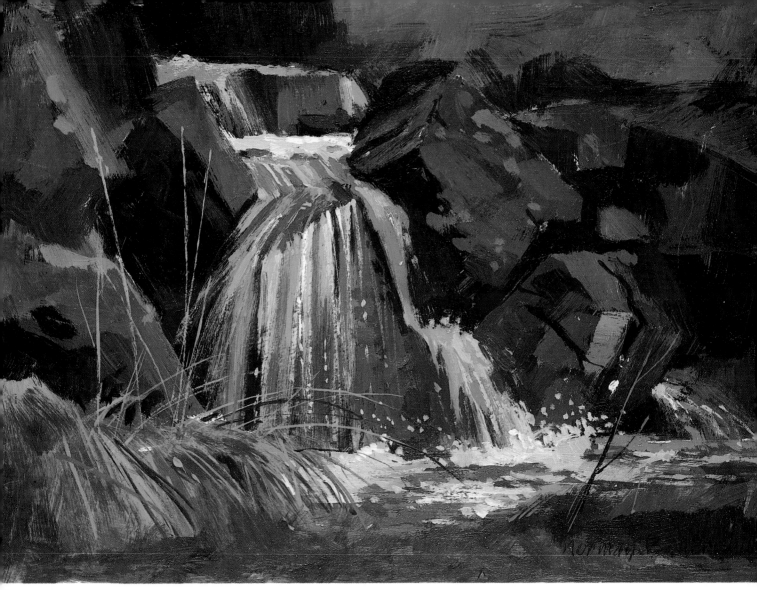

Acrylics and pastels for outdoor subjects

Medium Acrylic on board
Size 12 × 7 in.
Title **Waterfall**

The criticism usually levelled at acrylic paint is that it dries too fast for ease of handling. I have not found this a particular disadvantage and believe that the problem is easily overcome after a little experience with this versatile medium. The painting illustrated was done entirely outdoors in a stiff breeze and presented very few problems with drying. You can of course use an appropriate retarder to slow down the drying rate, or simply add more water, as I do.

I have included this painting as an example of water falling into a shallow pool. The pool occupies only a small part of the picture but the horizontal is an important counter-balance to the complexity of angles formed by the rocks and cascading water. Without the horizontal flat effect of the pool the subject would be too much of a jumble. Cover up the pool and you will appreciate how important it is to the main vertical fall of water. Paintings of moving water must have a calm area so that the eye can rest from the visual tumult.

What interests me most about the subject are the powerful angles, the peat colour of the water and its emergence from shadow into light.

I made the mistake of starting to paint on the white priming and quickly found out the tone values were going all wrong. So I stained the board all over with a diluted wash of burnt umber and started again. I now had a rich compatible tone to work on. It is tempting with a subject like this to concentrate on the water first, but it was developed along with the rest of the painting.

My colours are:

cadmium red ultramarine
burnt umber cobalt blue
yellow ochre burnt sienna
titanium white

Looking directly down into shallow water you can see the pebbles at the bottom, but as you look obliquely along the surface reflected light from the sky obstructs the view into the depths. To achieve the effect of transparency in the foreground I painted the pebbles first and then fixed the pastel with charcoal fixative. When this was dry I lightly rubbed a grey pastel over the top, to suggest the surface of water over the pebbles.

Although pastel can be a very rapid medium to use, like other painting mediums it takes time to build up a picture. This study of a brook is no exception.

Every stone and rock had to be considered for form, tone value, and reflected light. I omitted many to simplify composition and make more of the soft blue light reflected from the sky, which is my main interest. It would be easy to make the stones as dark as they really are but the effect would be very spotty and lack unison, so I had problems in making them lighter in tone but look solid. I think I have achieved the right effect. The background had a very interesting arrangement of boulders but were too disruptive for the composition, so I reduced their importance.

When I am working out of doors with pastel I often have pastel paper dry-mounted to the smooth side of hardboard (Masonite). It is then rigid enough to work on without the need to carry a drawing board. Several of them clipped together are easily transportable with interleaved sheets of paper (it is advisable to do this, even if the pastel has been fixed as particles are still loose on the surface). This method also prevents loose sheets of pastel paper being carried off in the wind. Your picture framer will dry-mount paper for you. Some pastel painters argue that the surface of the paper is flattened under the heating process. This may be true, but I personally think only marginally so.

Medium Pastel on pastel paper mounted to board
Size 15 × 11 in.
Title **Brook**

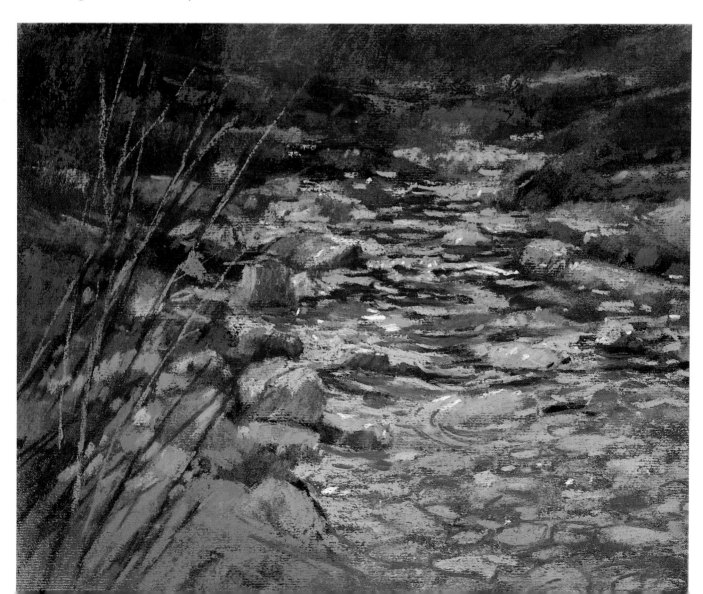

This view is from the other side of the sand dunes illustrated on page 74. The sea is just to the left and provides lively sailing on the estuary. I have tried to convey a feeling of action in my painting. The shallows, although not the main interest, contribute to the liveliness of the scene.

If you turn the page upside down you can see how the foam and waves harmonise with the movement and texture of the clouds. The leaning sail emphasises forward movement and we can sense there is a stiff breeze blowing.

The foreground could quite easily dominate the painting but I have avoided this by drawing attention to the dark line of the horizon and the sails pointing to the sky. Immediate foreground is softened and blended to avoid hard lines which would fix interest on to the bottom of the painting. There is an interesting contrast of movement in the foreground of this illustration. The shallow water looks shallow because the foam is suggested with horizontal lines, but the waves sweep up and are indicated by short and vigorous vertical marks to give an illusion of higher and deeper water.

This attention to composition is not as calculated as it may seem. After my many years of designing and painting it becomes a natural thing — but I have never taken balance and harmony for granted. Even the slightest sketch deserves proper consideration.

Medium Pastel on grey pastel paper
Size 15 × 10 in.
Title **Fresh breeze**

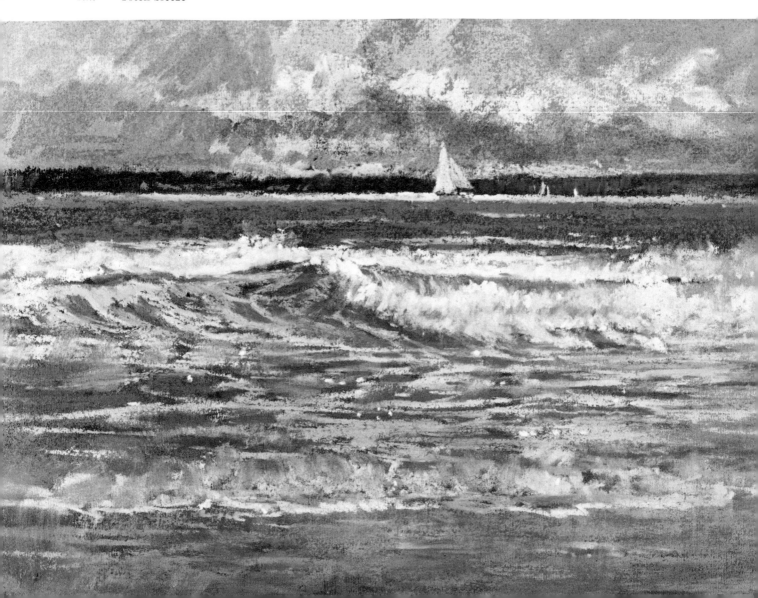

5 Weather

Water is an essential part of weather conditions. Clouds, so often neglected by landscape artists, are formed from countless tiny droplets of water. Precipitation from clouds often starts as snow but melts and reaches the ground as rain. Adept handling of weather conditions in a painting conveys mood successfully: to achieve this you must work from nature as often as possible. What you learn outdoors is reflected in your studio painting.

The broad and expressive medium of charcoal is an ideal choice to capture the transitory effects of nature. Your drawings do not have to be big or impressive — small sketches can show an effect just as well. The most important thing is to try and capture the mood of what you are drawing. A quick rough sketch of a rainy sky tells you more than painstaking detail of the landscape beneath it.

The colour of distance is influenced by the blue-grey veil of aerial perspective. Looking out to sea on a day when the atmosphere is moist the horizon is affected by a veil of grey. To achieve this effect in painting considerably enhances the feeling of space and air. It is a quality I try to get in all my work. The sky is generally complementary to the landscape but some painters make it a dominant feature. Whatever the choice it must be done well, with a sense of light and distance. For monochrome or colour work soft chalk pastels are excellent because you can work rapidly with maximum results.

Whatever your subject remember that it will have more than one aspect as the weather and seasons change, so even though you may have already done a painting from it there will be many more different opportunities. Don't be like the student I knew who got bored if she went to the same site twice. I often go out drawing and painting down a country lane near here. It is a familiar place but it never looks the same as it did last time. Light and weather conditions are constantly changing its appearance.

Wet streets after rain are a good example of how familiar scenes can assume different moods. Snow covered landscape is a rich source of painting material. There is something quite exhilarating about drawing or painting in the stillness of a snow-covered landscape. Errors often arise when students attempt to paint a snowy vista — there's nothing wrong in painting a panoramic view but you do need to have a good deal of experience to make it work, or it can look like a map. A few trees, or a gate and shrub in thick snow have an intimate beauty that may express much poetry.

Morning mist over a stretch of water is one of nature's most beautiful and romantic effects, and also one of the most difficult to paint. Correct tone values are essential, or the veil of mist will look like a smooth band of grey paint swiped across the canvas. The effect of falling rain is better achieved by suggestion rather than diagonal lines, so carefully depicted in some amateur paintings, which resemble an avalanche of falling arrows. But however loose in style or impressionistic your work it should show some thought behind it.

In all varieties of weather conditions the important thing is to feel what the effect is, not blandly copy what you see. Experiencing a sense of exhilaration and closeness to the landscape will come as your powers of observation and awareness develop, and it will show in your work.

In my effort to understand weather conditions, I have even painted in thick mist. I can recollect the utter quietness and the ghostly appearance and disappearance of trees as the mist swirled around me. My painting wasn't worth shouting about but the experience is registered in my memory bank.

The following drawings and paintings are some examples of water associated with weather.

Weather effects with charcoal

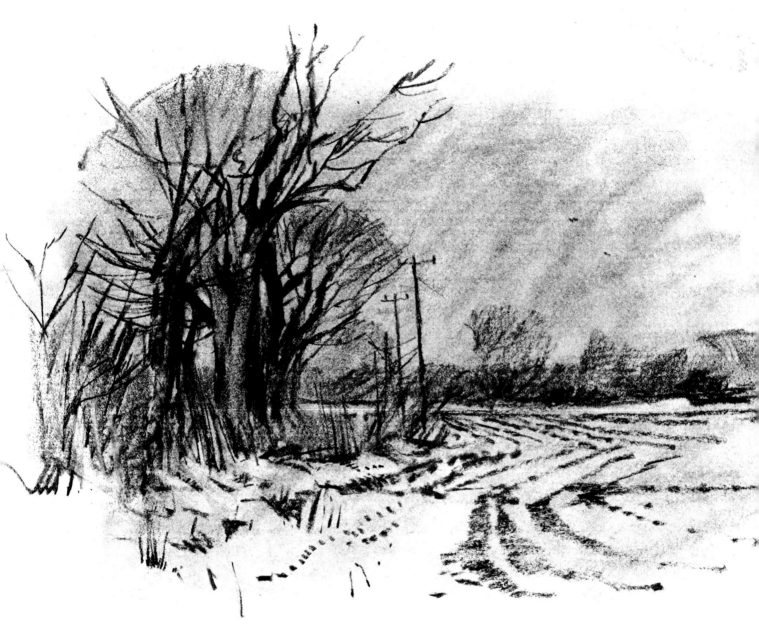

Medium Charcoal on cartridge paper
 (drawing paper)
Size Both illustrations, 10 × 7 in.
Title **January snow**

I never miss an opportunity to paint out in the snow.

A blanket of whiteness dramatically alters a familiar landscape, creating bold contrasts of light and dark. The air is different too. It seems to be quieter and very still. I did the drawing on the facing page just after it had snowed. The sky was an indigo colour and quite different in

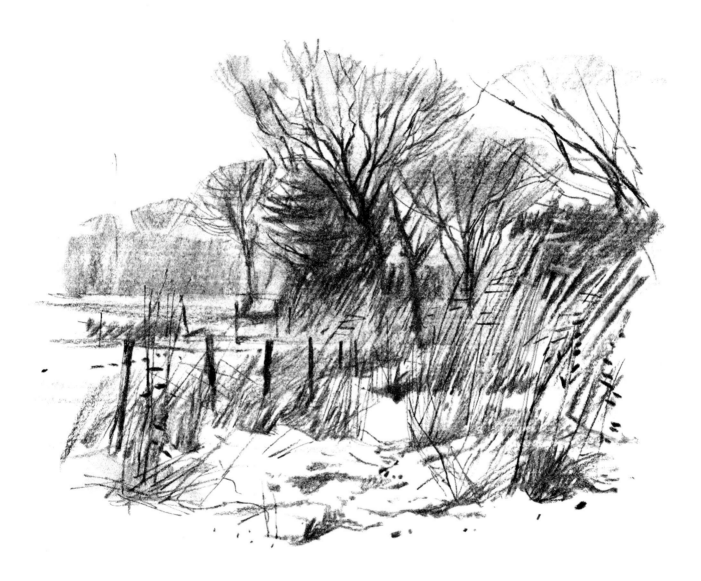

atmosphere to this sketch. Both are very interesting compositions and have possibilities for paintings which I may get around to one day. Drawing outdoors is not just copying what you see. Trying to get a sense of atmosphere is more important. That is what I have endeavoured to achieve in these two sketches. Snow is not always pure white, as is generally imagined. It reflects colour and light from the sky. Making the sky and background slightly darker gives emphasis to the lightness of snow. A snow scene is not always of brilliant blue skies and crisp contrasts, but even on a dull day the atmosphere is magical.

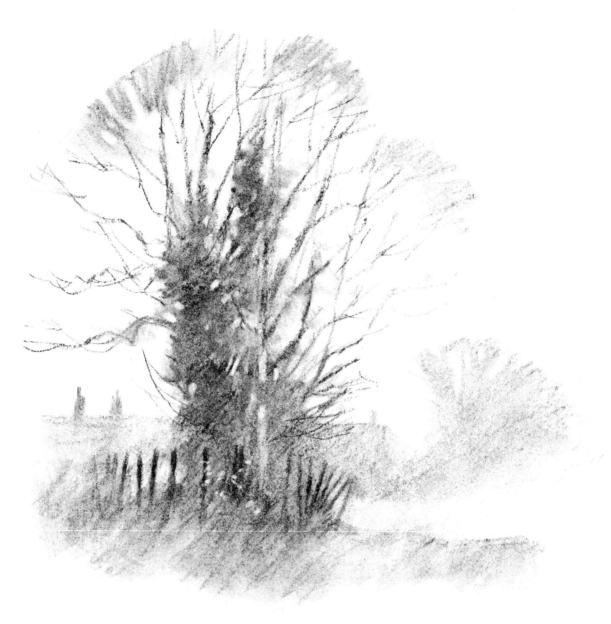

Medium Charcoal on cartridge paper
(drawing paper)
Size 8 × 8 in.
Title **Elms**

The misty light of early morning is one of the most subtle natural effects. It occurs when sunlight shines through an atmosphere of moist air. Grass and hedgerow become saturated with moisture and cobwebs glisten in the soft light. Back lighting casts everything into blurred edged silhouettes, blending and fading into the grey distance. Misty light is subtle with gentle gradations of tonal contrast. Make them too dark or distinct and the effect is lost.

Although the general colour of mist is grey it takes on the colour of sunlight, which in itself varies. When you are painting, add a touch of yellow ochre or red to warm the grey. How bright the sunlight appears through mist depends on how heavy the moisture content is. At ground level morning mist may be more dense than it is at tree-top level, as I have shown in this illustration. The variation in tone is subtle and contributes to the effect of light permeating the mist. My sketch was done in the studio: I roughed it in first of all to establish the proportions of the foreground

and distant trees, then I began drawing the nearest tree. When the composition was completely drawn in I used a paper tissue to blend the charcoal into subtle tones. Light parts are lifted out with a putty rubber. The final touch is the paling fence.

You can see how important the dark tone is to create a strong contrast with everything else.

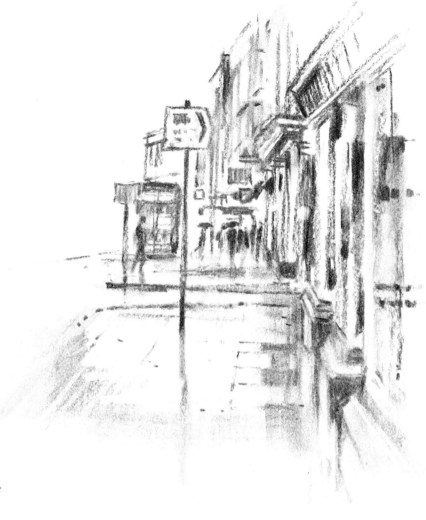

Medium Charcoal on cartridge paper
 (drawing paper)
Size 8 × 6 in.
Title **Wet street**

Rain

A wet street scene offers fascinating combinations of reflections, rich colours and glistening surfaces.

The thin clear film of water, unlike a muddy stream, allows the colours of the various surfaces to show through clearly. A wet surface also darkens the tone of a colour and makes it appear richer (wet pebbles on a beach are an example). Tone values and reflected light are the principal concerns and a black and white drawing illustrates how important it is to get them right in relation to each other. As surfaces and colours are more clearly defined when wet, simplifying what you see into big shapes is more likely to give a truer impression than a mass of detail.

My charcoal drawing illustrates the value of deleting detail, and only retaining the big shapes. The shopfronts in the foreground had a lot of detail in the fascia and window columns, but much as I like drawing detail, I kept to my intention of making an impression of a wet street. I added figures with umbrellas to give a bit more atmosphere.

Misty rain softens the features of landscape and reduces contrasting tones to a minimum. I did this charcoal drawing in the studio from an outdoor sketch at the Lizard on a February morning. It is typical of the misty conditions that occur along the coastline. The foreground hedge and grass bank should obviously be darkest in tone because they are nearest—like the trees in the illustration *Elms*—but then the illusion of mist would not be so apparent, so the foreground is almost the same tone as the roof of the cottage in the background. Three tones, very similar in value, are all that is needed to create this mistiness.

Areas of white paper were left to give the necessary contrast between silhouetted shapes and pale tones. You can easily visualise the difference had the sky not been left white and a shade of grey laid over it. It is a wise plan to leave a critical area until last so that its relationship with the rest of the picture is harmonious and unified. The sky is vital to my drawing. To avoid a mistake which might spoil the effect I wanted, I left the sky until last. I'm glad I did.

To include clouds would have detracted interest from the landscape and the misty atmosphere surrounding it. On my painting trip to Cornwall I worked outdoors every day—painting and drawing this lovely unspoilt part of the wild landscape. A change of environment helps us to see things afresh. I learnt a lot about rain and mist when I was at the Lizard. It was part of everyday weather.

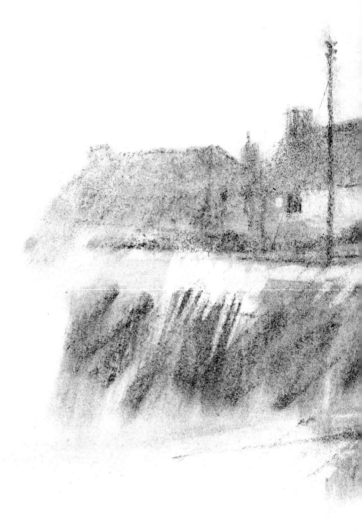

Medium Charcoal on cartridge paper
 (drawing paper)
Size 12 × 6 in.
Title **The Lizard, Cornwall**

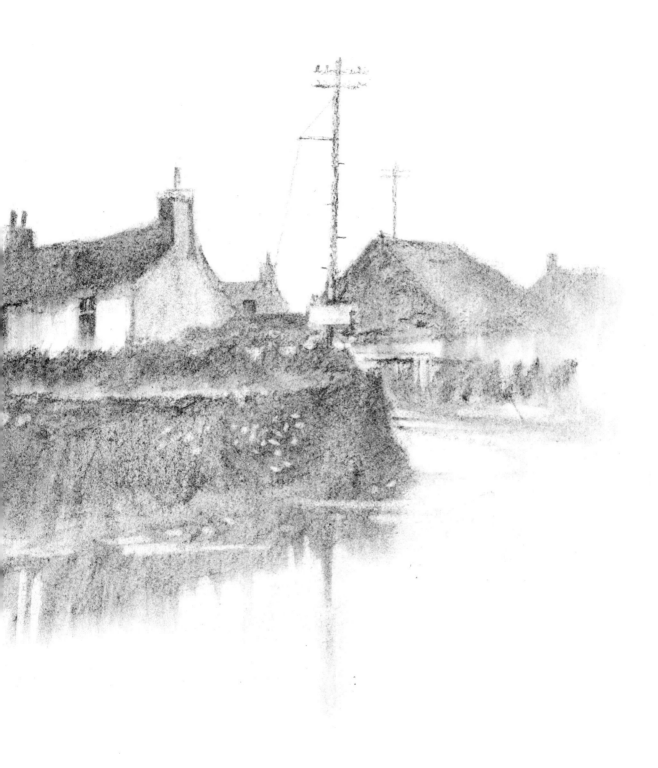

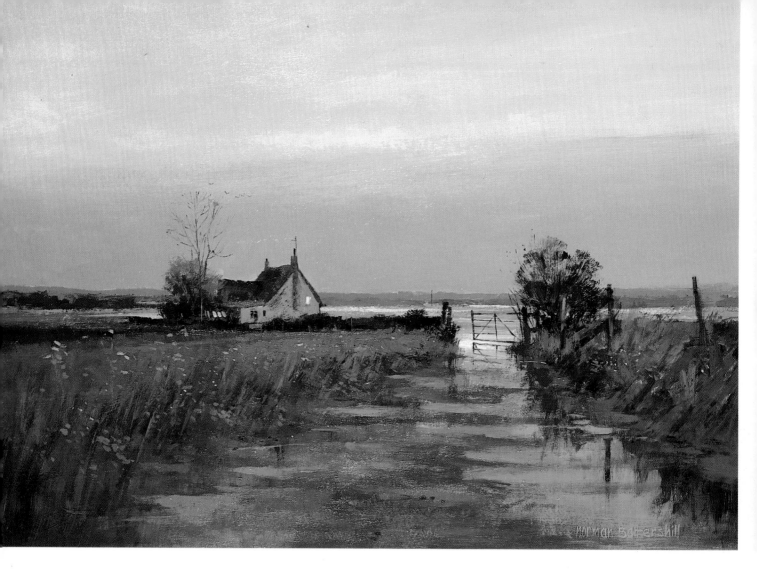

Skies can become distracting in a landscape if painted haphazardly. In my paintings the sky has to suggest light without showing its source. Light envelops the landscape and affects the colour of the air. To me, this is what painting a sky is all about — but what a difficult task to try and achieve it is. In my painting here I have attempted to suggest the feeling of pervading light and the atmosphere of day-break. The landscape is linked to the sky by several touches of related colour. The yellow of the sky is repeated in the illuminated window of the cottage. That tiny patch of related colour is all that is needed to link sky and landscape. A deeper tone of the dusty purple is on the wall of the cottage, the distant hills and the puddles.

Although a picture will benefit by your emphasising weather conditions, such as sunlight or dark cloud, the landscape must not be subordinated. A common error is to make the sky look ponderous and top heavy. To achieve an overall harmony of colour I first of all lightly stained the board with very thinly diluted yellow ochre. This pale tint gave me a toned ground to build upon, instead of my usual white ground. Because the sky is flat and subtly gradated I painted it in first, and then put in the landscape when it was completely dry.

I used the dry brush technique for the trees and hedge. My palette for this painting is:

quinacridone red red iron oxide
ultramarine cobalt blue

Medium Acrylic on board
Size 3 ft × 2 ft
Title **Another day**

azo yellow light burnt sienna
titanium white

For the dusty lavender colour of the sky horizon I mixed quinacridone red, cobalt blue, yellow ochre, ultramarine and white. I painted this into the wet pale yellow background and gradated it with a large nylon brush.

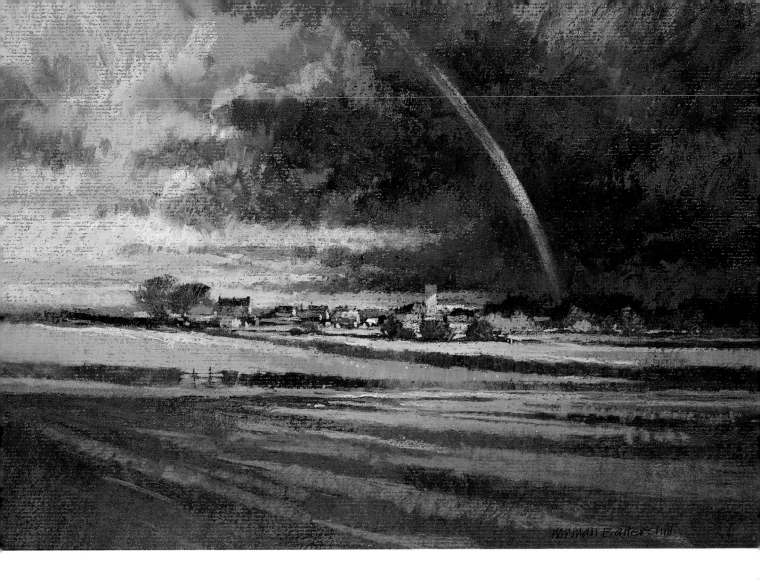

Medium Pastel on brown paper
Size 18 × 13 in.
Title **Rainbow**

The dramatic effect of a rainbow is caused by the refraction and reflection of the sun's rays in drops of rain. A rainbow is always opposite the position of the sun, and often occurs when there are showers.

The light and colour of the rainbow soon fades but the beautiful vision remains in our eyes for a few seconds longer. A rainbow is the most difficult of all nature's aspects to try and capture in paint — especially in pastel, because it is a dry medium and glazing to gain transparent effects is impossible. I achieve the appearance of transparency by fixing the original layer of pastel, and then working over the top, as I did with the brook painting on p. 89. If I were painting a rainbow in oils or acrylics I would glaze the colours over a pure white ground to get as much brilliancy and transparency as possible. My pastel is on brown wrapping paper which I had mounted on the smooth side of hardboard. It is a very sympathetic surface and takes the medium well.

To achieve the maximum effect of light and colour I have placed the rainbow against dark storm clouds. Instead of making the complete arc in clear bright colours only a small part of it is brilliant.

The rainbow arc is a strong shape, but in nature there is the vast expanse of space surrounding it so it never looks cramped or over-forceful. But trying to harmonise the curve within the confines of a picture frame presents a difficult problem. My painting shows one way of solving it. Both ends of the rainbow are blended into the clouds so the curve is not too pronounced. The light patch of sky on the left is a counterbalance to the rainbow and so is the sunlit church tower and bright green field.

My painting is based on a photograph I took in Norfolk during a painting trip along the coast. I was very glad I had my camera with me at that particular time.

Medium 2B Conté pencil on cartridge paper
 (drawing paper)
Size 8 × 6 in.
Title **Rain**

I have included this drawing so that you can see the difference between charcoal and conté pencil used for similar subjects (see p. 95).

Conté has a much denser black line than charcoal but not quite such expressive versatility. To blend charcoal I use paper tissue. For this conté drawing all the blending is done with a tortillon stump, and lighter parts are lifted out with a putty rubber.

Falling rain is suggested by indefinite lines and ragged edges to the drawing. Reflections are not defined because falling rain textures the surface of the road and pavement. I have lightened some parts of the sky with soft chalk pastel after the conté has been fixed.

Step one

Charcoal and soft chalk pastel is an excellent combination for expressing a wide range of light and dark tones. The Ingres pastel paper is a mid-grey shade with just the right texture for drawing with both mediums.

Sunlight and shadow is the theme for this demonstration drawing. My first step is to rough in the main shapes.

Step two

Having decided on the direction of light the shadow side of the cottages are indicated.

I smudge some of the charcoal to produce the beginning of the effect I want. It is better to decide at the preliminary stage the kind of atmosphere you want to achieve. Refinements are added in the final stages and must not be hastened. Icing on the cake comes last.

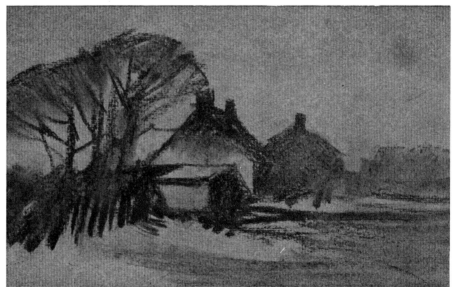

Final stage

Now the idea is coming to life. I strengthen the drawing and make the shadows more positive. Washing on the line adds pattern and a rhythm to the composition. These shapes are lifted out with a putty rubber.

The even tone of the grey paper looks a bit bland, so I smudge some charcoal across the horizon. After detail has been added I spray the charcoal drawing several times with a fixative. When this is dry I use white soft chalk pastel on the sunlit areas, taking care not to overdo it. The pastel is then fixed so that I can draw on top of it without any smudging. My imaginary scene is now finished.

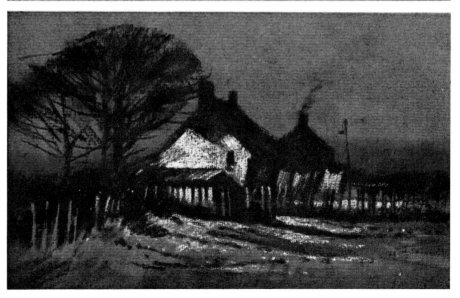

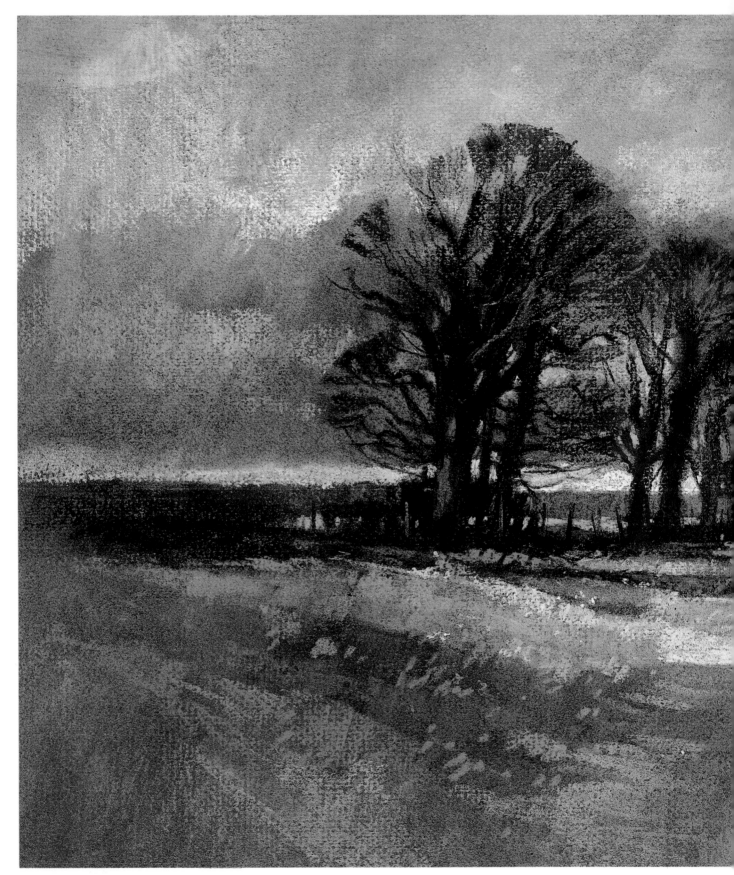

Medium Pastel on pastel paper
Size 18 × 12 in.
Title **Rain cloud**

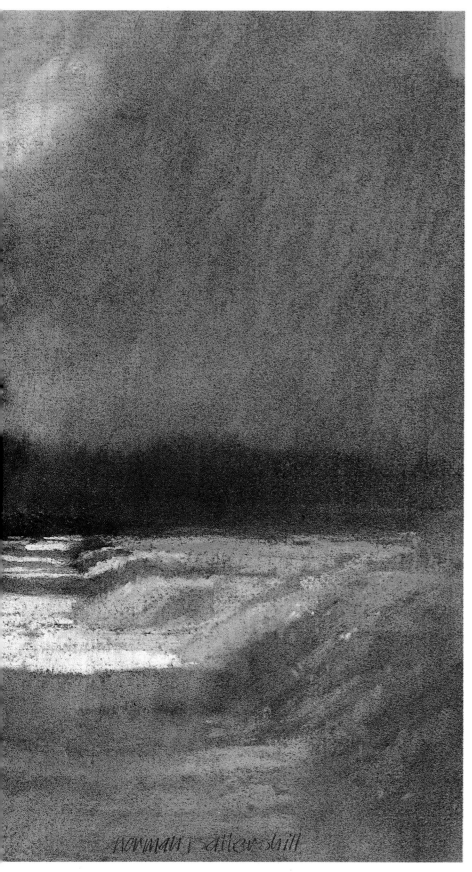

Dramatic light and shade

My pastel painting is imaginary, visualised after I had seen an elm tree silhouetted against a rainy sky. I had the idea of a big cloud of falling rain moving across the landscape and a momentary flash of sunlight. Creating a feeling of distance and atmosphere are two of the things which interest me most. I put all these ingredients together and this picture materialised.

There is an interesting point about the composition. The storm cloud, trees and sunlit track are all on the right. But the one large tree to the left balances the whole of the composition.

In the early days of teaching myself how to use pastel I used it a lot outdoors and very quickly became impressed with its ability to express light and all conditions of weather. It is without doubt the easiest of mediums to use. Mistakes can easily be rectified by wiping out or applying charcoal fixative and working over the top.

When you are trying to paint a momentary effect of light go for the contrast of light and dark first. If you have to stop work sooner than anticipated you will have recorded the important features sufficiently to finish it at home. Sometimes a spontaneous outdoor painting is ruined by over-working in the studio.

It should not be assumed that the colour of falling rain in the distance is always a negative grey. It can vary from blue-grey, brown-grey to indigo. Touches of rain cloud colour added to the landscape will harmonise the different elements in a painting.

Here is one of my favourite themes, falling rain, sunlight and distance.
The picture illustrated is simplified into basic shapes, and the brushwork is decisive. I used four colours:

cadmium red cadmium yellow pale
cobalt blue deep yellow ochre
titanium white

The colour of the distant falling rain is a dusty mauve — I mixed cobalt blue deep, cadmium red, and a touch of yellow ochre to neutralise it.

Yellow ochre in various tones predominate the foreground reeds and is also touched into the darker reflection. The lightest part of the sky is yellow ochre and white, and a slightly darker tint of the same colour is used for the light on the water. Touches of the same colour throughout a painting unify it successfully.

My subject is very simple, chosen to show you that only a few elements are needed to make a picture, but it is the rain in the background that adds the extra interest.

Medium Oil on board
Size 10 × 7 in.
Title **Approaching rain**

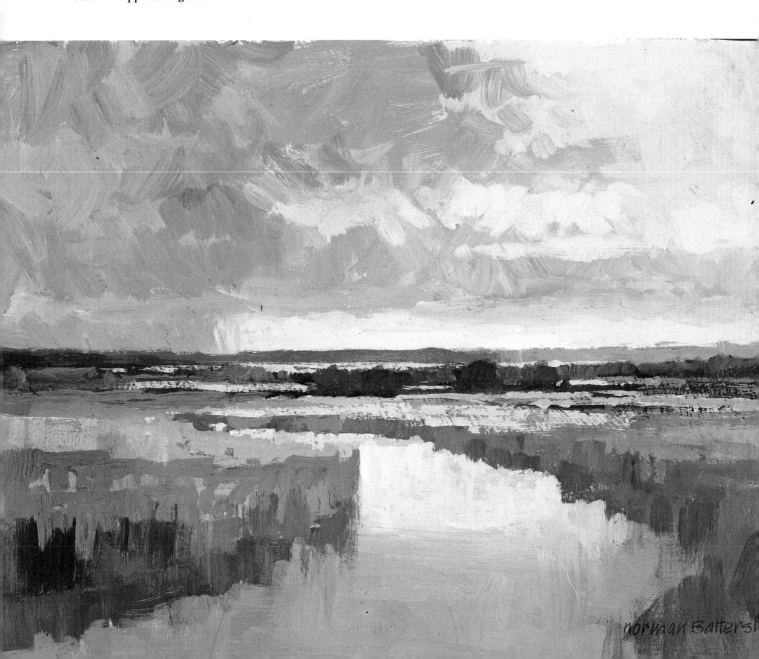

norman Battersby

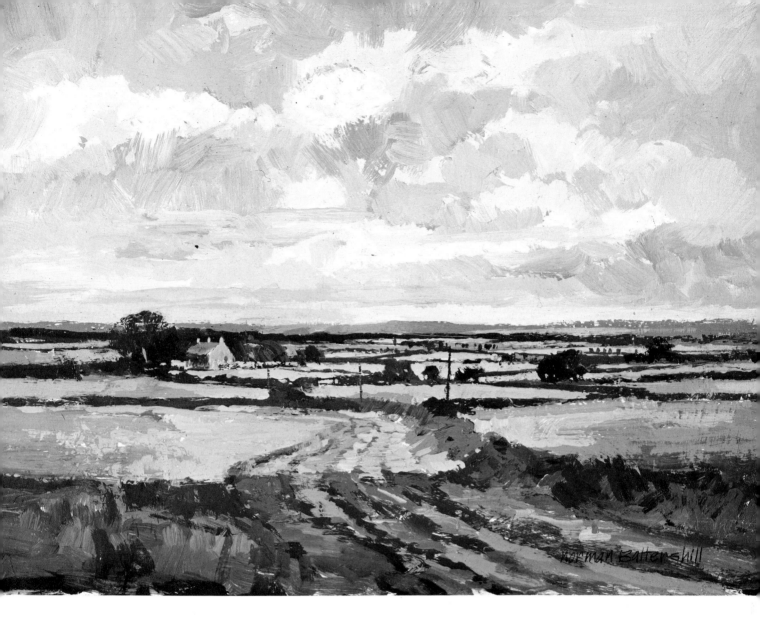

A cloudy sky can add a lot of interest and movement to a picture. Clouds also increase the illusion of recession by appearing to diminish in size and become closer together towards the horizon.

If you are painting outdoors on a cloudy day leave the sky until almost last. By then you will have decided on the cloud arrangement best suited to your scene. Paint as freely as possible with plenty of soft blended edges and the minimum of detail. Clouds are big shapes and should be painted as such.

Determine the direction of light before you begin painting. Clouds, like the landscape, become greyer as they diminish towards the horizon.

The oil painting illustrated is an outdoor study of hay fields in West Sussex on a bright summer afternoon. The mown hay in the foreground makes an interesting pattern which leads into the picture. There were other buildings but I omitted them because there just being one house suggested space and isolation, which added to the effect I wanted. My palette consisted of just a few colours: light red, cobalt blue, cadmium yellow pale, titanium white. For the sky I mixed cobalt blue and light red and titanium white. The colour of the cornfields are mixed from light red, cadmium yellow pale, a touch of blue and titanium white.

Medium Oil on board
Size 10 × 7 in.
Title **Summer fields**

Step one

I lay a wash of diluted acrylic ultramarine blue over the whole of the watercolour paper surface to establish a general tone. When it is dry I draw in the general layout with ultramarine and red iron oxide. Indicating shadows right at the beginning of a painting establishes contrast of light and dark. My preliminary drawing is quite basic but already it suggests a picture with a marked atmosphere.

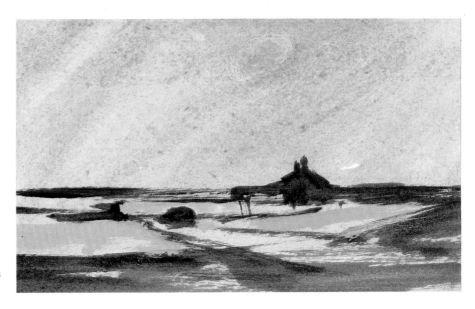

Step two

I now concentrate on the effect of sunlight and shadow. The rainy sky is mixed from cobalt blue and red iron oxide with a touch of cadmium yellow medium. These colours are the basis for the whole of the sky.

Sunlight on the river bank is mixed from cadmium yellow medium and lots of titanium white.

I must make sure in my final painting not to make the arch of the bridge too prominent.

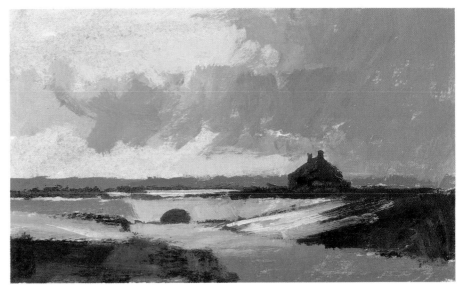

Final stage

I tone down the sunlit grass and the bridge because it prevents interest going into the picture, and detracts from the house. The colours and tones are made a bit more subtle; I want an effect of soft light. Details of figures, window and pole are added last.

The colours I have used are:

cobalt blue	red iron oxide
ultramarine	titanium white
quinacridone red	
cadmium yellow medium	

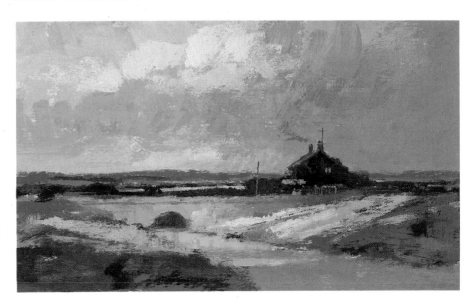

The small amount of sky in this woodland scene may seem insignificant but the colour and tone must be exactly right. It has to fit in with the rest of the subject.

A common fault with students is to make the sky too light and too blue when seen through the tracery of trees. This makes it look like paint, not sky. A patch of sky surrounded by a deeper tone always looks darker than it really is, and that is how it should be represented. As we have noted, the surface of snow is reflective and picks up subtle colours, light from the sky and its surroundings. In my pastel painting the sky is overcast and therefore both snow and water are predominantly grey. If the snow had been shown pure white the effect of diffused light would be lost and the trees stark in contrast.

Sunlight, shadow and distance are my interests in this Sussex landscape. I used the ripe cornfields and the lush green of summer as the means of contrasting light and dark tones to create a patch of bright sunlight. The most critical tone is that of the sky. In a subject like this there are various alternatives as to how it is represented.

The colour is mixed from ultramarine, cadmium red and a touch of yellow ochre, and white. You will notice how the colour of the nearest cornfield is repeated in the distance. Transferring a touch of colour into the background is a means of creating the illusion of recession and space. A track or road leading straight into the picture is a forceful directional movement and must not be either too light or too dark as it will then be distracting. A middle tone is more likely to harmonise with the rest of the picture.

Medium Pastel on pastel paper
Size 10 × 7 in.
Title **Woodland snow**

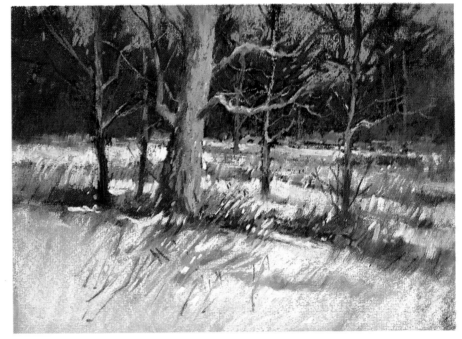

For a sunny green I mix azo yellow light, cobalt blue, titanium white. This colour combination compares with the beautiful oil colour cadmium green. For the cornfields I mixed azo yellow light, red iron oxide and titanium white, with a slight touch of cobalt blue.

I painted the sky last of all so that I could more easily judge its tone value in relation to the cornfield and distant fields and so on. The touch of sunlight was added last for the same reason.

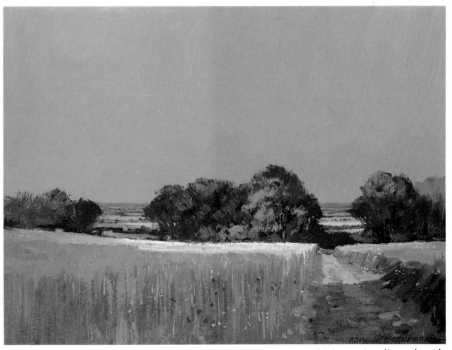

Medium Acrylic on board
Size 11 × 7 in.
Title **Approaching storm**

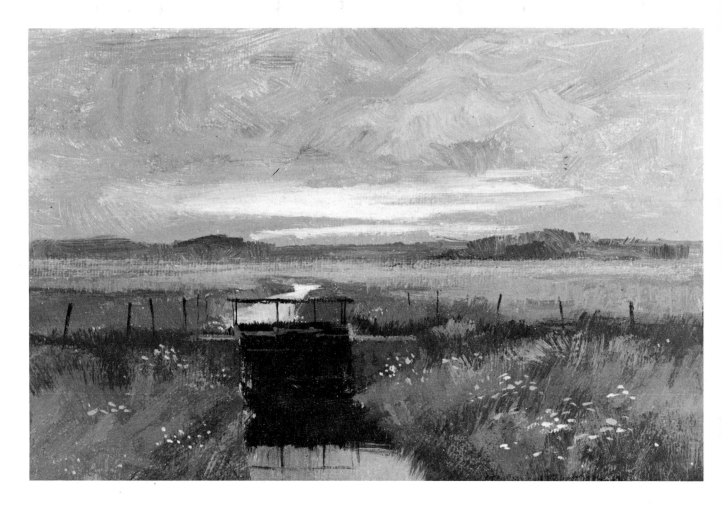

Medium Acrylic on canvas board
Size 11 × 7 in.
Title **Sunset**

A landscape that looks flat and commonplace can be transformed by mood or atmospheric effect into an interesting and successful picture.

It does not have to be picturesque or a complicated subject but a few simple elements suffice —as with this illustration of trees, water and the effect of light. As your memory and observation develops so will the ability to create imaginative pictures. Of course this will also depend on your technical ability to translate the idea into paint.

Working in the studio from sketches, photographs or other references means you can eliminate unnecessary detail, reconsider composition, colour and atmosphere.

But most artists, myself included, have the need to get outside to draw and paint as often as we can.

Sunset paintings are a legacy of the Victorians. Although they perhaps portrayed the subject with too much sweetness, their pictures do however show an understanding of how to depict weather. Where some of these artists failed was with their exaggerated use of colour. Sunset is not a predominance of bright red and yellow, as often imagined. Nature is always subtle and that is how our interpretation must be. Deleting red from the palette and replacing it with orange makes a big difference; painting on a grey ground can also modify and harmonise all colours.

Sunset is very fleeting and the time in which it may be painted is, of course,

equally short. But it can be done.

For the final sequence of a Winsor & Newton feature film on acrylics I was asked to paint a sunset outdoors. Fortunately for me and the film crew the painting was successful, and went right first time. I worked on a toned ground as I would for oils or pastel and roughly indicated the dark tones and then concentrated on the light in the sky. When the sunlight finally faded I stopped painting. To continue would have meant losing the spontaneity and freshness I had achieved. This was a very practical lesson about painting one of nature's more transient phenomena.

It is important that you plan carefully where to leave areas of white paper untouched when painting a subject like this. And each tone must be accurate and concise if a crisp effect is to be achieved.

I used a square nylon brush for most of the painting—you can see the precise marks in the foreground—and a small sable for cutting around the cottage window and reeds, and so on. The combination of these two differently shaped brushes and a fine tipped pen produce interesting results. I avoid the use of white paint.

When you paint a snow scene keep the number of tones to a minimum. A dark tone like the background in my watercolour will emphasise the whiteness of the untouched paper and give strength to the whole of your subject.

I produced this painting in the studio from outdoor pencil drawings.

Medium Ink on watercolour paper
Size 9 × 8 in.
Title **Snow—Flansham**

ne Lizard · Cornwall

Feb/83

Medium	Writing ink on cartridge paper (drawing paper)
Size	$7\frac{1}{2} \times 5\frac{1}{2}$ in.
Title	**Wet evening**

The watercolour illustrated is taken from a drawing I did on a painting trip in Cornwall. To make it appropriate for this section of the book I transformed it into a rainy scene. As an exercise you can transpose one of your paintings or drawings into a 'weather' subject. Remember that surfaces are reflective and correct tone values critical in painting wetness.

If you are unsure of the effect you want do some small pencil or charcoal sketches, and ideas will then begin to materialise. It takes a while to paint a successful picture by this method, so don't be too disappointed if it doesn't work first time.

6 Seascapes

Throughout this book I have stressed the need to understand the various aspects of water to achieve any success in drawing or painting it. The sea is no exception. Sea painting is the most difficult of all our subjects, and demands the most study. The sea is never still and constantly changing in shape, in colour and the way it reflects light.

A sandy beach or rocky coastline is a rich source of painting material to delight the marine or landscape artist. Painting and drawing the sea is an exhilarating sensation quite different from that of painting the countryside.

Preliminary studies of the sea should of necessity be fairly modest. Begin your studies with charcoal and soft white chalk on the rough side of brown paper. This is a very suitable surface for pastels too.

No two waves are alike but once you have a rough idea of their movement you can express it much better. Don't attempt any detail in your preliminary studies. Simplify what you see into separate movements. Don't attempt to draw all of a wave, just concentrate on part of it. In the following pages you can see how the studies begin simply and then build up into complicated wave actions and effects.

Allow yourself time to produce a lot of sketches. They may not seem very much to anyone else but they are the beginning of experience for you.

For your first drawings include an element of landscape; it may be cliffs or some rocks, or a beach. This way the sea is part of the coastline and you can achieve an effect of scale. A vista of open sea is a difficult subject and not really suitable to start off with.

As you progress the importance of light from the sky becomes more apparent, but to begin with just concern yourself with understanding the form and movement of waves. You will find that the movements of waves are repeated in a roughly similar manner—the upward curl of a big wave forming, for example, or the drag of the under-tow on the shingle. The continuous ebb and flow of tide will tempt you to work quickly. This is an advantage because the ability to make a quick impression is essential in seascape painting. But don't rush it to the point of being careless. Observation is all important and the right way to success. There's no other way to achieve it.

Drawing the sea is just as much fun as painting it—and don't forget your studies are the foundation of your pictures. Don't rush into colour too soon. Wait awhile until you have mastered preliminary black and white work. An experienced artist can visualise the scene on his canvas before he begins work, whether indoors or out.

When you progress to painting the biggest problem will be what colours to choose for painting the sea. Start with just a few is the best advice—you can, if you like, use the following palette:

ultramarine	burnt sienna
yellow ochre	cobalt blue
cadmium yellow pale	

and titanium white if you are painting in oils or acrylics. If you prefer pastels then don't limit your selection of colours. Being a dry medium you can't get the same results by mixing as with moist colours. Until you gain a bit of experience leave out the all-powerful viridian green, it can cause havoc on a painting. Skies over the sea are different in atmosphere and light to clouds over the land. The sea reflects light from the sky back into the sky, so on a clear day a blue sky has a wonderful luminosity of light. Clouds also appear more luminous because of the reflected light from the sea.

Painting or drawing seascapes is without doubt one of the most exciting subjects an artist could possibly wish for.

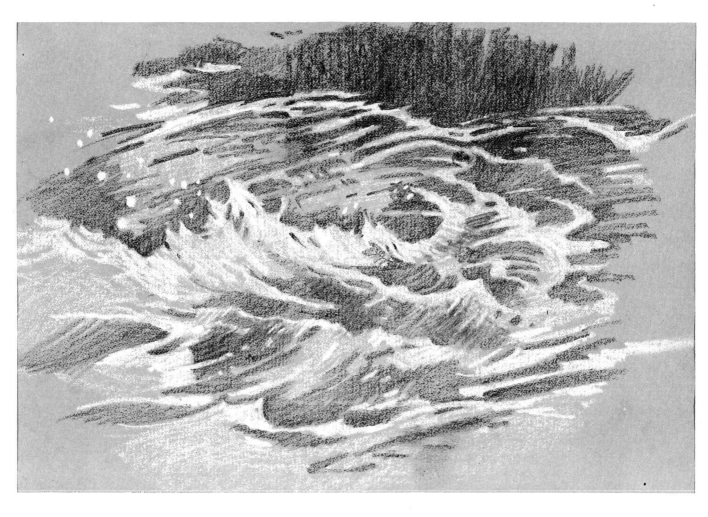

Medium Charcoal pencil/soft white chalk on
blue sugar paper
Size 10 × 6½ in.

Outdoor sketches

Preliminary observation is absolutely
necessary when studying the
movement of the sea. The problem
of where to start is simplified by
using a viewfinder and isolating a
section at a time. A close-up of one
small area shows enough variation in
movement for a dozen or more
drawings.

You will see that movement has a
repetitive pattern—never the same
but similar. This is true of all water
movement—cascading waves, for
example, are never identical but are
always similar in shape.

There are so many distracting
smaller waves and eddies to confuse
you that even a small area seems too
difficult. Throughout this book I
stress the need to simplify what you
see, and this is particularly applicable
to your first sea studies. By close
observation you will see that some
shapes and movement are more
pronounced than others. Concentrate
on these and exclude all small detail.
My drawing is an example. There
was much more in the subject than I
have shown, but by isolating the
important shapes, which in this
instant were the waves, I have
captured the movement.

I began by drawing in the white
parts with pastel and then fixed
these with charcoal fixative. When
the fixative was dry I drew in the
darks with charcoal pencil, taking
care not to go over the pastel
because it would have made a grey
smudge.

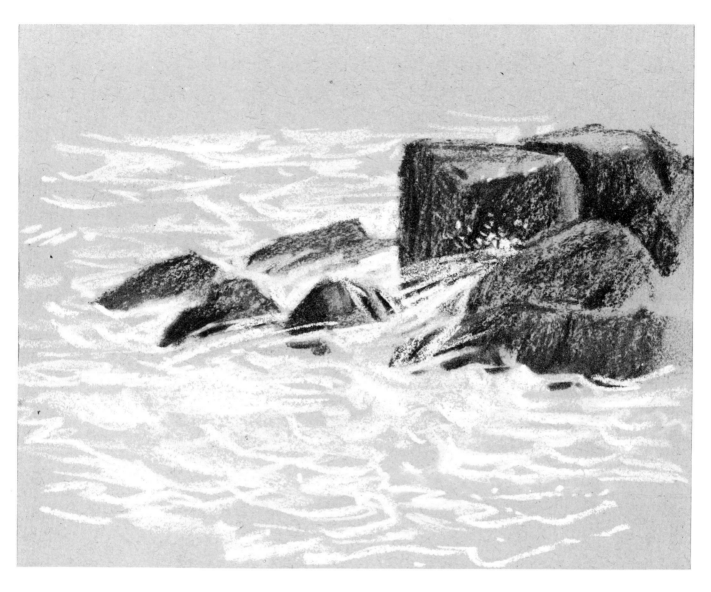

Medium Charcoal and soft white pastel on sugar paper
Size Actual size

This illustration is another outdoor study, only a few yards from where I did the sketch on the opposite page.

When you are drawing rocks and waves draw the position and the tone of the rocks first. The flow and impact of waves is influenced by the position and shape of the obstructions. When you are drawing half close your eyes now and again. Everything will be reduced to their principal shapes and tones. Forget about the interesting effect of light on wet rocks and delicate lacelike patterns of foam. Start off boldly. Your main concern at this stage is the study of movement. Don't rush your foundation course.

Step one

For my demonstration drawing of rocks at Mullion Cove I have chosen grey Ingres pastel paper. The surface is sympathetic to charcoal as well as pastel and conté. The general composition is drawn in freely and quickly.

Step two

At the same time as drawing in I indicate the dark areas so that I can see how the tone values will work. I smudge some parts with a paper tissue to soften edges and lighten tones.

The movement of the breaking wave is important at this stage so it is suggested by curved lines and some blending.

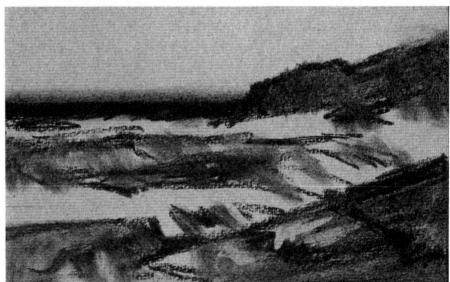

Final stage

The charcoal is not dark enough so I fix it and draw on the top with soft black conté. White pastel is worked into the sky and the sea, blending with a tissue to get soft edges. I make sure to try and give sufficient movement to the curving wave, because it is a strong contrast to the rigid lines of the rocks.

I have tried to capture the bleakness which is typical of the Cornish coast in winter.

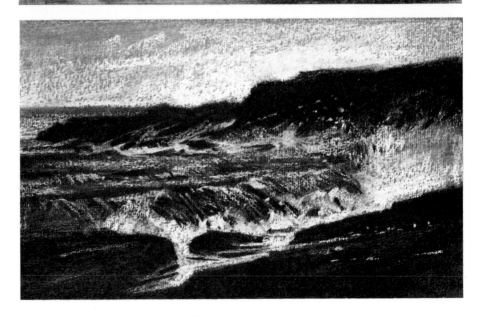

Experiments with drawing media

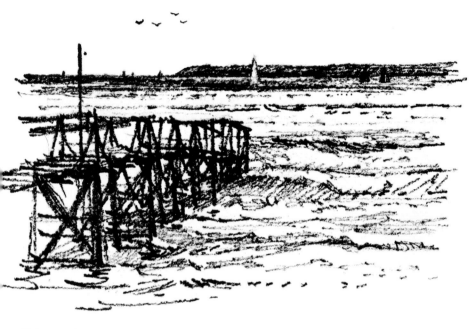

The perspective of this landing stage may seem a bit odd, but it is because the end is actually dipping into the sea. For my sketch I used Bockingford 140 lb watercolour paper and a black fibre tip pen. The rough texture of the paper gives sparkle to a drawn line, and it is tough enough for mistakes to be scratched out if necessary.

The drawing of the incoming tide and suggestion of reflected light has enough information about the sea for me to paint a big oil colour from it in the studio at a later date.

Most coastlines are a rich source of painterly subjects if we look for them.

Medium Fibre tip pen on watercolour paper
Size 6 × 4 in.
Title **Landing stage, Weymouth beach**

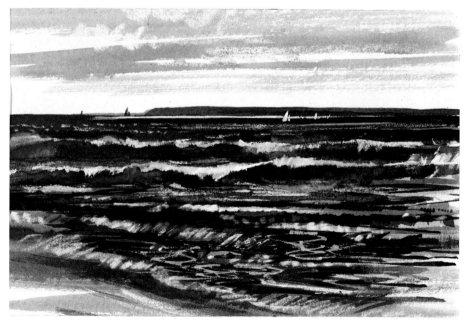

Writing ink and pastel seem an unlikely combination but they do work well together.

When the ink is dry I apply white soft chalk pastel to the breaking waves, sky and foreground water.

This illustration is an example of the principle that painting only a few waves is more suggestive than an endless series of lines stretching into the distance. Three are sufficient — the rest are indicated by broken lines. Repetition can be boring so don't include everything that you see.

Some seascape painters argue that a painting of the sea should be sufficient in itself without any additions. But on an open sea a boat or two immediately gives an impression of scale, atmosphere and distance.

Medium Writing ink and pastel on cartridge paper (drawing paper)
Size 7 × 4½ in.
Title **Incoming tide**

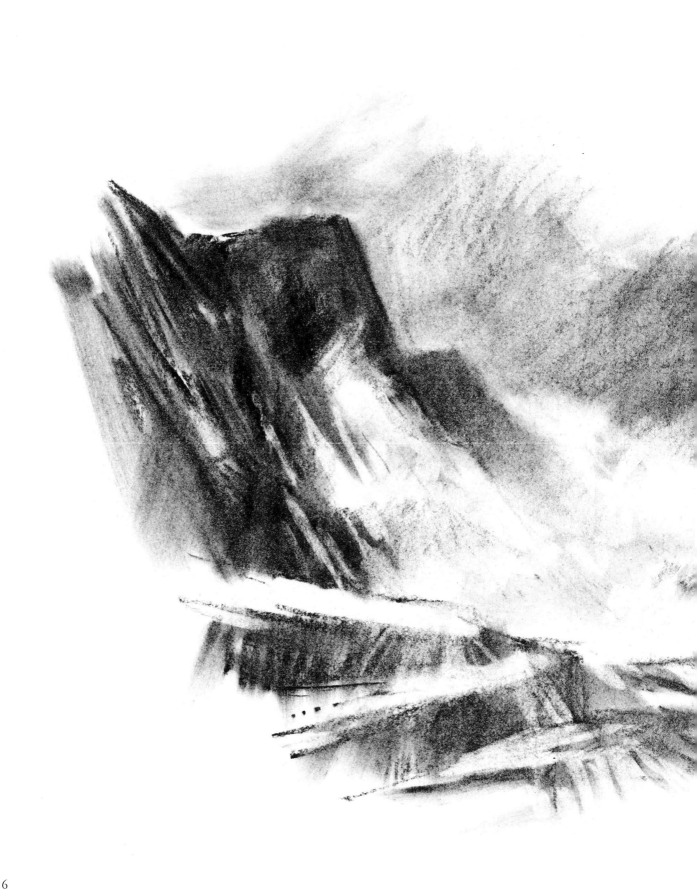

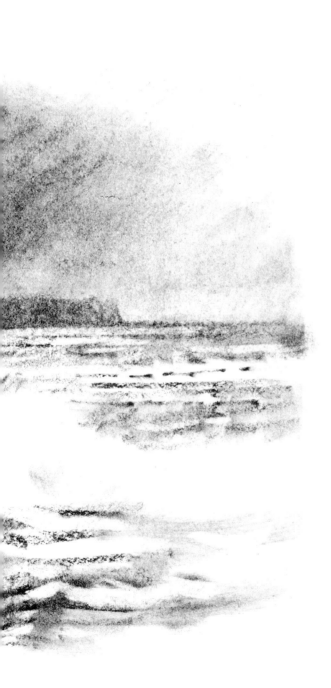

Medium Charcoal on cartridge paper
 (drawing paper)
Size Actual size
Title **Storm—Portland, Dorset**

Seascapes need not all be bluey-green waves with a touch of translucent light at the peak — dramatic weather effects of wind and rain are just as exciting. I find the atmosphere of a wind-swept sea powerful and inspiring. The foam mist in my drawing comes from the haze of water particles caused by the wake of a burst of foam carried upwards by the wind. Generally, a burst is caused by the sea striking rocks, but sometimes it occurs when opposing movements of water crash together and produce foam. In a strong wind the foam is whipped off the top into a fine haze of moisture. I have shown the effect in my illustration. Charcoal is ideal for this kind of atmospheric drawing.

The drawing was roughed in lightly with charcoal to get a firm idea of the composition. Drastic alterations are not advisable half-way through a picture; they have a habit of not working.

Getting the tone values right is critical in a subject like this because the atmospheric effect can easily become a failure. The dark cliffs are drawn in boldly and then tones created by rubbing with paper tissue. You can see the effect of a dragged charcoal mark to the extreme left of the cliff face.

Next came the sea, sky and distant headland using the same technique. If charcoal is rubbed too hard it leaves a stain on the paper which won't come out, so I made sure that the whitest part of the foam is the white of the paper. Other light areas on the rocks, sea and mist are lifted out with a putty rubber. There are not many hard lines in this drawing. I wanted to achieve a softness suggestive of rain and mistiness. Side lighting gives shape to the cliffs and mist. Contrasts of light and dark are subtle but enough to distinguish form and movement throughout the drawing.

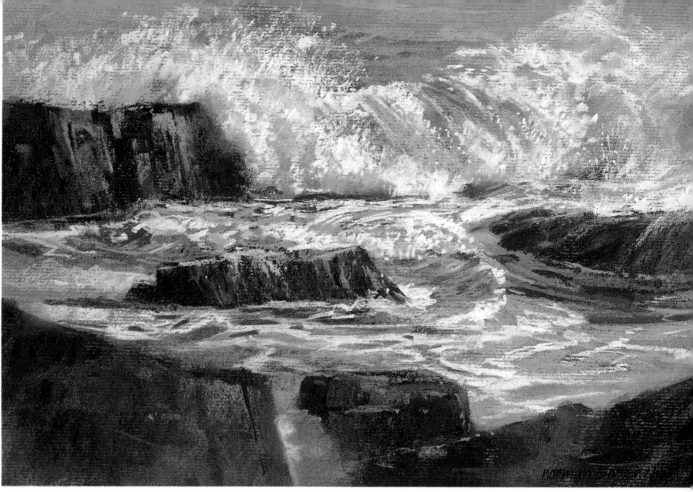

Medium Soft chalk pastel on brown paper
Size 18 × 12 in.
Title **Incoming tide**

My pastel painting shows a combination of water movements, typical of an incoming tide among rocks.

One of the problems for a student is how to make a rock look as if it is partially submerged and not floating on the surface like a piece of debris. The trick is to show some of the rock below the water line or through breaking waves. This technique is shown with the central rock in the illustration. The shape below the clear water is visible but not sharply defined. Foamy water is not transparent so a rock behind it is not so visible. Water moving in a variety of ways makes a picture interesting, but it cannot be approached in a haphazard manner. A successful seascape painting is not only a convincing impression of movement, but also an harmonious arrangement of other principal

features. Rocks are often the most prominent of these and if badly placed can spoil an otherwise pleasing picture. A preliminary compositional sketch will help solve some problems. Your rendering of a breaking wave should suggest movement. Soft and blended edges contribute to this effect, whereas hard and defined edges look static. Compare the rocks and spray in my painting.

To paint water flowing over a rock, paint the rock first of all but leave unpainted the areas where water will be. When you come to paint the water the clean colour will not then be spoilt by a dark colour underneath. If you are working in pastel, paint the rock first, then spray with fixative and superimpose the effect of water. But if you are using dark paper, this is unnecessary. For example my

painting here is on deep brown paper and serves as a basic tone for the rocks.

Remember that the wet surfaces of boulders and rocks will to some degree reflect light from the sky. The pattern of foam swirling around rocks contributes to the feeling of motion in the water. Patterns of surface foam and cascading water provide contrasting effects and combine to add variety and interest to a picture. You can see how surface foam joins together and harmonises with all the rocks in my painting.

A complicated subject like this requires very careful consideration for composition, texture, movement, tone values, shape and the effect of light. Putting it together successfully depends entirely on how much knowledge you have gathered from outdoors and your technical ability.

A moment of sunlight can transform a dull seascape by the dramatic effect of sparkling light on the sea. Some of these moments are so fleeting you have to rely on memory or a photograph. My acrylic painting was done in the studio: I have seen the wonderful effect of sunlight on a dark sea so often where I live on the coast, and in Dorset too. Generally the light is a warm silver colour — sometimes it is white with a touch of pink, or white with a touch of green. The colour of light depends upon the clarity with which it is filtered through the atmosphere.

An overcast sky with featureless clouds and no direct sunlight produces a soft light over everything. The scene can be without much contrast of light and dark, but it may have the potential for painting material. If so it is worthwhile doing a drawing or painting of the subject even if you know it has not the lighting you want, but has enough interest for a studio painting. It is then that the dull picture can be transformed by introducing sunlight.

Colours I used are:

cadmium red	cobalt blue
red iron oxide	yellow ochre
titanium white	

I began my painting by staining the board with a thin wash of cobalt blue, which gave an overall tint on which I built up the other colours. Cadmium red and cobalt blue and white produce a lovely lavender colour. Red iron oxide also has a similar result.

Medium Acrylic on canvas board
Size 15 × 12 in.
Title **Sunlight and sea**

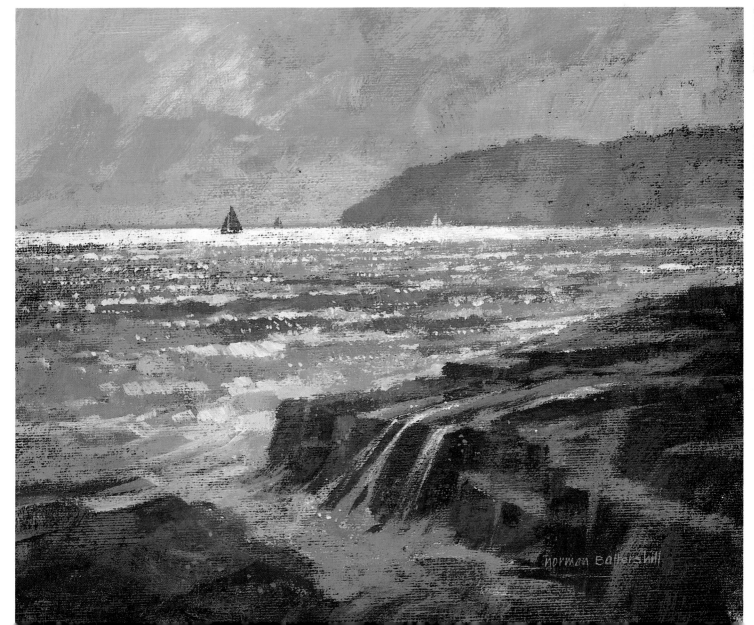

norman Battershill

Monochrome

For this illustration I have used one soft chalk pastel and deep blue pastel paper.

It demonstrates the versatility of this combination for a very wide range of tone values. The illustration is simple and has no pretensions to being a picture. Basic studies like this are a very refreshing departure from full colour paintings, and put you back to square one. I often see this ketch off the coast at Dorset and have made a number of drawings of it.

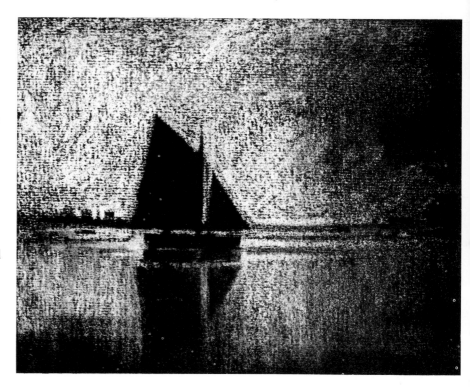

Medium White soft chalk pastel on pastel paper
Size $5\frac{1}{4} \times 4$ in.
Title **Ketch**

I like this composition because all the interest is around one area and contributes to a feeling of activity. The sea is glassy and reflections broken by long ripples from an ebbing tide. To achieve this I have used Chinese white for the reflection of the white sail, and flicks of light on the foreground ripples. Elsewhere the effect of sunlight is from the untouched white paper. My painting is from the viewpoint of the harbour wall. Every few paces the view changed into different angles and light and shade. I could have made half a dozen paintings but finally chose this composition, where the sea, sky and the old fisherman's shed, are balanced successfully.

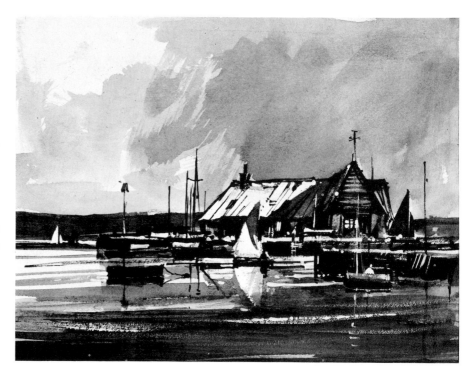

Medium Writing ink on cartridge paper (drawing paper)
Size $4\frac{1}{4} \times 6$ in.
Title **Harbour scene**

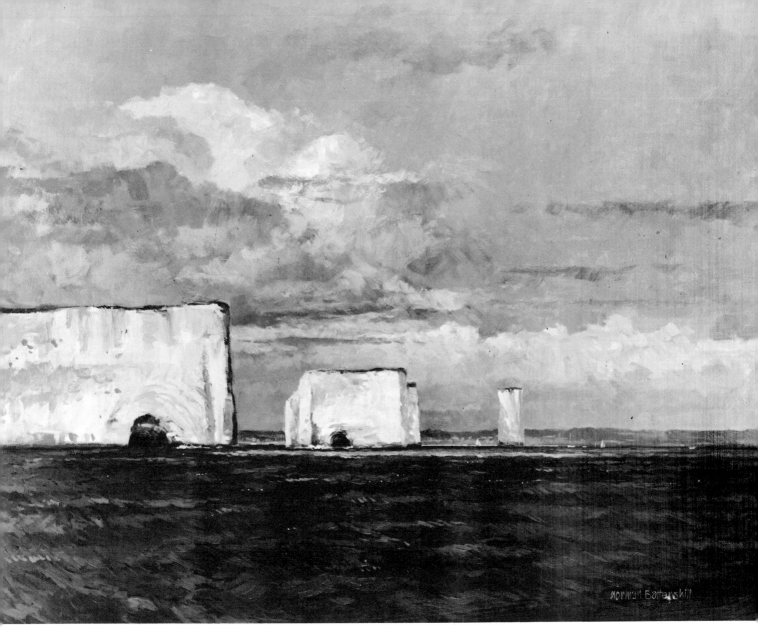

Medium Oil on board
Size 4 ft × 3 ft
Title **Studland, Dorset**

This fascinating coastline is a marvellous unspoilt part of Dorset, the same as that shown on p. 127. For my painting I went out in a boat and made a number of pencil sketches and also took some photographs for reference. My principal interest in the subject is a feeling of the big open space of sea and sky —and, of course, distance. The colour and texture of the sea gave me the greatest difficulty. On the day I went out in the boat it was a deep Mediterranean blue, but the colour did not fit my painting because it was much too assertive. It was a case of getting the tone right but the colour all wrong. Eventually I arrived at the colour which harmonised with the rest of my painting. The colours for the sea are:

ultramarine blue yellow ochre
cobalt blue burnt sienna
titanium white cadmium yellow pale

The colours of the sea are introduced into the sky and create a harmonious link between the two elements. Colours of the cliffs are kept to a minimum, mostly yellow ochre, with pink, blue and pale mauve for the shadows.

It was one of the most difficult paintings I had tackled. But the outcome I like to think was quite successful.

Medium Gouache and acrylic on
 watercolour board
Size 20 × 14 in.
Title **The Witterings**

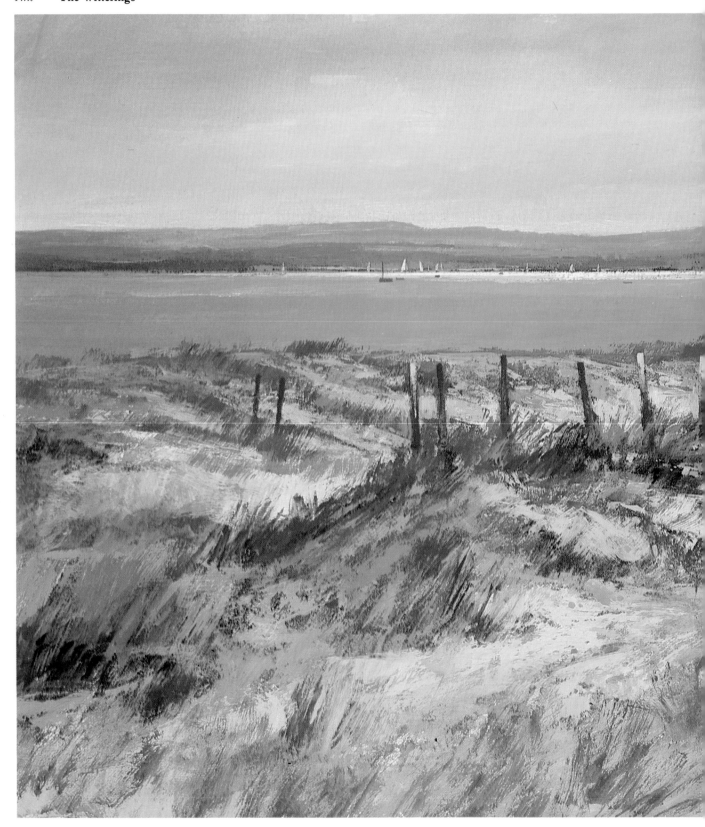

Foreground texture

This high horizon picture illustrates how foreground can form a major proportion of a composition but not unbalance it. My two interests here are the texture of sand dunes and creating a feeling of space.

The sea and sky suggest a warm summer day with a light breeze. To achieve this I touched some of the sky colour into the sea colour, and painted them both in a similar manner. All parts of the painting are tinted with colours from the sand dunes so harmony exists throughout.

The horizon line of the sea had to be worked out carefully, to give a correct impression of the position from which I was viewing the scene. Making the horizon too high would suggest I was standing in a dip — too low would give the impression of my being high up. If hills beyond a shoreline are low a greater sense of distance is achieved because the line of sight is almost level with the true horizon plane. If the range of hills in this picture were high the illusion of distance would be considerably reduced. I included some yachts to increase the feeling of space between the foreground and horizon, and also to suggest scale. The tiny specks of sail echo the rhythm of posts in the sand dunes. Hills in the distance are similar in shape to the undulating dunes and link the foreground to the background.

The colours I used are:

poster red	ultramarine
yellow ochre	cobalt blue
burnt sienna	light red
burnt umber	titanium white

The foreground of the painting is a combination of acrylic and gouache — mostly yellow ochre and burnt sienna gouache on a ground of tinted acrylic.

For the sea and sky I mixed cobalt blue, cadmium red, ultramarine, yellow ochre and white. So that the distant hills were not too mauve I added a touch of burnt umber. To make sure I did not make the sand dunes too yellow I omitted bright yellows from my palette.

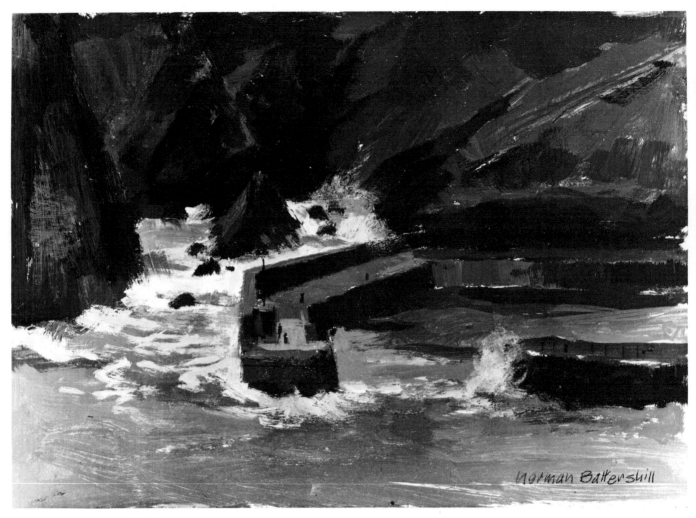

Outdoor painting

A high viewpoint without any sky is an unusual angle to choose, but for my painting I wanted the massive rocks and a rough sea contrasted against the small harbour.

The 200 ft climb up the cliff was amply compensated for by not only the view but the marvellous atmosphere of a very windy and cold February morning. The force of the wind was so great I had to seek shelter behind a rock to paint in safety. A short while earlier I had walked along the harbour wall and saw a notice saying 'Beware of waves coming over the wall'. That point is near the corner of the wall in the middle of my picture — waves do indeed come over the top, with

volume and force as the painting shows.

On this occasion I did not stain the board and worked direct to the white priming. The colours are mostly rich browns and green-greys, with a few accents of pure white to sharpen the contrast with the generally dark tone.

Pronounced shapes may spoil the balance of a painting. Here the left hand side of the harbour is a bold pattern so I am careful to place it off centre. Part of the dark wall on the right is obscured by a breaking wave to prevent its getting too much attention.

Considering the weather conditions, I was quite pleased with the finished

Medium Acrylic on board
Size 11 × 7 in.
Title **Mullion Cove, Cornwall**

picture. For this painting I used the earth colours: yellow ochre, red iron oxide, and burnt umber. The rest of the colours were:

azo yellow light ultramarine
cobalt blue yellow ochre
titanium white

For the sea I mixed cobalt blue, yellow ochre and a touch of red iron oxide, and white. These combinations of colours are also used for the harbour walls. The deep green of the cliffs is mixed from azo yellow light, ultramarine and red iron oxide. For the dark areas I used burnt umber and ultramarine and white.

The placement of rocks is as important a part of composition as the positioning of the harbour in the illustration opposite. Rocks are often so powerful and irregular in outline that it is difficult to create a harmonious composition. Balancing dark and light areas and repetition of movement is one way of getting a pleasing arrangement of shapes, as in this picture.

This subject attracted me because of the angled rock, variety of water pattern and the effect of light. I used a lot of deep green-blue for the sea, with a slight tint of the same colour in the white of the waves. The angled face of the large rock reflects the sky, with various subtle colours of blue, purple, green and yellow ochre. Brush marks add vitality to the rocks and waves, by following the direction of movement. The ability to express movement and texture by the use of brushwork should be of particular interest to the student of seascape painting. A smooth interpretation of the water in my painting would not suggest the vigour of movement and the surface texture so well. Using one large square-ended bristle brush is a good beginning for developing the techniques of expressive brushwork.

I don't often use viridian. It is a very powerful staining colour but many artists include it with their usual colours. I have added a few touches mixed with cobalt blue for a rich blue-green effect. For the rocks I used ultramarine and cadmium red, and burnt sienna and cobalt blue. These are the basic colours. For the lighter areas I mixed cobalt blue, cadmium red, yellow ochre, ultramarine and titanium white.

Medium Oil colour on board
Size 12 × 10 in.
Title **Incoming tide**

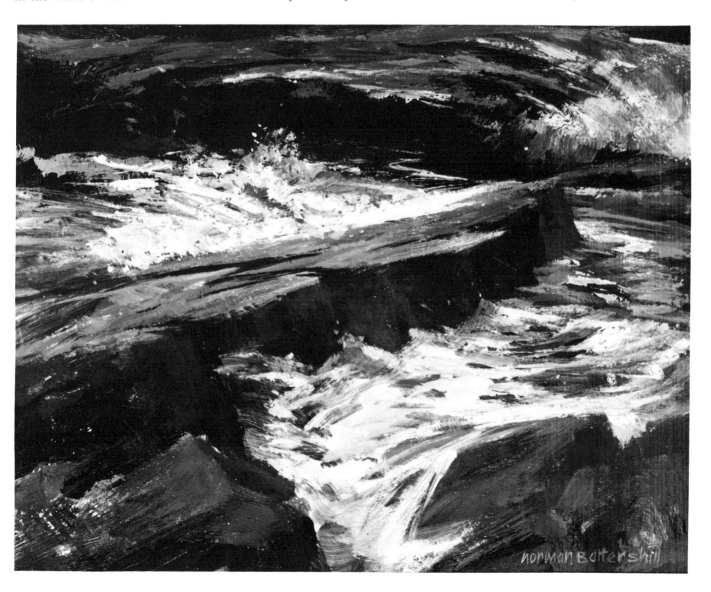

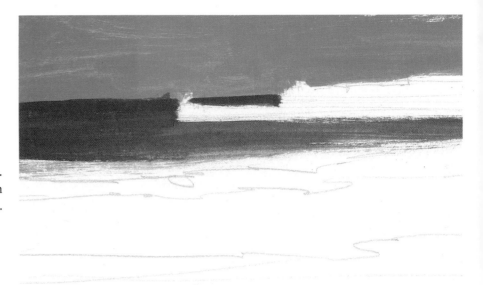

Step one

Gouache is a delightful medium but
unfortunately not as popular as it
should be. I enjoy working with it
because it is versatile and is distinctive.
Gouache dries much lighter than when
it is wet, but this is the only problem.

After a very basic drawing I made a
rough indication of colour areas
using an oil colour bristle brush.

Step two

For the sky I mixed poster red and
ultramarine with a touch of yellow
ochre, plus white. The colour
scheme is to be muted so that all the
colours of the sea are greyed. For
these I mix permanent yellow pale,
ultramarine, poster red and white.
The waves are yellow ochre, burnt
umber and white, and I roughly
indicate the direction of movement.
To emphasise the harbour wall I run
a light strip of grey-green along the
base. This also adds to the
movement of the sea.

Final stage

There are a lot of subtle colours
added to the sea at this stage,
mauve, blue, grey and green. It is
tempting to overstate the whiteness
of surf, but in fact there is very little
light just before twilight. The yachts
are hurrying to their moorings in a
stiff breeze and make interesting
shapes and angles against the dark
background. For the navigation
light at the end of the harbour, I put
a spot of pure white gouache. When
it is dry I superimpose a glaze of
diluted poster red.

A suggestion of foam pattern in the
foreground completes the painting.

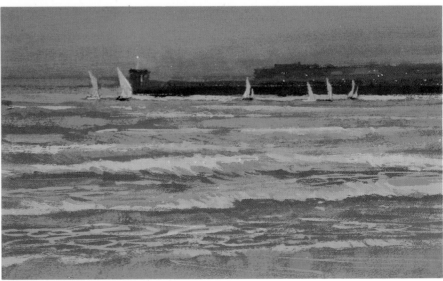

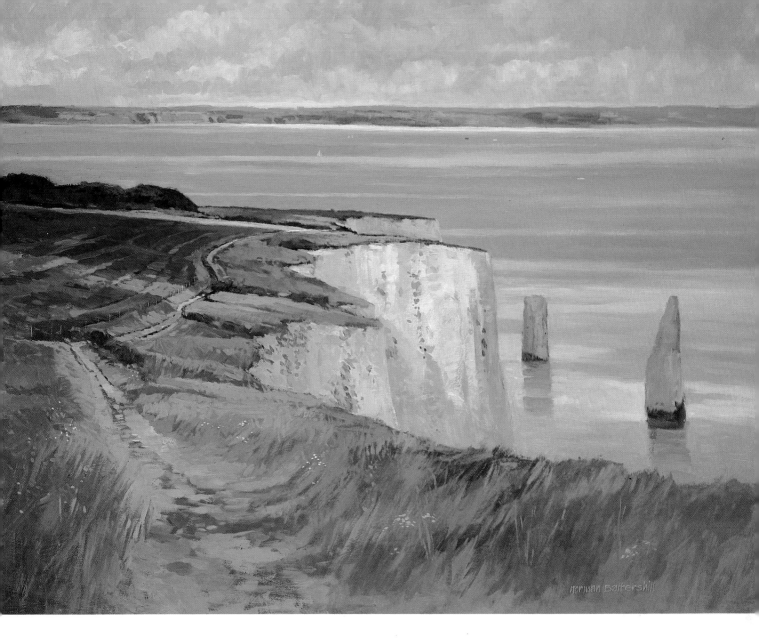

This path is one of my favourite Dorset walks. The views and atmosphere of wide open space are exhilarating and exciting.

Although the sea and sky were painted in the final stages I established a general tone to begin with, so I could judge other tones against it. This method is better than building up a picture piecemeal. The surface of the sea is swept by the wind into streaks, except at the base of the foreground cliffs where its surface is unruffled and smooth enough to show reflections. It is interesting to see the effect of light on the sea around the two isolated rocks.

You will notice that this painting also has a high horizon similar to the picture of the sand dunes, on pp. 122–23. In the distance a flash of sunlight gives interest to the calm flat sea. Flashes of light on water are often very bright indeed, but the effect has to be played down a bit sometimes. If it is too pronounced the illusion of recession is lost.

My colours used are:

cobalt blue
cadmium green
light red
yellow ochre
titanium white

ultramarine
burnt sienna
cadmium red
cadmium yellow

Medium Oil colour on board
Size 4 ft × 3 ft
Title **Studland, Dorset**

For the colour of the sea I mixed cobalt blue with a slight touch of red to add warmth. I added red to the green fields as well, which creates harmony and these colours are also repeated in the sky. Light red is a powerful hue but mixed with yellows it produces a range of russets quite different from any other tube colour.

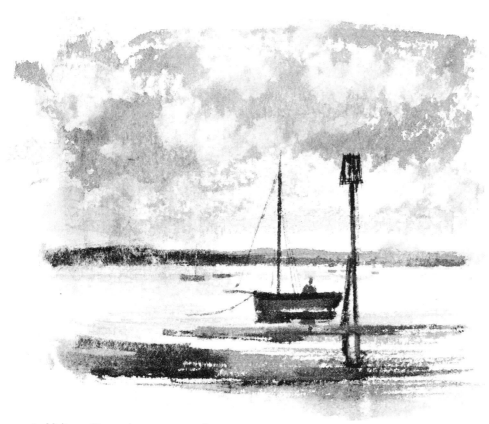

Medium Watercolour on watercolour paper
Size Actual size
Title **Rain**

This small watercolour is done on Bockingford 140 lb watercolour paper, the surface of which is excellent for the dry brush effect of sparkle on water. A spontaneous approach works best on this type of paper. The painting is a simple subject composed of sea and sky, distance, a boat, and marker. There were many more boats moored in the middle of the subject but I deleted most of them to arrive at a stronger and more compact composition.

When the watercolour was thoroughly dry I moistened the sky on the left and dragged down the colour with a piece of paper tissue to get a rainy effect.

For this watercolour I kept my choice of colour to a minimum:

> burnt sienna cobalt blue
> yellow ochre

The sky is cobalt blue with a slight touch of burnt sienna to warm the colour. The boat is the same colour but darker.

This part of Littlehampton Harbour is always bustling with sailing boats and launches, and it can be quite choppy at times. I have painted the water with broad brushmarks which contribute to a feeling of movement. A common error with some students is making boats look as if they are on the water surface and not actually in it. Generally, the reason for this is that the hull is too clearly defined at water level, whereas coarse brushmarks and blending will more convincingly render the effect of a boat being in water and not on it.

This painting is warm and sunny. The colours I used are:

> indo orange red quinacridone red
> cobalt blue ultramarine
> titanium white
> cadmium yellow medium

Medium Acrylic on canvas board
Size 11 × 7 in.
Title **Littlehampton Harbour, Sussex**

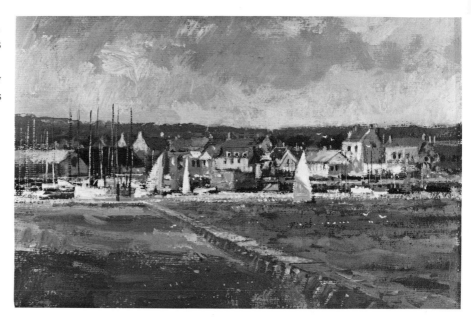

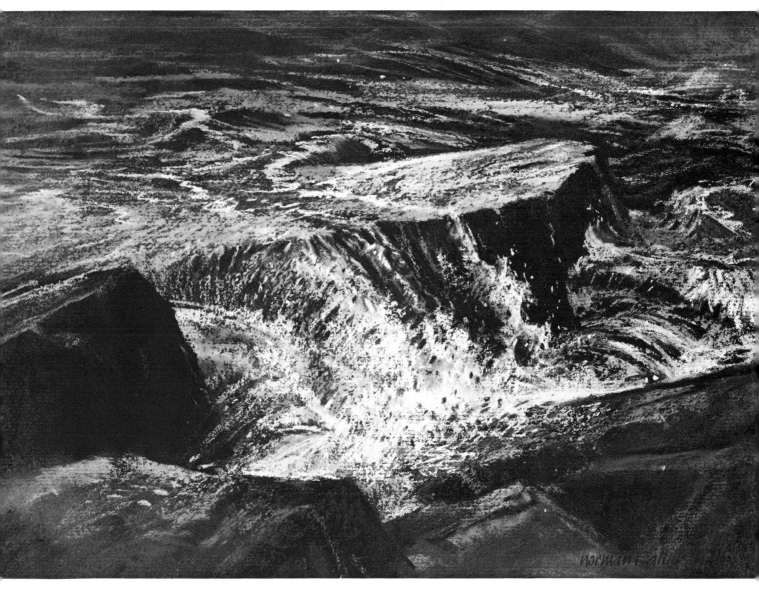

Medium Pastel on brown paper
Size 18 × 12 in.
Title **Tide**

My pastel painting is a study of reflected light on the wet surface of rock and the texture of cascading sea.

Side lighting on the central rock gives a strong effect of light and shadow here and emphasising the shadow throws into relief the angled surface and the nearest cascade. The degree of contrast between light and dark is critical to the overall concept of the subject. If the shadow side of the rock is lighter the effect of sunlight will be minimised.

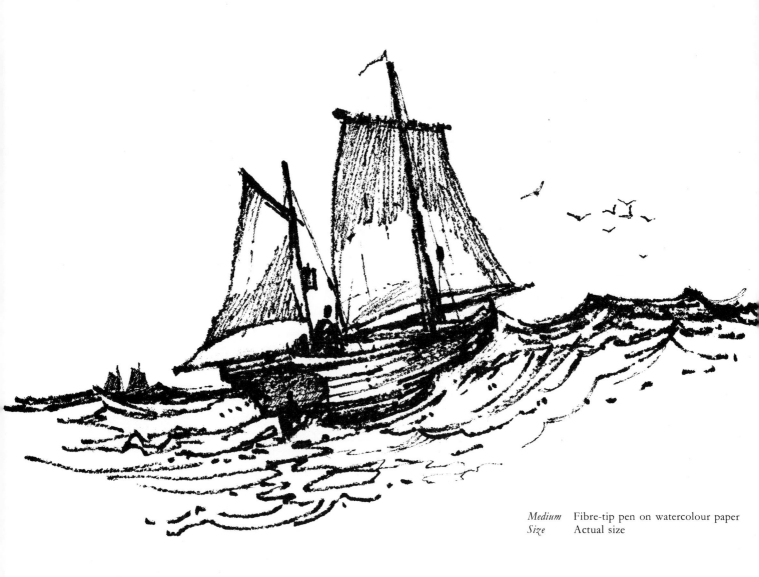

Medium Fibre-tip pen on watercolour paper
Size Actual size

I have chosen this drawing to close
the chapter because to me it conveys
all the power and grace of the sea,
without my having to over-
dramatise the subject to express
these qualities.

7 Gallery

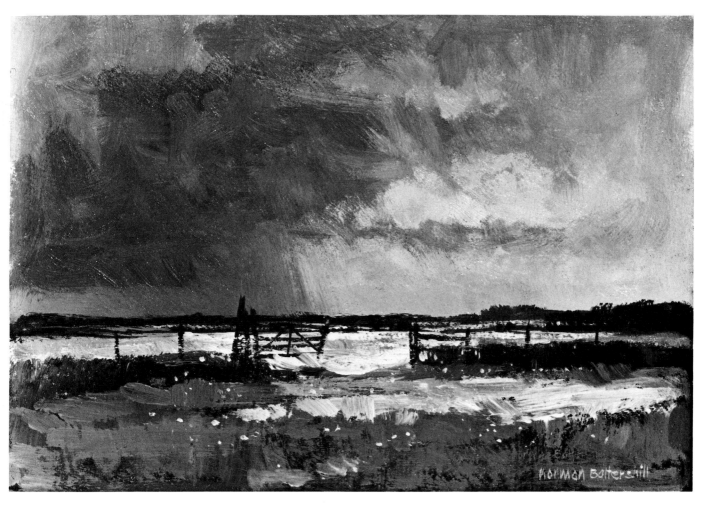

Medium Acrylic
Size 24 × 20 in.
Title **Downpour**

Rain moving across the landscape is a wonderful sight. Sometimes it falls from the clouds like smoke, sometimes in diagonal sheets.

My painting has only a gate as the main focal point. I am more interested in the overall atmosphere than anything else.

The colours used are:

cadmium red ultramarine
cobalt blue burnt sienna
titanium white
cadmium yellow pale

Vigorous brush marks contribute to the movement of the rain.
Sometimes when I feel my painting is getting in the doldrums I take an old rough bristle brush and loosen

up the picture a bit.

For this acrylic painting I used an oil colour brush and applied the paint heavily. The texture when dry was just right for drawing in the gate with a nylon 'rigger' brush. Painting a very simple subject like this can be quite expressive. The picture prompted a friend to make the remark 'It's like my front room—not much in it.'

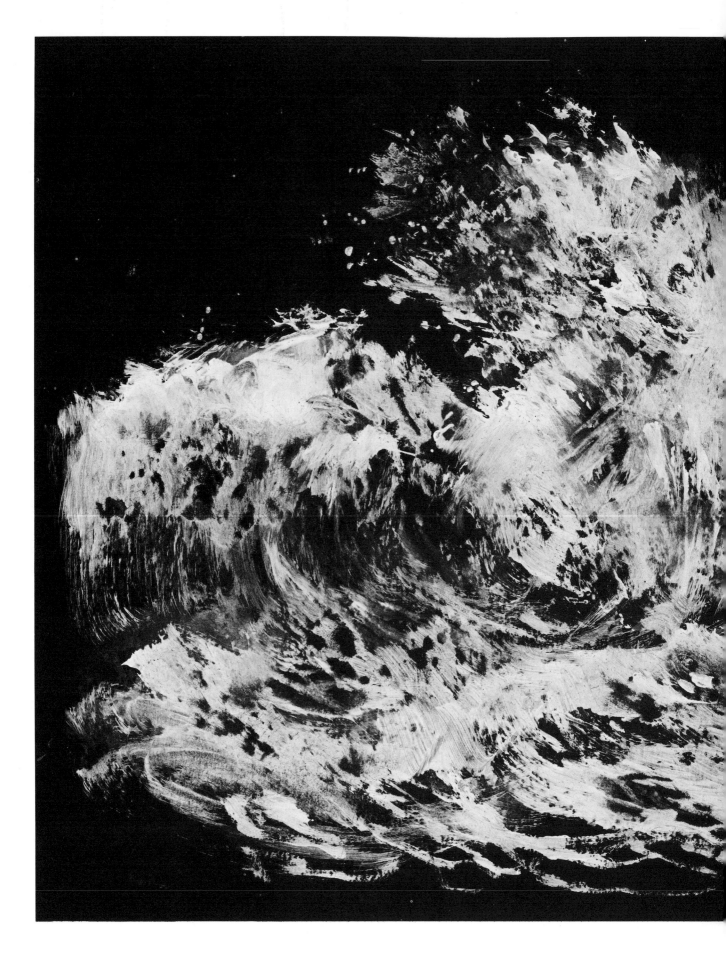

My painting is a free interpretation of a bursting wave. To achieve this effect I used acrylic white paint and an oil colour brush on black card.

I had a preconceived idea of the effect I wanted, and painted with the brush straight away without any preliminary drawing. Fortunately it went as I wanted it to first time. A lot of the texture is accidental but I was in control of the brush all the time and knew the kind of effect I wanted.

Acrylic dries quickly so I was able to complete the painting in one operation without having to stop to let parts dry. I have not used any reference material, preferring to rely on memory and imagination. The study has no 'picture' value but illustrates an approach you may like to try yourself. Paint with as much freedom of movement as you can, and don't worry about failures.

Medium White acrylic on black card
Size $8\frac{1}{2} \times 7\frac{1}{4}$ in.
Title **Wave**

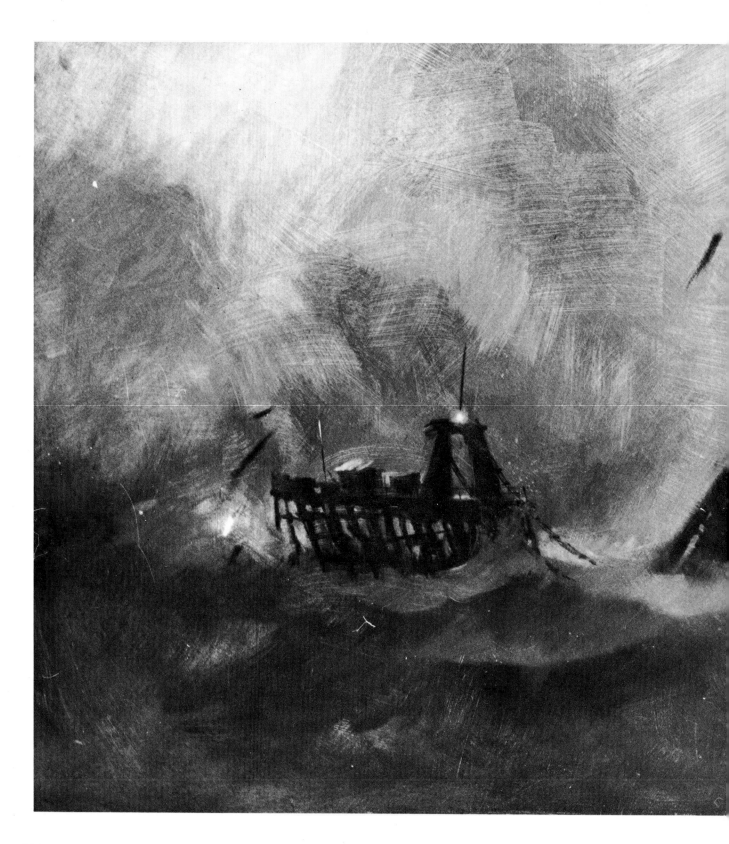

Medium	Oil colour on board
Size	4 ft 6 in. × 2 ft 5 in.
Title	**Collapse of the Brighton Chain Pier, 1896**

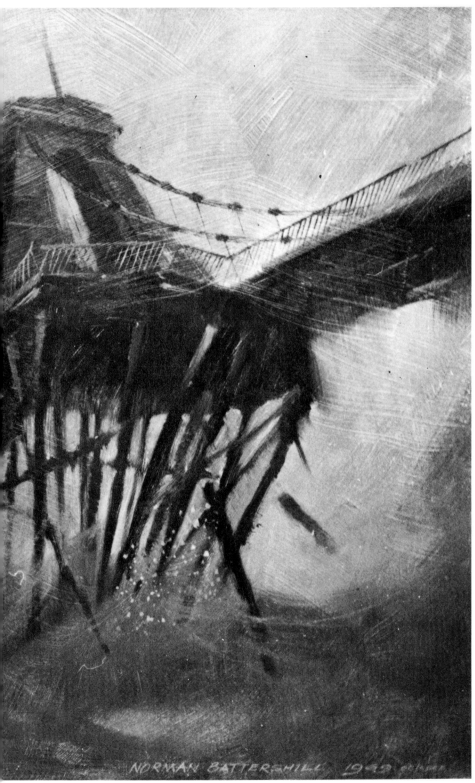

My painting was reconstructed from reading an eye-witness account of the collapse of the elegant Brighton Chain Pier during the night of the 4th December, 1896. Apparently the last thing to be seen was the navigation light on the end staging, and I have made the red lamp the focal point of the storm.

To get the structure authentic I studied drawings and old photographs taken when the pier was at its prime. Next I did a number of small pencil drawings to determine an imaginary stormy sea and its action against the pier structure. As the towers moved the enormous linking chains must have hastened its destruction. By the morning of the 5th there was very little left.

In my painting I have emphasised the power of the tide rather than giant waves crashing against the pier. To achieve this the two structures are leaning at opposing angles suggesting a swaying motion from the movement of the sea. Flying debris and torrential rain contribute to the effect of this entirely imaginary painting.

It does, I think, illustrate the relentless power and energy of the sea.

The overall colour scheme of this oil painting is green-grey which I mixed from:

burnt umber	burnt sienna
cadmium yellow	cadmium red
ultramarine	cobalt blue
titanium white	

To get the effect of the navigation light at the end of the pier I glazed cadmium red over a spot of dry titanium white. This gave the colour a glow. For most of the sea colours I mixed ultramarine, cadmium yellow and cobalt blue and cadmium yellow. To reduce the greens I added a touch of brown or red. The paint is thin throughout the painting to suggest the feeling of wetness.

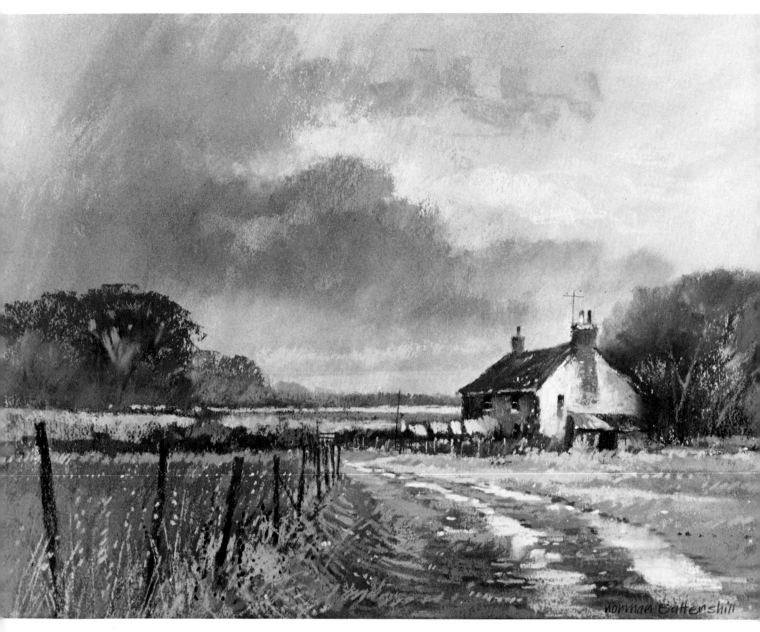

Medium Pastel on pastel paper
Size 18 × 10 in.
Title **Wet washing**

Light rain gives a misty atmosphere
to the landscape, softening the
middle distance and distance to a
warm grey. The atmosphere is soft
and colours are pearly. My pastel
painting is on grey pastel paper
mounted to board.

A studio oil painting from drawings I did near Arundel. The colours are warm, with a contrast provided by blue shadow in the foreground.

The snow reflects many colours but I don't set them all out on my palette at once. I personally prefer to start with a few and add to them as the painting progresses. To ensure that the snow colours are clean I always use a separate paper palette and separate brush.

Medium Oil on board
Size 24 × 20 in.
Title **December**

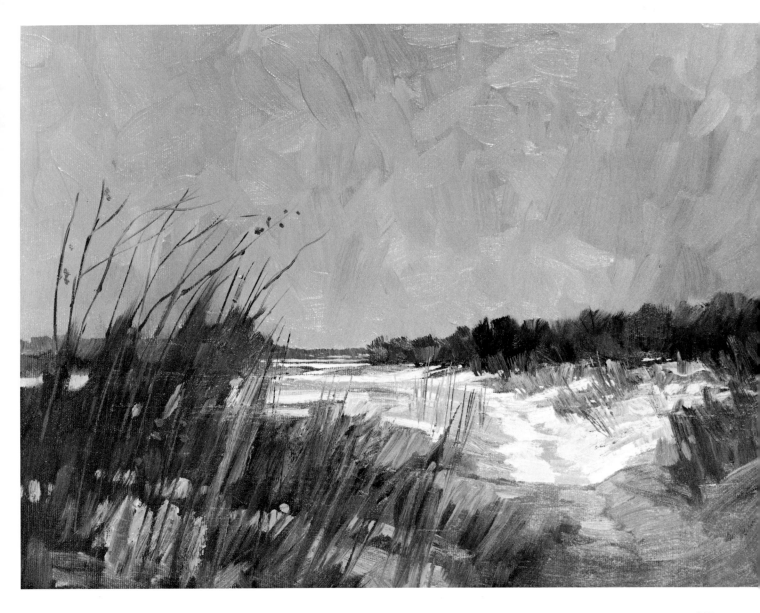

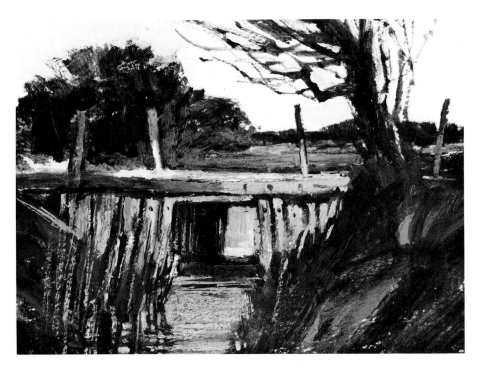

This old bridge is constructed from timbers, which have a patina as a result of many years' exposure to the weather.

When you are painting a bridge it is tempting to emphasise the lightness of water seen through the arch. It is in fact, much darker than you think.

I have used only two colours for this sketch: ultramarine and burnt umber, plus white. To gain both the effect of light on the bridge and its texture I painted it over first of all with thick acrylic white. When this was dry I applied a thin stain of diluted burnt umber, mixed with a touch of blue. The combination of transparency and opacity makes an interesting contrast of paint surfaces.

Medium Acrylic on watercolour paper
Size $6 \times 4\frac{1}{2}$ in.
Title **Old Bridge, Dorset**

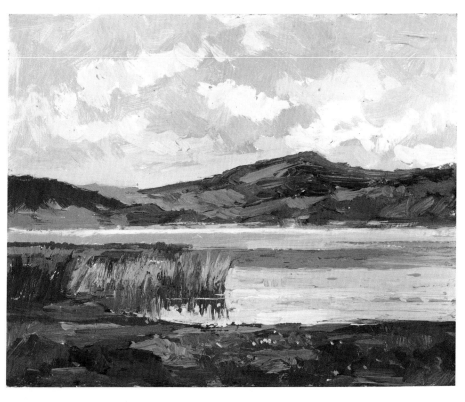

For this painting I mixed gel medium with the acrylic colours, and you can see the brushmarks it produces. My palette for this painting consists of only three colours:

cobalt blue red iron oxide
yellow ochre

For the sky I mixed cobalt blue, red iron oxide and a touch of yellow ochre with white.

The distant mountain is a rich purple mixed from cobalt blue and red iron oxide, with the addition of a little white. The same colours are used for the water, adding yellow ochre to suggest the warmth of the sun. For the foreground shore and reeds red iron oxide, yellow ochre and white produces a warm colour into which I painted some purples and blue whilst still wet.

Medium Acrylic on board
Size 10 × 8 in.
Title **Welsh landscape**

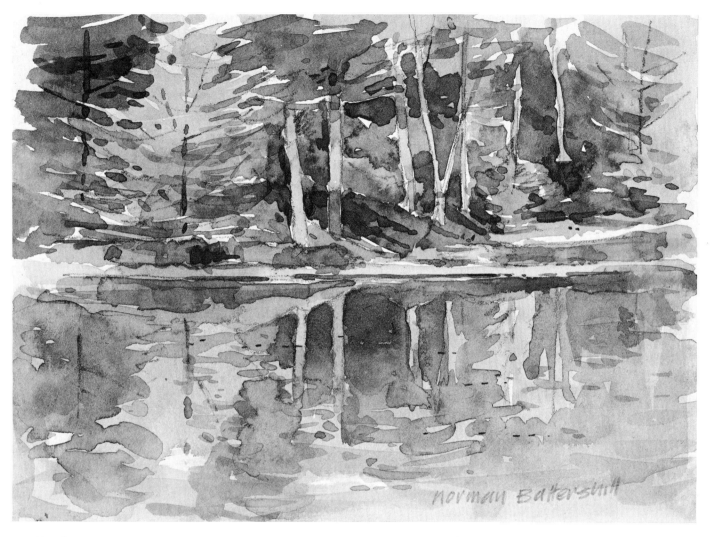

continued

Brushwork is expressive and here I have made use of the impasto technique to add vigour and movement to a lively subject. If you wish to use a lot of gel medium with your colours make sure the picture is thoroughly dry before handling it. It takes a bit longer for the thick paint to dry out completely than it would normally.

Medium Watercolour on cartridge paper (drawing paper)
Size $6\frac{1}{2} \times 4\frac{3}{4}$ in.
Title **The Blue Pool, Dorset**

My outdoor watercolour of trees and reflections is a complex subject so I had to simplify it a great deal. I laid a wash over the pool of pale green which gave me a base colour and tone. For the upper part of the painting I worked direct to the white paper.

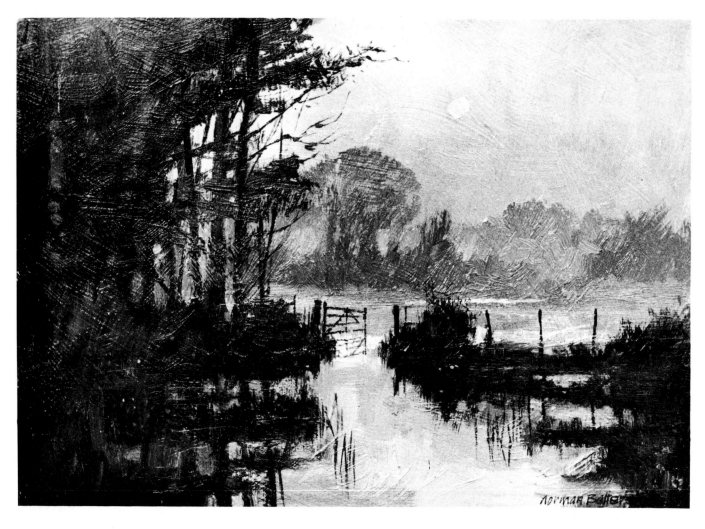

Medium Acrylic on board
Size 11 × 7 in.
Title **Winter morning**

The colour scheme of this painting is silver grey, to suggest mistiness after rain in the early morning. It is not easy to capture an impression of moist air. Subtle gradation and recession of tones and a textured surface is the method I have used in this acrylic painting. I started my picture by establishing the three separate tones of distance, middle distance and foreground.

Positive division of tone adds to the dramatic effect of atmosphere and depth. Contrary to the principle that water is darker than sky, in this painting I have made the water lighter in tone to suggest bright light from the sky, and it seems to work satisfactorily. To thicken the acrylic paint I mixed acrylic gel medium. You can see the effect it gives to brushmarks to the right of the gate. The colours used for this almost monochromatic painting are:

burnt umber cobalt blue
cadmium red ultramarine
titanium white

I did this oil painting outdoors in the fields near where I live. The landscape was carpeted in snow and I had great difficulty in selecting a subject—I wanted to paint it all. I used the grey back of illustration board; the warm colour was exactly right for the underlying shade I needed to work on.

The composition of fence poles and the shrub fascinated me so I began painting straight away without any drawing. My palette consisted of:

cadmium red ultramarine
cobalt blue yellow ochre
burnt sienna titanium white

I mixed shadow colours on the snow from cobalt blue and cadmium red with a slight touch of yellow ochre. The large shrub is deep russet mixed from burnt sienna, ultramarine and yellow ochre. Because the board is absorbent I could paint direct with plenty of pigment, which particularly suited the way I wished to express the scene. The background hills are painted in a deeper blue-mauve than the shadows on the snow. Small touches of white paint suggest a patch of sunlight in the foreground, but I was careful to restrain my use of neat white so that the effect of snow would not be lost.

Medium Oil on illustration board
Size Actual size
Title **Snow—Sussex**

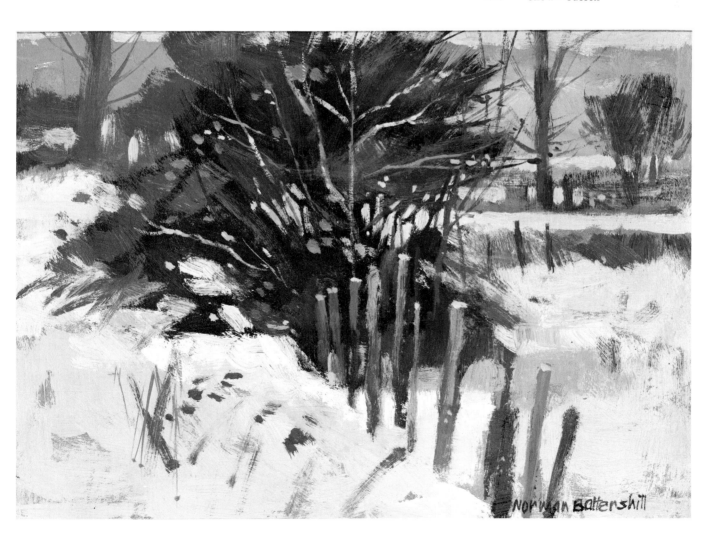

Norman Battershill

Painting and drawing water is a most absorbing subject. This book can only embrace a small part of it, but will, I hope, encourage you to look more closely at water in the landscape, and how you can include it in your paintings.

My drawings and paintings may help you to make a start—but remember, understanding what you are doing is the way to success. Because it is seldom still water is the most difficult of all natural phenomena to draw and paint, and it will take a lot of hard work to develop your ability to express the many varied forms of water. You will need lots of patience—but you will find it all an immensely rewarding and enjoyable experience.

Bibliography

Seascape Painting Step-by-Step Borlase Smart (Pitman, 1978)

Expressing Land, Sea and Sky in Watercolour Rowland Hilder (Watson Guptill, 1982)

Marine Painting in Watercolour Edmond J. Fitzgerald (Pitman, 1972)

* *Painting and Drawing Skies* Norman Battershill (Pitman, 1981)

The Seascape Painter's Problem Book E. John Robinson (Watson Guptill, 1976)

Gruppé on Painting Emile A. Gruppé (Watson Guptill, 1976)

Gruppé on Colour Emile A. Gruppé (Watson Guptill, 1979)

Brushwork Emile A. Gruppé (Watson Guptill, 1977)

Painting Seascapes John Raynes (Studio Vista, 1971)

Painting Landscapes in Pastel Ernest Savage (Pitman, 1971)

* *Draw Seascapes* Norman Battershill (Pitman, 1980)

* *Draw Landscapes* Norman Battershill (Pitman, 1980)

* now available from A. & C. Black

List of suppliers

All materials discussed in the text are obtainable from good art shops, but in case of difficulty you might refer to the following:

General materials and equipment

Arthur Brown and Bro., Inc., 2 West 46th Street, New York, New York 10036

Binney and Smith, Inc., 1100 Church Lane, Easton, Pennsylvania 18042 (chalks)

Charrette Corp., 212 East 54th Street, New York, New York 10022

Duro Art Supply Co., Inc., 1832 Juneway Terrace, Chicago, Illinois 60626

Faber Castell Corp., 41 Dickerson Street, Newark, New Jersey 07107

Flax, 747 Third Avenue, New York, New York 10017

M. Grumbacher Inc., 460 West 34th Street, New York, New York 10001

Frank Herring & Sons, 27 High West Street, Dorchester, Dorset

A. Ludwig and Sons Ltd, 71 Parkway, London NW1

E. Ploton Sundries, 273 Archway Road, London N6

George Rowney and Co., PO Box 10, Bracknell, Berkshire

Winsor and Newton Ltd, Whitefriars Avenue, Wealdstone, Harrow, Middlesex

Yasumoto and Co., 24 California Street, San Francisco, California 94111

Daler Board Company, Westminster Road, Wareham, Dorset

Canvases

As above and:

Russell & Chapple Ltd, 23 Monmouth Street, Shaftesbury Avenue, London WC2

Easels

As above and:

Guys Art Products Ltd, Longbridge Meadow, Cullompton, Devon

Paints

Bocour Artists Colors, Inc., 1291 Rochester Road, Troy, Michigan 48084

Salis International, 4040 North 29th Avenue, Hollywood, Florida 33020

Index